THE
HIDDEN
ELEMENTS
OF
DRAWING

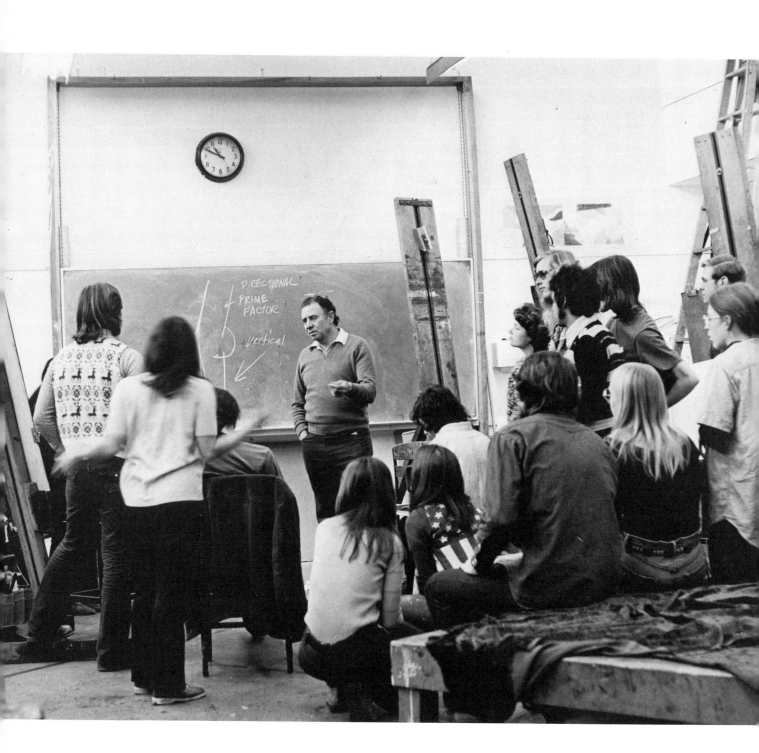

THE
HIDDEN
ELEMENTS
OF
DRAWING

JOSEPH MUGNAINI

VNR VAN NOSTRAND REINHOLD COMPANY
New York Cincinnati London Toronto Melbourne

Van Nostrand Reinhold Company Regional Offices:
New York Cincinnati Chicago Millbrae Dallas

Van Nostrand Reinhold Company International Offices:
London Toronto Melbourne

Copyright © 1974 by Litton Educational Publishing, Inc.
Library of Congress Catalog Card Number 73–3944
ISBN 0-442-25722-8 (paper)

Diagrams by the author
Photographs by Skip Takeuchi, Ernest Robischon, David Starrett, and
Bill Creamer
Designed by Visuality
Published by Van Nostrand Reinhold Company
A Division of Litton Educational Publishing, Inc.
450 West 33rd Street, New York, N.Y. 10001

16 15 14 13 12 11 10 9 8 7 6 5 4 3 2

Library of Congress Cataloging in Publication Data

Mugnaini, Joseph A
 The hidden elements of drawing.

1. Drawing — Instruction. 2. Form (Aesthetics)
I. Title.
NC735.M82 741.2 73–3944
ISBN 0-442-25722-8 (paper)

AND THIS ONE IS FOR RUTH

I want to express my thanks to Skip Takeuchi and Ernest Robischon, who patiently, during the year, photographed the models and demonstrations in this book; to David Starrett and Bill Creamer- who contributed important photographic sections when they were urgently needed; and to Marie Starr, Nancy Hughes, and Henriette Simon, for identifying and categorizing the bulk of the material.

I am indebted to the administration of the Otis Art Institute, its board of governors, and the Los Angeles Board of Supervisors for the freedom to use the schools facilities; to Ruth, who, playing the devil's advocate, helped me to achieve consistency in a theme which at best is extremely difficult to maintain; and finally to my students, from whom I am constantly learning.

And a special thanks to Barbara Klinger for helping to put it all together.

CONTENTS

PREFACE

This book was in existence long before it was written, taking form in the notebooks and memories of students who, along with myself, have struggled to lay bare the secrets of draftsmanship and the intangibles of art.

The contents are a condensation of material from the notes of those who have studied with me for the past twenty-five years. To insure that only the commonly accepted theories and practical exercises would be included in the book's format, I asked a representative cross section of those students who at the present time are either teaching or established in the various fields of art to submit the raw material — the notes and diagrams they recorded as students in my drawing classes.

I eventually discovered, when examining the formless mass of scattered ideas and concepts which I had accumulated, that a logical pattern of diagrams and demonstrations began to develop. The concepts involved in these diagrams had been accepted by at least 90 percent of the contributing group, confirming my feeling that the above-average art student accepts only concepts that seem relevant to the problems he is involved with at the time.

I then compiled the material these students considered most valid into a year's teaching program, during which the diagrams, demonstrations, and lectures given in individual class sessions were recorded in photographs and on tape.

This book, then, is in essence a visual and graphic recording of a rewarding symbiotic relationship which existed within the environment of a well-established, well-directed class in drawing.

Charcoal drawing by Marie Starr. An example of structural draftsmanship.

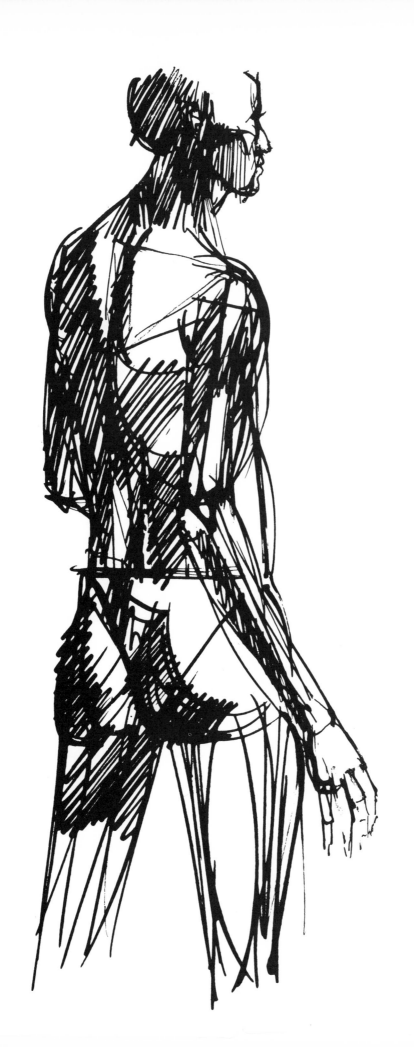

I. READING FORM

THE VISIBLE ELEMENTS: LINE AND TONE

The artist has no covenant with nature in his ability to read the general characteristics of form, space, and motion. Life upon this planet is in varying degrees dependent for survival upon the awareness and recognition of form, space, and movement. This is true of the simplest as well as the most complex systems, including man. We, as well as other vertebrates, through conscious and subconscious processes related to physical activity, have learned to associate visual phenomena to tactile experience. This means that our sense of sight has become co-ordinated with our sense of touch to convey similar information on the nature of form and space.

Because of this, we are able to translate an optical version of an object into a tactile experience related to edges, planes, texture, and space. This suggests that, in a sense, we are able to see with our hands as well as feel with our eyes. You may prove this with a simple experiment. Select a solid, opaque object. Gauge the angle of light striking it, and, with your eyes closed, physically probe its edges and planes. Mentally translate what you touch and feel with your fingertips into light and dark values. You will find that a sudden turn in the form away from the light source will appear to the mind's eye as a strong, sharply edged dark area next to a light area, while a gradual transition of the object's contour will result in a gradation of tonality. A rough-textured plane or contour facing the light will be envisioned as gray or toned. Conversely, there is no question as to our ability to visually recognize, even at great distances, the tactile qualities — the projections, ridges, planes and textures — of visible form. This is illustrated in the two following charts.

In both cases, illustration A was designed as a prototype representing form in general and demonstrating how it may be reduced to a graphic image of mass, volume, and space with two of the most important visual elements: *line* and *tone*.

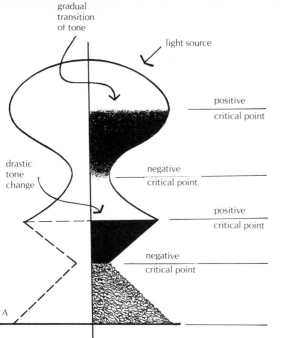
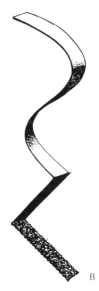
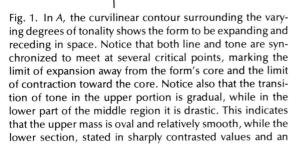

Fig. 1. In *A*, the curvilinear contour surrounding the varying degrees of tonality shows the form to be expanding and receding in space. Notice that both line and tone are synchronized to meet at several critical points, marking the limit of expansion away from the form's core and the limit of contraction toward the core. Notice also that the transition of tone in the upper portion is gradual, while in the lower part of the middle region it is drastic. This indicates that the upper mass is oval and relatively smooth, while the lower section, stated in sharply contrasted values and an acutely angled outline, consists of two circular planes combining to form a rounded, sharp edge. The gray staccato tone on the surface of the base reveals it to be roughly textured.

B represents a strip of paper shaped to conform to the contoured shape of *A*. It is a practical experiment demonstrating how edge and volume may be translated into line and tone. The shaded areas represent volume and tone; the thin edge represents edge and line.

Fig. 2. *B* represents a slot cut out of a piece of cardboard. By placing the opening near the center on prototype form *A*, the element of tone is isolated from line, demonstrating that tone is capable of transmitting information related to the expansion and contraction of mass directly confronting the viewer, while line (*C*) conveys information revealing the lateral, positive and negative limits of mass from the same viewpoint. You may try this visual experiment yourself by cutting a slot out of a piece of cardboard and holding the opening against a strongly lighted object.

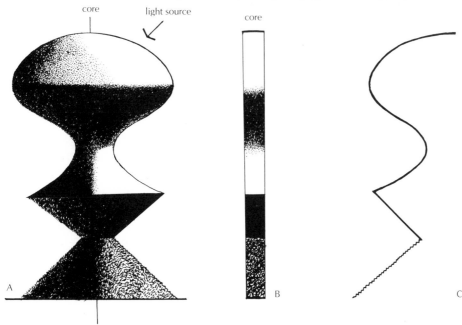

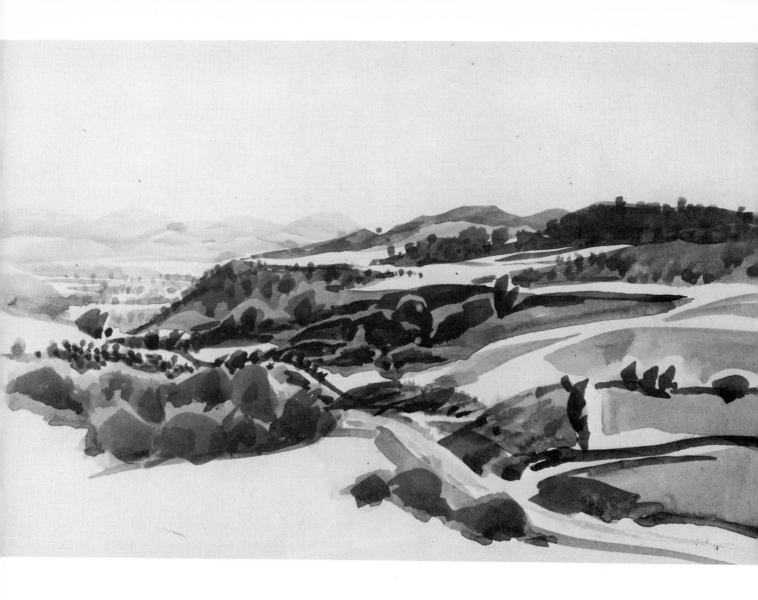

Fig. 3. *Utah Benchland,* Harrison Groutage; ink and wash. A top-rate landscape artist is familiar with the geological structure of the land, which lies below the fields and forests and which — like that of the human frame — governs the essence of its form. The freedom exhibited in the execution of the above drawing was made possible because of the draftsman's insight into the hidden elements of form.

THE INVISIBLE ELEMENTS: NATURAL LAWS

While the artist is not privileged in his ability to read form through line and tone, he can cultivate a method of reading form that will give him insight into its appearance and nature. Such insight enables the artist to render his own understanding instead of merely imitating someone else's, and it comes from the recognition of the invisible elements of form, elements that govern the properties and actions of mass in space. One such element is the force of gravity, which forces a balance on all things in nature.

Perhaps, we shall be able to understand this better if we return to the previous two charts and imagine figure *A* to be modeled of soft clay. It will then become evident that a reduction of the form's core at any negative

12

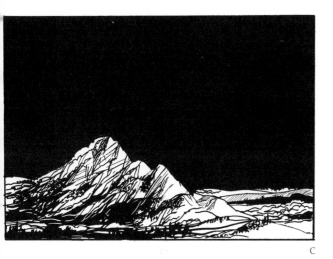

Fig. 4. All forms are subject to the universal force of gravity. The uplifting of geological masses on the surface of this planet and the subsequent erosion of these masses no doubt resulted in extremely irregular forms with excessive critical points, both positive and negative; yet gravity has inexorably reduced unbalanced mass above the earth's surface to the most permanent of shapes, the cone and the pyramid. A mountain range, for example, is composed of a series of cones and pyramids; so are piles of debris, and mounds of sand.

critical point would cause it to collapse from its own weight, while expanding its mass at any positive critical point would also cause it to collapse for the same reason. This emphasizes that, in the absence of a supporting armature, the extension of mass into space is limited and any expansion or reduction quickly reaches a critical point. As curves and angles generally indicate expansion or reduction of mass, we can conclude that, in the absence of proper support, nature cannot afford extraneous curves or angles.

Nature has in fact developed two basic devices which allow a greater extension of bulk in space. The first device is an exoskeletal shell supporting the body plan of most invertebrates, including insects and crustaceans. The second device is the endoskeleton, or inner skeleton, which forms the supporting and protective framework of the vertebrate. The evidence which proves the efficiency of the endoskeletal frame is overwhelming, for nature has successfully developed innumerable vertebrate types with this device, ranging from the smallest rodent to the elephant and whale in the mammalian category, and from the tiniest lizard to brontosaurus in the reptilian.

In the case of vertebrate life, bulk must be accounted for in terms of serviceability as well as supportability. For here, bulk must be maintained nutritionally and, unlike plant life, animal nourishment requires activity and locomotion to acquire. Movement requires muscular structure, which forms the animal's bulk. Briefly stated, this means that bulk, energy, and motion interact in a perpetual cycle, which manifests itself in the shape the animal must have to perform the various functions required to maintain its existence. Here, excessive bulk endangers not only the animal itself but the species as well. We shall examine the interaction between form and function in more detail in Chapter 3. As we shall see, other natural laws, governing the actions of mass, also influence form.

THE ELEMENT OF TIME

In many cases, the shape or form of an object is not the result of the manner in which mass *occupies* space but is a product of the *motion* of mass in space, which involves the factor of time. If we consider that inorganic, non-living forms — such as sea waves — maintain a constant, rhythmic pattern of motion and a relative consistency of shape, then we may safely assume that a wave, like other more permanent forms, regardless of size, origin, or location, possesses characteristics analogous to anatomical structures. The following analysis of a wave striking a rock illustrates the invisible, dynamic pattern of momentum generated by wind and water (Fig. 5).

Contradictory as it seems, an artist whose imagery is founded on a natural phenomenon such as the sea cannot be termed a seascape painter. He is instead one who has been able to penetrate the visual drama of wind, wave, and movement to visualize cosmic forces which manifest themselves through the medium of the sea. His images transcend the trivia and banality of the seascape as a picture — complete with transparent and translucent masses of reflected and refracted green light. As a draftsman, he has reduced, through observation and experience, the usual, commonly accepted version of the sea to a definite pattern, which serves as a basis for his personal idiom.

Under similar conditions, the pattern of a breaking wave will remain the same, differing only in minor detail, because the pattern is produced by invisible natural laws governing mass and motion, time and space. The pattern is recognizable only if we realize that what we see is actually a segment of an event originating at a remote point in space and time. Simi-

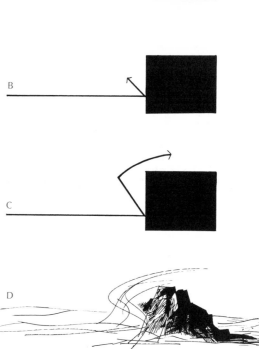

Fig. 5. *A:* The arrow represents the movement of the sea wave. The rectangle represents the opposition of a large rock.

B: The movement is, for a brief moment, arrested but not completely.

C and *D:* The water's momentum carries it forward.

larly, it is not difficult for the artist to conceive of a mountain as an event. Does a mountain not grow, remain stable for a time, and then finally succumb to the invisible forces of erosion and gravity?

We cannot possibly see these events take place; an individual's life is too short and, like the fast shutter in a camera lens, it frames action and change into an apparent state of immobility. In the same way, to an organism whose life spans a fraction of a second, a wave would seem as permanently structured as a

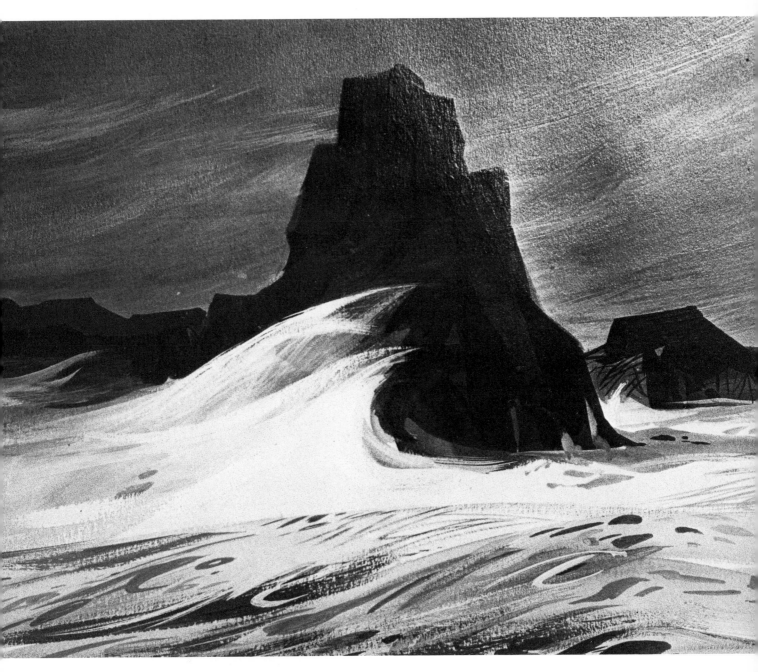

Fig. 6. *Baja Tide*, Joseph Mugnaini. It is not difficult to conceive of the breaking wave as an event and to discern its pattern.

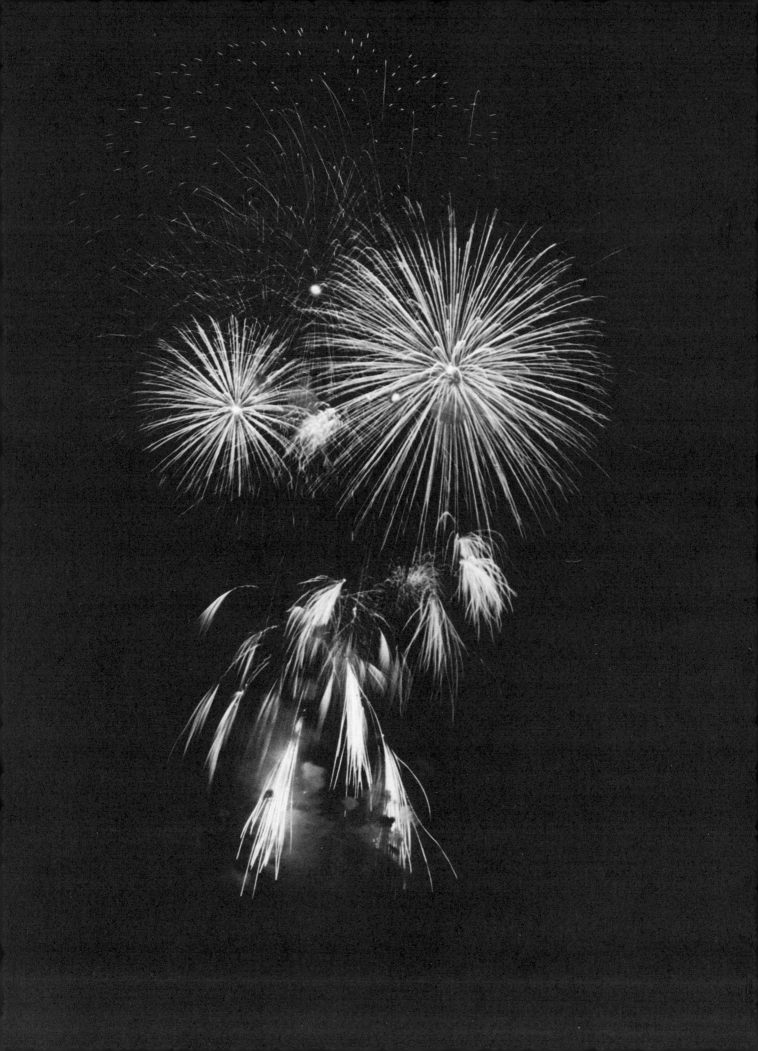

mountain, while the burst of a Roman candle (Fig. 7) would seem forever still. Although it is a practical impossibility to extend our lives over a few billion years and to witness the rise and fall of mountains, the advance and retreat of ice across the continents, and the ebb and flow of oceans over the surface of the globe, the artist is able to perceive and interpret form in the light of such events. The tools for creative perception are sensitivity to human events and an awareness of the invisible forces and laws of nature.

Beyond this, there is the artist's conceptual power, springing from human consciousness and from an innate curiosity, the latter of which is too often squandered during the pro-

cess of growing up. As children, our probing young minds are stimulated by ordinary events and simple objects considered to be either trivial or unimportant by average, adult standards. In contrast, both child and artist see, in common subjects, drama and magic beyond either the interest or comprehension of a pragmatic society. This point of view is an inner vision without which creative thought and art are both impossible.

Fig. 8. This photograph is of a delicate-appearing weed that grows in the harsh plains of southern Idaho. It also represents the partial image of an event; for time-lapse photography over a period spanning the weed's growth would reveal a pattern similar to the explosive action of a fireworks display.

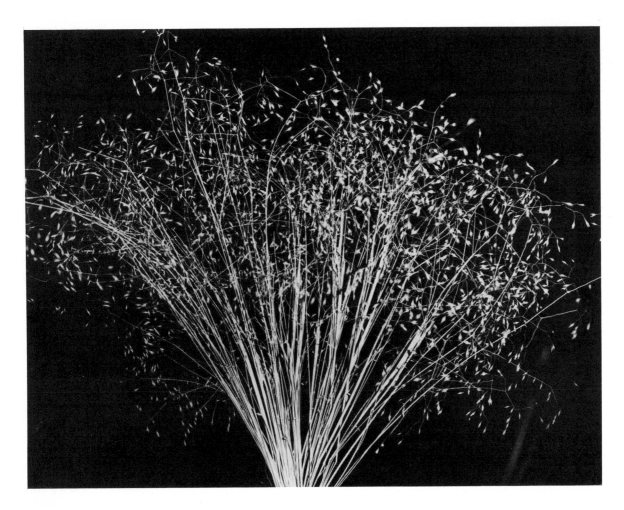

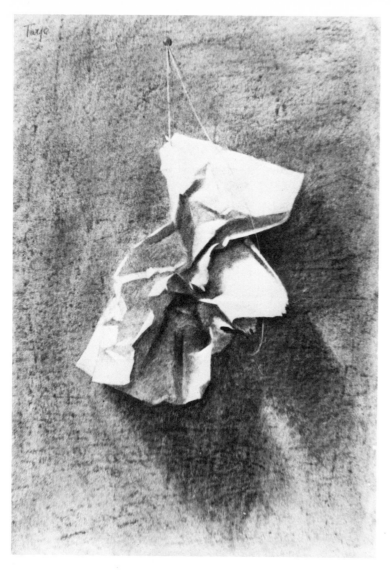

Fig. 9. *Crumpled Paper*, John Taye; charcoal, 16 by 24 inches.

HIDDEN CONTENT: A GRAPHIC ESSAY

In comparison to a mountain and oceans, a common item such as a sheet of paper seems totally lacking in character. Yet only a material such as paper could respond to the act of being crushed by recording with such crisp, angular and faceted detail the impression of that past event. In addition, paper — with its unique capacity for subtle resistance — can surrender a portion of its former shape without total capitulation. In Fig. 9, we see that each fiber within the paper's form firmly clings to a pattern of inherent rigidity even while contributing to the crumpled impression left by the

firm grasp of a human hand. Because of this, we may be certain that paper does possess characteristics which are consistent and indicate a rudimentary structure.

These comments on the forlorn-appearing sheet of paper may seem overemphatic. I mean them to be, for although the drawing's ostensible subject is a mildly mangled sheet of paper contrasted against another, still-flat sheet, which is slightly modified by tone, we can almost recapture in our minds the act which changed the first paper's form — the act or event being the hidden content of the drawing.

Just as invisible elements are implicit in form, hidden content — the artist's concept — is the essence of visual art. A drawing may be totally realistic but its true meaning is conveyed through symbolic devices that may easily escape notice. The drawing by Charles White (Fig. 10), for example, would be termed realistic, but its true content lies in the symbolic elements expressing the artist's concepts. Describing the stratified, poster-laden wall, the artist comments, ''[It is] a wall that is so characteristic of every ghetto in our country, and the inhabitants that become an intimate part of that wall, and little children that seem to be born old.''

The artist's concepts and intent are conveyed in part by the way in which he uses basic graphic elements, intuitively selecting them to express his imagery. Here, the artist employs diametrically opposed elements: light tones against dark ones, horizontal lines contrasted with verticals, active areas versus passive areas, roundness against angularity, etc. These elements of the graphic language are universally comprehended; and, perhaps more importantly, they are comprehended as conveyors of abstract factors in addition to being instruments of alleged realism. These elements and other conceptual aspects of drawing will be considered in later chapters. Before we can use form to express our ideas, we must first be able to perceive it correctly.

Fig. 10. *The Wall,* Charles White; Chinese ink brush and
cotton rags, 38 by 52.

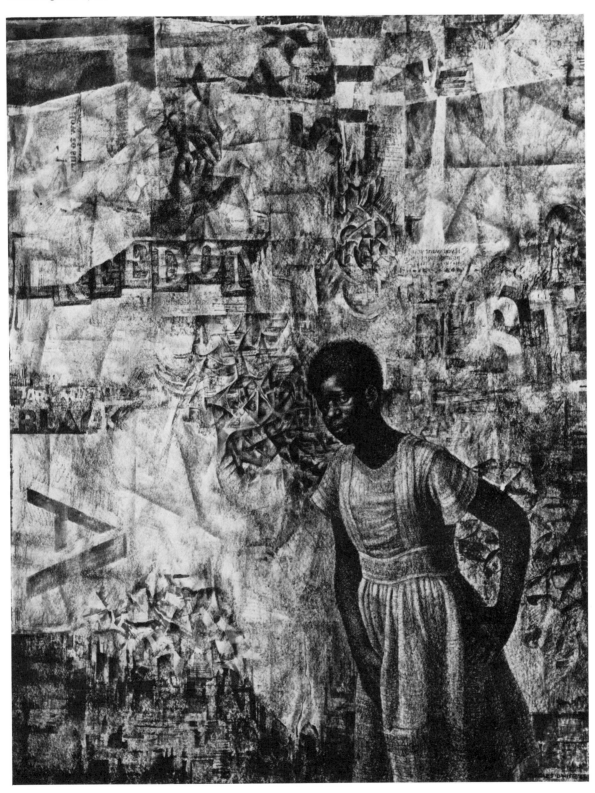

2. FORM AND FUNCTION: UNDERSTANDING STRUCTURE

In reading form, we can obtain certain clues by being aware that all form is strongly influenced by invisible forces and known universal laws. Similarly, we can obtain additional insight by investigating the relationship between form and function. In Fig. 11, four apparently different forms show the same branching pattern. This is because each form reflects the same function, and that is to carry or distribute something from one locale to another.

In plants, the branching pattern is related to the distribution of vital fluids necessary to maintain the organism. In animals, this pattern of distribution occurs in both the circulatory and nervous systems and is based on a primary and subsidiary flow of nerve impulses as well as of vital fluids. In stream systems, the pattern is caused by the natural flow of rainfall from mountain slopes to sea level, along land channels and basins, to form a connected system of drainage between bodies of water above sea level and the ocean.

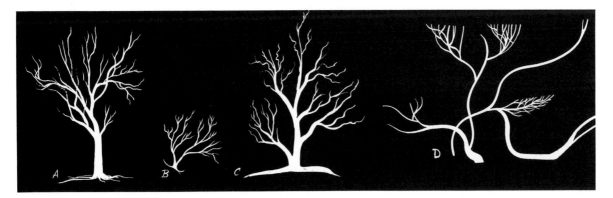

Fig. 11. Branching patterns related to the function of distribution: *A* is a leafless peach tree; *B* is a section of the cerebral ganglia of a sea worm; *C* is the delta of a river; *D* is a section of a frog's nervous system.

Fig. 12. The pattern below is not of a city map; it is a section of a Mohave desert plant, and is an excellent example of a circulatory pattern.

Fig. 13. This photograph is of the whole plant; the pattern shown resembles the pattern of circulation in most large, flat leaves.

Fig. 14. Each tree in a grove is distinct, but to read form correctly the observer must concentrate on the structural essentials common to all rather than on the differences that set each apart from the other.

Just as function can account for similar shapes in diverse objects, adaptation of functional systems to environment can account for diversity of form among similar objects. In Fig. 14 we see a grove of a single tree type; yet each tree in the grove bears distinct characteristics. If we are to draw any one tree from this grove convincingly, we must start not with the details of difference but with the elusive character

Fig. 15. Two different plant types nevertheless share a common structural principle, which may also be applied to a human limb *(C)*. Each is massive at its source and diminishes in size while successive parts multiply in number.

common to all. To do this, we must identify and isolate the structural and functional essentials each shares with the other.

Fig. 15 shows two different plant types (*A* and *B*) that nevertheless share a common structural principle. Each has its total mass divided into equal sections, beginning with the trunk and moving in successive stages to the branches and the final spray of twigs. The tree trunk is massive for two reasons. It is the main support for the total structure and it is the main avenue for the flow and distribution of fluids moving from the roots to the leaves. In each succeeding stage, the branches diminish in size but multiply in number; however, the total mass in each new stage remains roughly equivalent to that of the preceding one. This is the structural principle we would have to incorporate in our interpretation of any individual tree belonging to either plant type.

A similar structural principle could be applied in analyzing a vertebrate limb (*C*). A human arm or leg, for example, is massive at its source, while the bones, muscles, nerve conduits, and arteries diminish in size and multiply in number through each of three phases from source to terminus. The vertebrate limb, however, is designed for purposes of articulation in addition to circulation, and therefore assumes a highly specialized form.

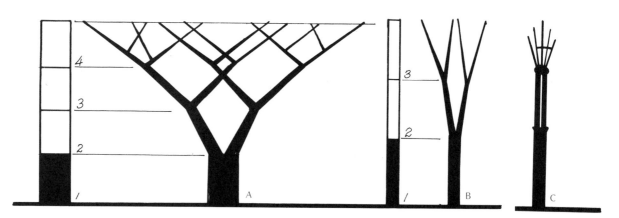

Fig. 16 shows three additional plant types and the effects of their adaptation to environment. In each example, the mass of the trunk becomes increasingly predominant until, with the cactus — which maintains a compact shape because of its harsh, dehydrating environment — we find a fundamentally unified structure containing no twigs or leaves.

EXERCISE: ISOLATING STRUCTURAL ESSENTIALS

The following exercise illustrates how a systematic procedure may be applied to the reading and analysis of form. The procedure is based on the elimination of superfluous details from the object or subject under consideration. Essentially it requires one to isolate and compare fundamental characteristics or elements within similar or comparable objects and to note what structural principles the objects have in common. These fundamental characteristics may be referred to as common denominators. Identifying them is accomplished by reducing an observed shape to the basic elements required by its function.

Fig. 17 is a drawing of a baroque-shaped bottle. Can you reduce the form's ornate, curvilinear appearance to its functional essentials? Using line as a visual element, sketch with either a pencil or a pen what you consider to be the schematic or functional design of the bottle represented here. This may be accomplished only if this bottle is compared with the mental image of the average bottle or its prototype.

As in any analysis of shape and structure, the solution here requires careful consideration of factors which are not immediately obvious. First of all, we must ignore the object's superfluous contour and ornamentation and direct our attention to its shape in general. We shall then note that its primary function is that of a container. We must then ask ourselves

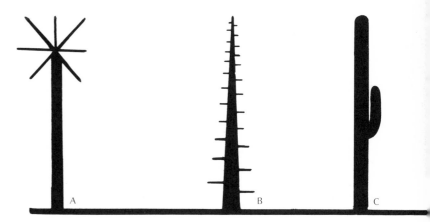

Fig. 16. Three additional plant types show that the necessity of adapting to environment creates structural changes.

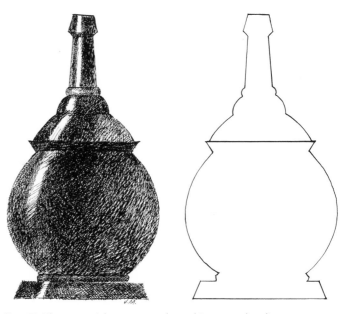

Fig. 17. The essential structure of an object may be discerned only by ignoring the extraneous elements of the observed form and determining the functional shape.

what feature distinguishes this container from other containers, such as a jar, or a vase, or perhaps a pitcher. Would the elimination of one or more of the form's features destroy its function?

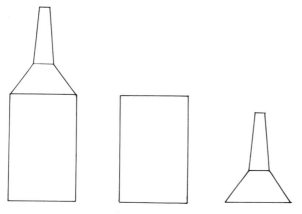

Fig. 18. The bottom portion functions as a container and the upper portion as a funnel. Both parts are essential if the form is to function as a bottle.

At this point a verbal cliché offers a clue. The term *bottleneck* refers to a slowing down or partial arrest of a steady flow or continuous movement. Following this thought through, you will notice that the shape of the upper portion is the form's distinguishing characteristic and that the basic structure of the entire form is that of a typical bottle (Fig. 18). If we were to detach the funnel-shaped upper portion, we would change the bottle into a container that could be described as a large-mouthed jar, and we would destroy the form's ability to function as a pouring apparatus. We may conclude, then, that a container plus a funnel equals a bottle, and that a bottle minus a funnel equals a container.

From this exercise, we may also conclude that a logical simplification of a redundant, overemphasized shape leads to a schematic concept of its structure, and that this structure is based on specific combinations of elements essential to the form's ability to function. The subtraction of any of these essential elements would not only change the appearance of the structure but would also nullify the function associated with it. This is true not only of man-made objects but also of natural organic

and inorganic forms as well. The student artist, therefore, must learn to read and interpret form just as a conductor reads and interprets music.

THE VERTEBRATE PATTERN

Although vertebrate life occurs in diverse forms, we can discover in the anatomical structures and life systems of all these forms many basic characteristics shared by all. In addition to the spinal column, these common structural essentials include a central nervous system culminating in a brain, a circulatory system employing a chambered heart, a jaw (except in some fish forms), and four limbs (except in fish and in some atypical reptiles, amphibians, and mammals).

This implies that there exists a basic structural theme, which — if clearly understood — will enable us to observe and draw all forms of vertebrate life with greater fidelity.

Evidence uncovered by the natural sciences, including zoology and paleontology, does indeed support the idea that these diverse forms are variations on a single structural theme. Paleontology tells us that a life form originally designed for aquatic and semi-aquatic existence was gradually transformed, by the evolution of specific structural features, to one that succeeded and proliferated on land. Because structure and shape are inseparably interrelated, paleontologists have been able to reconstruct, from fragmentary fossils of such structural features, the salient characteristics, general appearance, and life functions of extinct animals, and to determine the manner in which each form probed for survival.

Fig. 19 is a simplified section of a diagrammatic chart comparing the basic life systems that have developed through the long process of evolution. One is an amphibian, one is a reptile, and the other is a mammal.

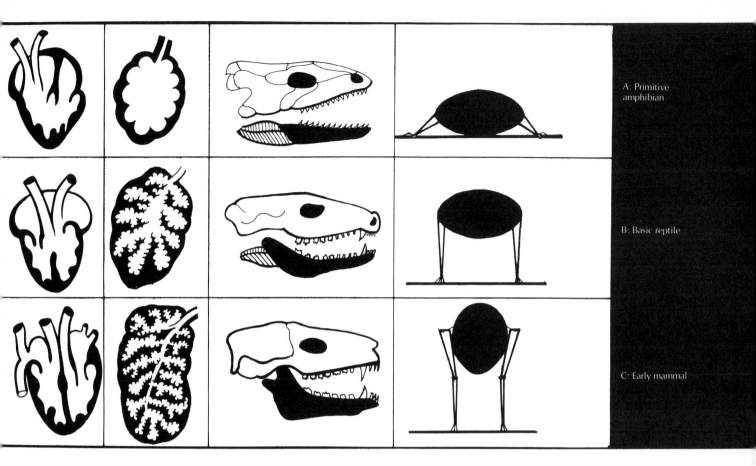

A: Primitive amphibian

B: Basic reptile

C: Early mammal

Fig. 19. *A* is a basic amphibian of the Paleozoic era. Its method of locomotion is sluggish and limited to a semi-aquatic environment. Its form is designed to be supported by water; its framework is relatively clumsy, its limbs feeble. The limbs are not able to lift the body cavity from the surface of the earth. The animal's skull is basically that of a fish, composed of numerous segments and having a small brain cavity. Its lungs are little more than convoluted air sacs, while its heart, not being completely divided into two chambers, cannot supply pure oxygen for extended or intense activity. Its nervous system, not shown here, is much more complex than that of its ancestor, the lobe-finned fish; yet in comparison to its successor, the reptile, it is still relatively simple.

B is a basic reptile, the descendants of whom reached their peak during the latter part of the Paleozoic period. This early model came equipped with a two-chambered heart, multi-chambered lungs, and a larger brain capac-ity — indicating a complex nervous system. All these systems were adapted for more efficient terrestrial locomotion. Notice that the body cavity has lifted completely from the surface of the earth. There are also differentiations in tooth structure and the beginning of an angle in the jaw.

C is a primitive mammal. The number of bones in the skull have been greatly reduced. The brain is enlarged, the nervous system more complex; the heart completely separates the blood being pumped to the lungs from that which is being returned. The lungs are enlarged and have developed more branches, thus increasing their surface area to accumulate more oxygen. The body cavity is lifted high from the earth, on legs which angle sharply toward the center of gravity. The skeletal frame is more compact, especially in the pelvic region. The mammal began to proliferate during the Cenozoic era and is the most successful of vertebrate types, able to survive in all zones, under all present environmental conditions.

Even a casual analysis of these diagrams reveals that, despite the drastic changes which animal forms have experienced in order to survive non-aquatic life, there are still marked similarities.

The vertical panel at the right, representing methods of locomotion, is the key to both the basic vertebrate pattern and the many variations of it. The changes in size and position of the limbs suggest a logical sequence in the

25

general development of terrestial life from a relatively inactive one to a more efficiently mobile one. In each case, however, the animals retain the basic structures related to locomotion. The forelimbs are supported by bones forming a pectoral arch or girdle, the hind limbs are supported by bones forming a pelvic arch or girdle, and the head and body are supported by the spine.

These structural elements may be said to form the basic vertebrate pattern; and each variation in the relationship of the pectoral girdle, the pelvic girdle, and the head to the spine provides a clue to the character of the specific animal. In Figs. 20 to 25, the further development of vertebrate structures from amphibian to human shows that the position of the spine in relation to the earth's surface has moved from a parallel to a perpendicular one. The change in the way the spine supports the body and offers a line of resistance to the force of gravity from the earth's core has been made possible by a modification of the pectoral and pelvic girdles that support the limbs.

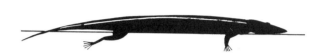

Fig. 20. The amphibian is partially supported by the earth. Its limbs are feeble, its pectoral and pelvic girdles are widely separated, rudimentary and weak.

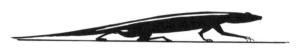

Fig. 21. The primitive reptile lifts its body cavity above the earth. The pectoral and pelvic girdles have been reinforced to support more active and stronger limbs.

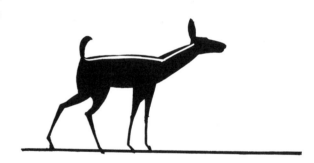

Fig. 22. The mammal has an extremely efficient locomotion system. Limbs are lengthened, and pectoral and pelvic girdles are strong and articulate.

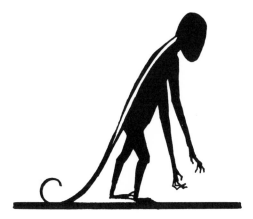

Fig. 23. In the primate, the pelvic and pectoral girdles are similar to those of the human; yet much of the body weight is still supported by the arms.

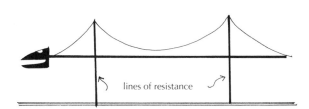

Fig. 24. With the spine horizontal and the body supported by four limbs, there are two vertical lines of resistance to the earth's gravity.

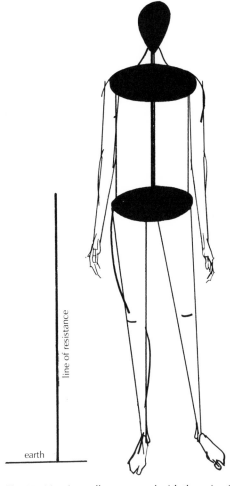

Fig. 25. Man is totally supported with the spine in a vertical position. Pectoral girdle and arms are completely free. Pelvis and legs offer a single line of resistance and support the total body weight.

27

The influence of modifications in the basic vertebrate pattern upon the functioning and shape of various contemporary animal structures is illustrated in Fig. 26, where the spine is represented by a straight line and the pectoral and pelvic girdles are represented by ellipses. Each variation of the basic pattern takes into account the fact that at least one element of the total structure must serve as either a weapon or an all-purpose tool.

Beginning once again with a common structural theme, the following drawings show that modifications of individual limb structures are also adaptations of a basic framework. The forelimbs of a dog, bird, whale, and bat have bone structures derived from their prototype amphibious ancestor (Fig. 27), a primitive tetrapod whose limbs were in turn derived from the pelvic and pectoral fins of very early fish forms. Although modification has resulted in the addition or the subtraction of the total number of bones, or in an alteration of size, the relationship of the primary forelimb bones (radius, humerus, and ulna) to each other remains remarkably consistent in all forms of vertebrate life (Fig. 28). This can also be seen in the drawings of the shoulder and forelimb of a lobe-finned fish and of a primitive reptile (Fig. 29).

THE SCHEMATIC PLAN OF THE HUMAN FRAME AND MUSCLES

Although each part of the human frame is shaped by its function and is complete in itself, it also is an element of a larger, more complex system, which is in turn part of the total organization. A comparable analogy would be the relationship of a twig to the whole tree. A twig is the final stage of the spatial organization of a tree before it becomes a leaf. Because of this, it forecasts some of the characteristics of a leaf, while retaining some of the qualities of its previous branch state. Each element of organic

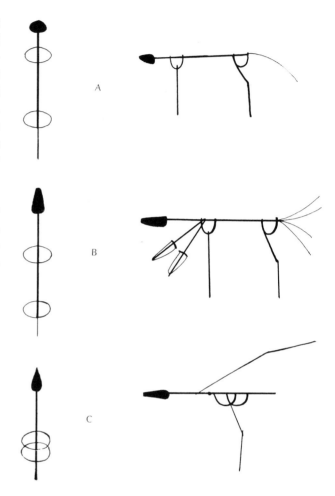

Fig. 26. *A:* The cat is an explosive, agile animal; its spinal column is totally articulated and serves as a lever for the entire body as well as a support. Its pelvic and pectoral girdles are widely spaced, which allows for unhampered movement. Because of its total mobility, the cat does not need a long neck.

B: The horse, being a long distance runner, requires a relatively rigid body cavity and stiff legs. Its pelvic and pectoral girdles are therefore not spaced as widely upon the spinal column as are those of the cat. Its neck, which serves as a lever for its head (an all-purpose weapon and tool), requires sufficient length to reach the earth while the animal is in a standing position.

C: The bird's forelimbs have been modified for flight. Its legs, being designed for scratching and clutching and not primarily for locomotion, are not efficiently articulated. Its body cavity, in conforming to aerodynamic laws, must be totally rigid. This is accomplished by fusing the pectoral and pelvic girdles with the remainder of the torso. The head is set upon a long, leverage-producing neck, for the beak is a weapon as well as a tool.

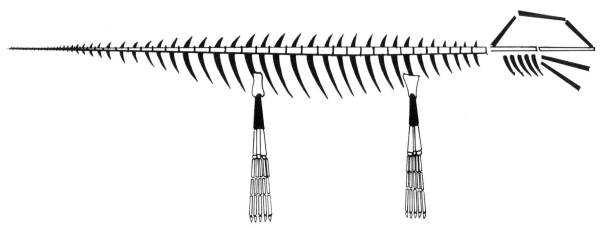

Fig. 27. Skeletal structure of prototype amphibian. Each of the limbs (there were four) had five digits.

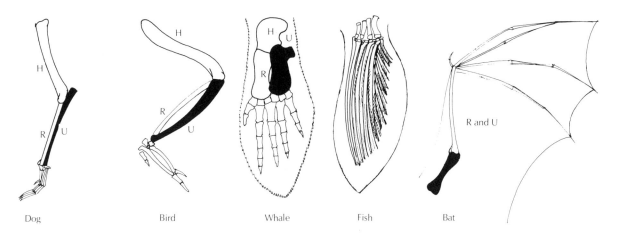

Dog Bird Whale Fish Bat

Fig. 28. The relationship of the primary bones in varied forms of vertebrate life derived from the prototype are strikingly similar. *H* is the humerus, *R* is the radius, and *U* is the ulna.

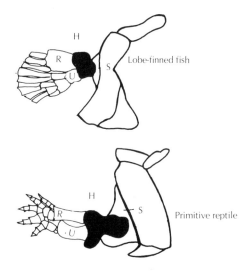

Fig. 29. The shoulder and forelimb of early vertebrates.

Fig. 30

structure is in reality multiple in nature, characterizing, along with itself, its neighboring elements and the total structure to which it belongs.

The prime factor which distinguishes the functional scheme of the human vertebrate from other vertebrates is the thrusting, direct design of its skeletal structure. Most of the bones which constitute the human frame are elongated. Examples are the femur, humerus, radius and ulna of the limbs, and the vertebrae of the spinal column. The function of each of these bones is to thrust directly into space. The muscular structure of the human form follows the same principle, and muscles that articulate each segment of the form can be grouped into a system that is quite different from any used in medical anatomy.

If we accept the premise that each part of the human frame reflects the total structure, then, as we shall see in subsequent chapters, it is simple to carry the functional scheme of straightness and directness from a conceptual state to a graphic one, by employing linear thrusts, and it is logical to use a schematic realization of the structural essentials as a basis for further development of the form. Schematic realization may be used as well to convey concepts directly opposed to spatial expansion. The human head, for example, which we shall discuss in a later chapter, retreats from spatial commitments into a domelike, compact shape, perhaps the most efficient in the known universe, and is graphically represented by arcs rather than by linear thrusts.

Figs. 30 to 37. These schematic diagrams chart the pattern of direct thrusts into space, a prime factor which governs the basic physical aspect of the human image. Note the compact interrelationship between the skeletal and muscular systems. This plan of muscular dynamics is distinctly different than medical anatomy and is to be employed as an aid in the study of artistic anatomy. You will find that any of the usual combinations of muscle and bone may be diagnosed and diagrammed into group systems such as those shown here.

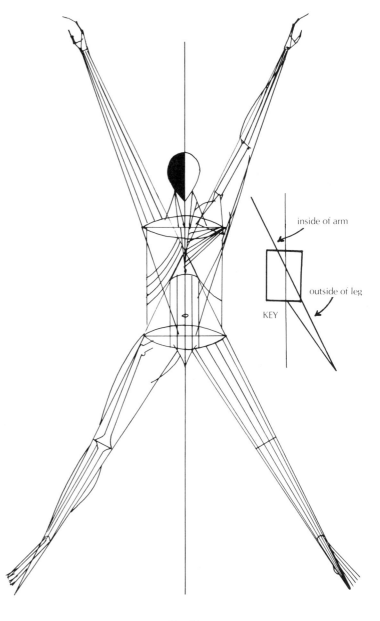

inside of arm

outside of leg

KEY

Fig. 31

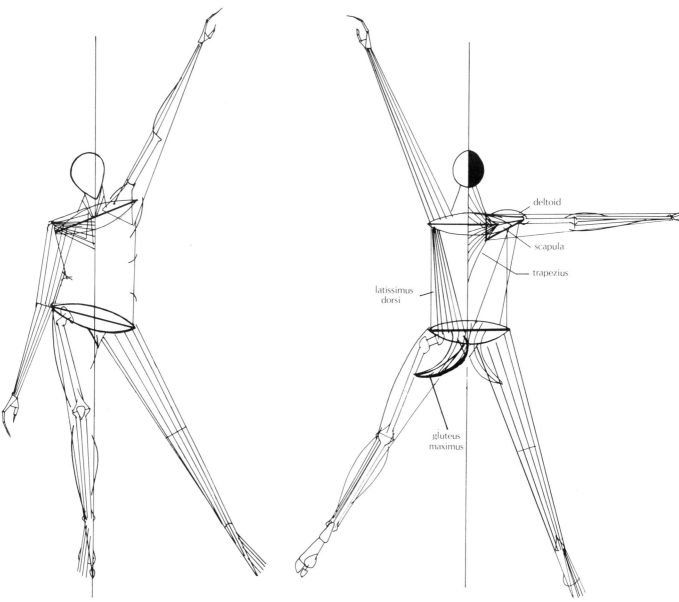

deltoid

scapula

trapezius

latissimus
dorsi

gluteus
maximus

Fig. 32

Fig. 33

32

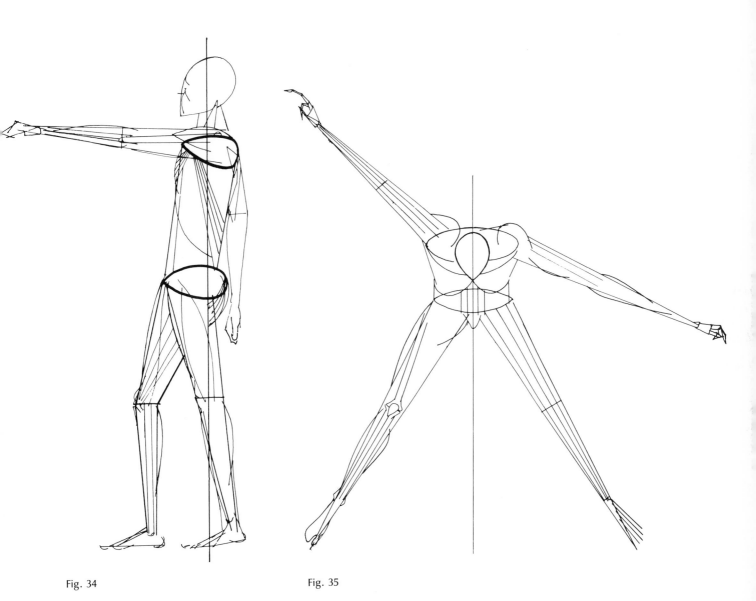

Fig. 34

Fig. 35

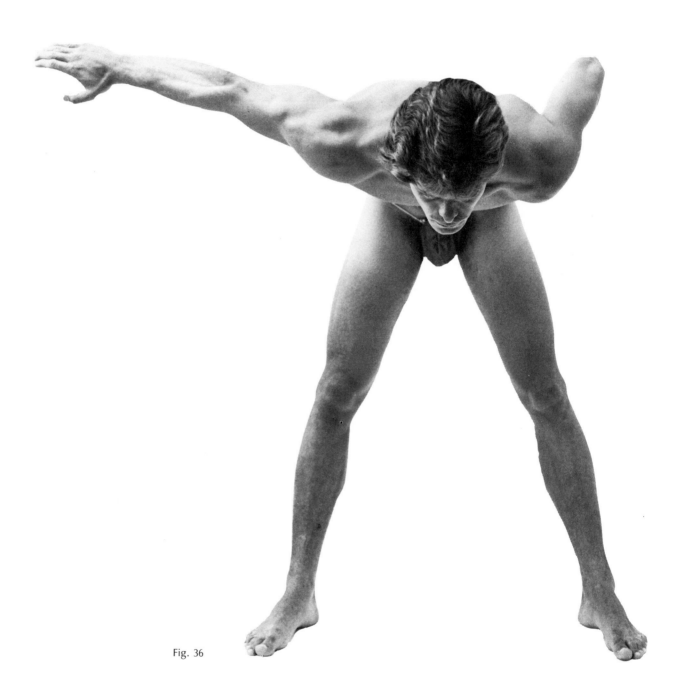

Fig. 36

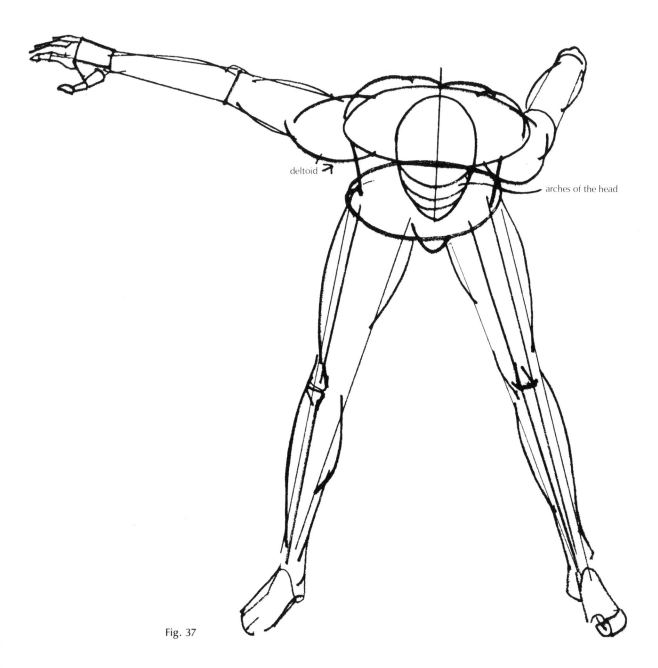

deltoid

arches of the head

Fig. 37

3. SPATIAL FACTORS

Up to now we have been considering the structural aspects of form, the way in which matter is organized to conform to universal forces and laws and to fulfill one or more specific functions. But we must not ignore the fact that form exists in space, where it has dimension, position, and direction. The ability to read these spatial factors is as important to the draftsman as is the ability to read structural factors.

As we have noted, in interpreting form, the prime structural factors — those that are essential to the nature and appearance of the object — must be separated from those of lesser importance. We have seen that this becomes extremely difficult to accomplish unless we formulate a logical method of reducing detail to its barest essentials, and that a decision as to what constitutes the salient characteristics of an observed form can be made only after assessing its various aspects. This immediately calls for the placement of detail into primary, secondary, and subsidiary categories. The same process of reducing form to essentials is necessary for interpreting spatial factors as well.

To begin, let us observe several abstract relationships between a line, representing a subject, and a rectangle, representing the picture plane (Fig. 38). (For now, we are concerned only with the perceptual aspect of the

Fig. 38. The spatial relationship of the line to each panel may be stated thus: *(A)* The primary spatial position or factor is total verticality. *(B)* Total horizontality. *(C)* The primary spatial factor is still essentially vertical with a degree of horizontality. *(D)* The primary factor is still horizontal with an element of verticality introduced. *(E)* The horizontal and vertical factors neutralize each other.

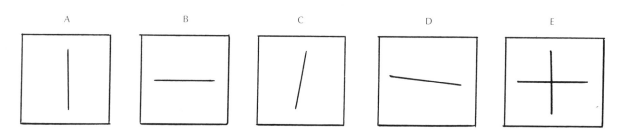

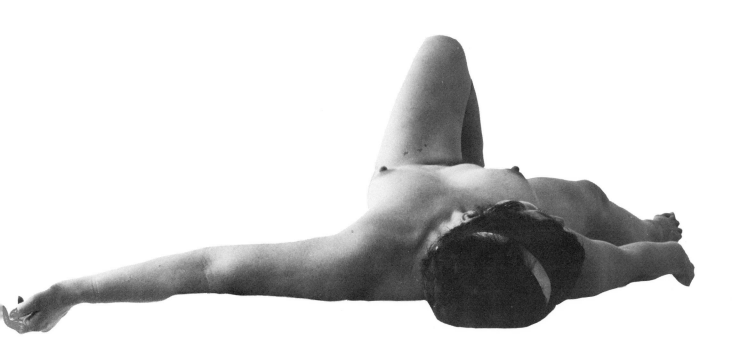

picture plane — the fact that it is a two-dimensional surface on which we wish to indicate three-dimensional objects.) What the line indicates about the subject it represents is how far into space the form extends at its maximum dimensions. In addition, it tells the direction these dimensions take (horizontal, vertical, or diagonal), and the relative position of the form within a given space (that bounded by the rectangle). Thus we see that the position of any subject in the space it occupies can be depicted by a linear thrust. If the subject is more complex, as in Fig. 39, it can have more than one thrust. Two thrusts may neutralize each other; or one may dominate the other. These thrusts are position factors and they indicate the main spatial movements of the form. Even so, the dominating factor may be considered a primary movement and the subordinate factor may be considered a secondary movement.

We also see in Fig. 39 that, in order to understand the subject's true spatial character,

Fig. 39. The model presents a complex pattern of various shapes. The initial phase of draftsmanship requires a breakdown of the form's position factors. Here the primary factor is horizontality and the secondary is verticality.

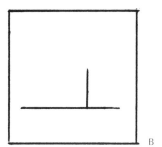

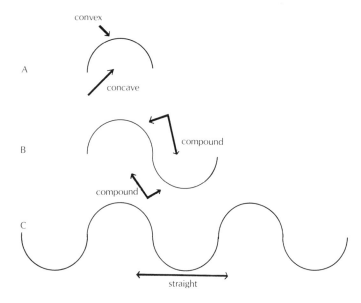

convex

concave

A

compound

B

compound

C

straight

we must view the subject in its entirety, properly assessing the form for its main thrusts in space and therefore ignoring the details depicted by its contours. This is further clarified by Fig. 40.

Once we have established the form's positional factors, we can further delineate the form by adding its contours, which detail the way in which the mass occupies space. Here again, though, a fluctuating line, while accurately detailing the mass, may confuse the basic spatial qualities of the form. In order to read the spatial position and general direction of each contour accurately, its complex movement should first be reduced to a straight thrust (Fig. 41). The straight line may then serve as a base for the complex, but more subsidiary, spatial movements of the fluctuating contour.

Fig. 40. Unless we eliminate details and correctly evaluate its total form we cannot understand the subject's true spatial character. For example, let us observe a familiar object, such as a corrugated roof, and assume that only a small section at a time is exposed to a viewer. Fig. 40 indicates the following:

(A) If one section is seen from the top, the conclusion would be that the roof is convex; if the same section is seen from the bottom, the roof would appear to be concave.

(B) The exposure of two sections would lead to the conclusion that a corrugated roof is based upon a compound curve.

(C) Only if a greater section is exposed can one see that a corrugated roof, regardless of its weaving detail, assumes a definite straightness in its totality.

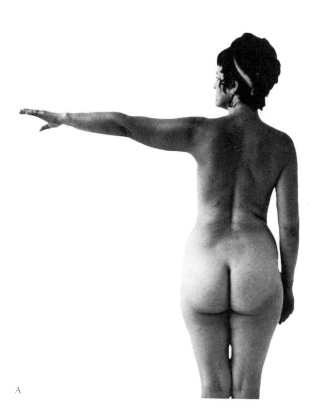

A

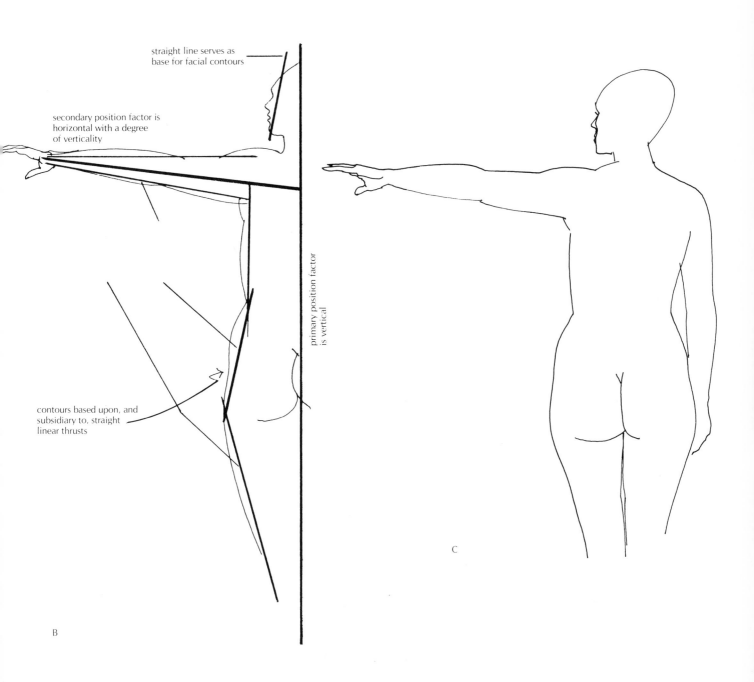

straight line serves as
base for facial contours

secondary position factor is
horizontal with a degree
of verticality

primary position factor
is vertical

contours based upon, and
subsidiary to, straight
linear thrusts

B

C

Fig. 41. The contours of a form are established upon
straight linear thrusts, which are subsidiary to the main
thrusts of the position factors. The complex movements of
a contour, whether it is a long, sweeping curve as in an
arm, or whether it is a series of sharp curves and irregular
angles as in the face, are subsidiary to the straight thrusts.
A contour drawing is based upon visual estimates of these
straight movements.

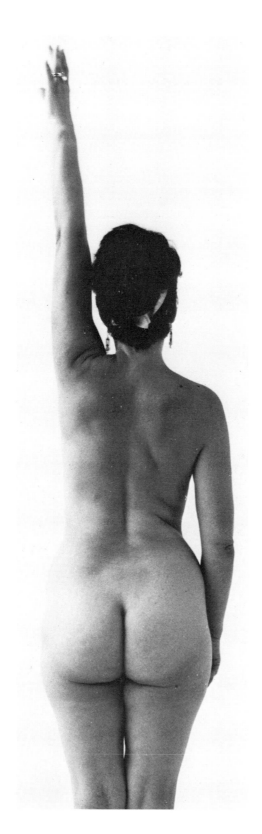
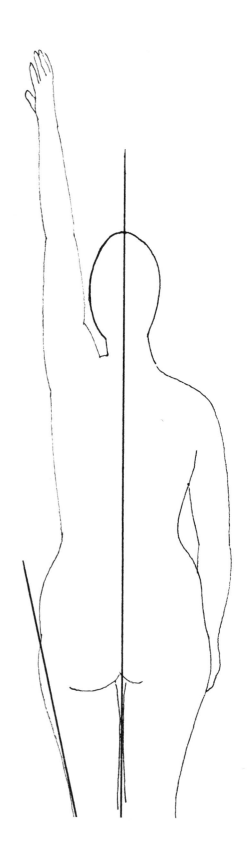

Fig. 42. The prime spatial movement of the human form when in a normal standing position is the vertical line of resistance perpendicular to the earth. This line also serves as a base for the contour of the inner thigh. The outer contour of the thigh is based on a linear thrust slanting toward the line of resistance.

Fig. 43. The main spatial factors remain constant when the human form is observed from opposite but equal points of view.

While Figs. 41 and 42 show the position factors of the human form in an upright stance, Fig. 43 shows these factors for the form in a reclining pose. Note that the main spatial factors depend on the observer's point of view as well as on the actual position of the form. In most cases, these factors remain constant when the form is viewed from exactly opposite points.

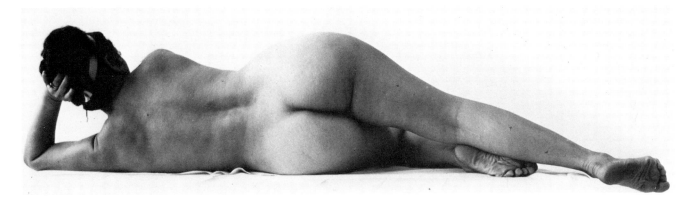

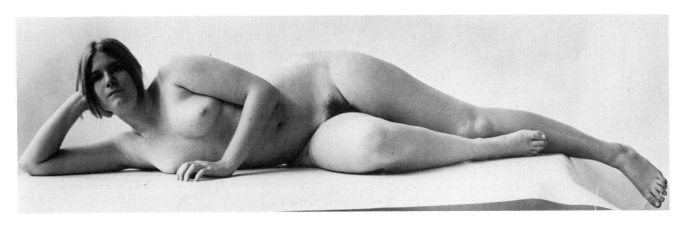

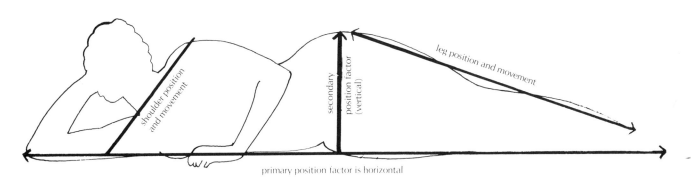

4. STRUCTURAL DRAWING

It is evident that in probing for the essential character of a form we have been relying on linear indications of how the object occupies space. This type of drawing is based on conceiving the form as a structural entity, and the basis for this is the proper reading and analysis of form through elimination of superfluous details and through an understanding of how the form functions.

The importance of this approach, which we may call structural drawing, is that it provides a solution to the dilemma confronting student artists who must contend with the inhibiting influence of existing art. Most of us would agree that we learn from such art, both

past and contemporary, but for the student to develop methods for realizing his own vision, he must discern the concepts that underlie the prototype-artist's vision and ignore the temptation to merely copy the manifestations of that vision. This requires the elimination of preconceived ideas regarding the appearance of form.

One way to eliminate preconceived ideas about a form's appearance is to replace them with insight into the essentials of its structure. Structural drawing, then, provides a basis for the eventual choice and development of a more expressive approach to drawing, one in which draftsmanship and conceptualization play equally important roles, and any or all of

the graphic elements — line, tone, texture, and color — may be employed in an individualistic way. In a later chapter, we will examine four basic approaches from which the artist may select a suitable forum for his concepts. But for now, we will concentrate our efforts on structural drawing as the groundwork for that choice.

The best-known examples of structural drawing can be found in the work of Leonardo da Vinci, where linear probes are used as a device to search out the essence of such varied natural phenomena as the structure of the human body, the principles of geology, and the anatomy of a tempest. The reliance on line rather than on tone is a direct result of concentrating on the basic structure and therefore eliminating unessential details of mass, texture, and color. The nature of the lines may vary however.

As we have seen, the structural theme of the human form can best be indicated with straight linear thrusts signifying the ability of the limbs to extend themselves in space. The muscular masses, as well as the bones of the limbs, are reduced to linear thrusts in the initial concept because the specific contours are not part of the essential structure and are variable. The characteristics of the head, however, which is designed to reduce and contain its spacial movements, in contrast to the remainder of the skeletal system, can best be described by four arcs and a circle. (See Chapter 6.)

Structural drawing therefore requires, first of all, an understanding of the form's function as it relates to the form's occupation of space. Secondly, it requires an ability to eliminate superfluous details, and finally it requires the use of line to probe and define the structural nature of the form. In applying this method of drawing to the human form, the first step we must take is to deromanticize the form and examine its functional aspects.

DEROMANTICIZING THE HUMAN FORM

The human eye has been romantically referred to as the "window of the soul;" yet, physically, it is also a delicately constructed, self-adjusting mechanism that receives and conveys to the brain luminous images of nature's forms. Before the artist can make an expressive statement regarding the eye, he must first comprehend the basic physical factors that characterize it; then, as a draftsman, he must be able to graphically convert his conception of the object's function into a corresponding shape. Finally, as an artist, he may modify its functional shape into a vehicle for his own imagery.

As an example, let us consider a part of the human physical system which has been both realistically and freely interpreted throughout

Fig. 44. Drawing from Botticelli's painting *Birth of Venus*. Analysis shows that the graceful interpretation of the arm also takes into account its functional shape.

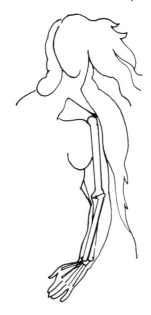

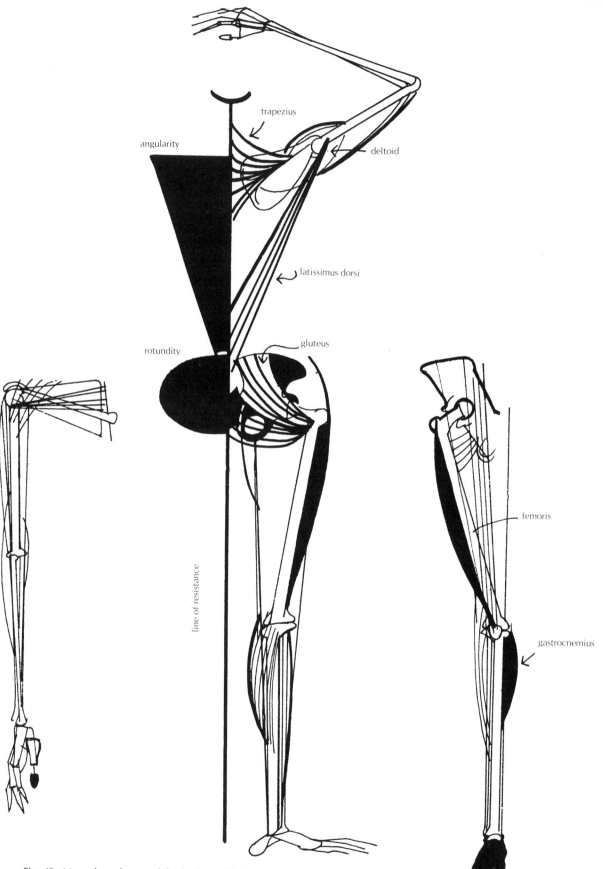

Fig. 45. Muscular scheme of the back and limbs.

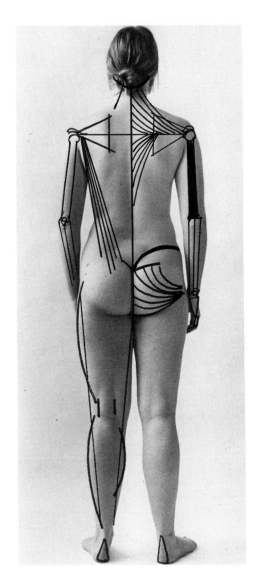

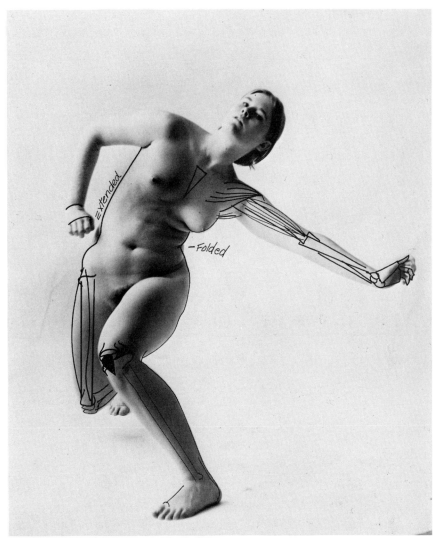

history. The human arm (which, of course, includes the hand), having been relieved from a previous assignment as part of the locomotion system, has been developed into a free-swinging, rotating, grasping device. As we have noted, the identical system which birds have adopted for flight and horses for running has been modified by man to function as a lever, to probe, poke and select its way through life. Botticelli visualized this limb as a lyrical, curvilinear form, reaching and gracefully touching breeze-driven drapery, garlanded leaves, and beribboned flowers. Yet, as a draftsman, he also knew that both effective metaphysical symbolism and sensitive visual interpretation spring from physical facts. This is evident in his work, for it shows that the basic functional shape was respected.

Figs. 46 and 47. An expressive curvilinear statement must be founded upon structural reality, shown by the superimposed drawings.

A free interpretation that is consistent with fundamental structural principles may be accomplished only by comparing the freely conceived image of the object against a prototype representing the structural scheme reduced to its functional essentials. This was demonstrated on page 23, where the analysis of the form's function provided the key to understanding the shape of the baroque bottle. Consistent with this, a breakdown of the human frame would reveal each part to be designed upon principles related to its own specific function.

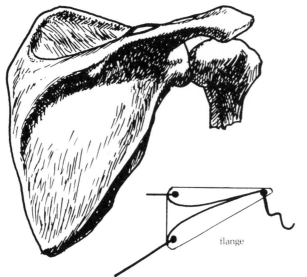

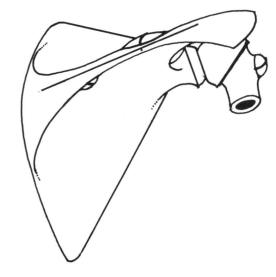

Fig. 48. The broad expanse of the scapula functions as a flange. Muscles are attached to the projecting spine as well as to the relatively flat base.

Just as the human eye is constructed upon optical principles, other anatomical parts follow appropriate principles. A human limb, for example, conforms to mechanical laws of leverage, while the scapula is designed to act as a broad flange to which many muscles of the arm and back are attached. Many structures serve dual purposes. The cranium is a dome that not only forms a chamber for the brain and auditory apparatus but provides a protective covering as well. The segments of the spine are designed not only to form a column capable of supporting the torso and head but also to provide a conduit for the nervous system. These are a few examples of how elements within the human structural scheme conform to universal structural principles according to function. With this in mind, let us examine more closely the structure and function of the pelvic girdle and lower limbs.

THE PELVIS AND THE LOWER LIMBS

The most efficient method of supporting weight is at, or near, its center of gravity. A waiter holds a loaded tray from beneath. The most effortless way of carrying a vertical ladder is to hold it close to the body and therefore close to the vertical axis of the body's center of gravity. The human pelvic girdle is a bowl-like device designed to support the considerable weight of the upper body; the two limbs on either side of the bowl conform to a single line of resistance counteracting the downward pull of the earth on the body's center of gravity. In Fig. 49, notice how each femur firmly grasps the pelvis at the side, yet moves inwardly toward the vertical axis of the body, and note how the inner edge of each lower leg parallels this axis.

The efficiency of natural structure and the relationship of function to shape are superbly

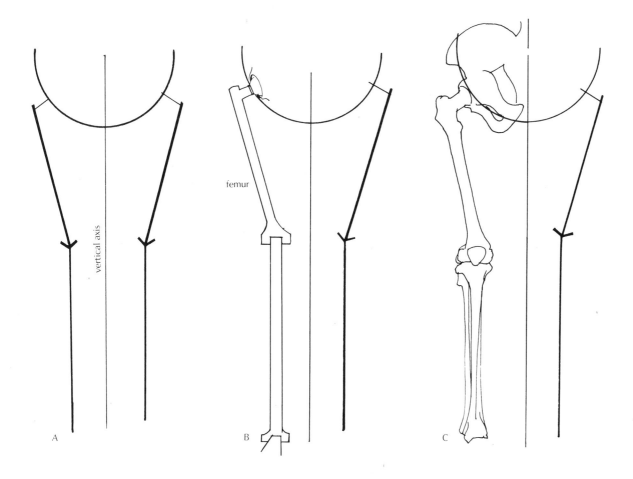

A

vertical axis

femur

B

C

Fig. 49. *A:* Schematic drawing of the pelvis and lower limbs shows how the structure forms a single line of resistance along a vertical axis corresponding to the earth's pull on the body's center of gravity.

B: A mechanized version shows the ball-and-socket design of the femur (which is inserted at the side of the pelvis), and the hinged joints of the knee and ankle.

C: Drawing of the bone structure conforming to functional principles.

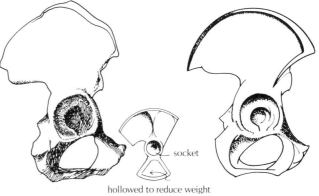

socket

hollowed to reduce weight

Fig. 50. Side view of pelvis, showing socket at hip joint.

Fig. 51. *A:* The vertical line of resistance.

B: The longitudinal arch, formed by two wedges of bones in the foot, buttresses the vertical line.

C: The converging conical mass of the leg muscles is stated as a triangular shape. A pressure bulge is formed behind the large toe.

D: A long, shallow arc at the front and a short, deep arc at the rear denote the contours of the leg.

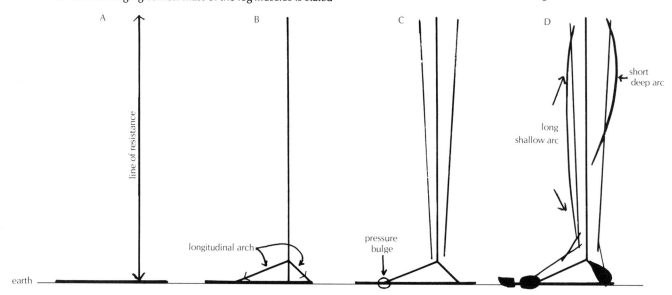

illustrated in the human leg. In Fig. 51, I have drawn a vertical line to symbolize the direct method by which the leg resists gravity. The horizontal base line represents the earth. Notice that the scheme of the leg is already stated. The next part of the side-view diagram shows the longitudinal arch, which is really composed of two wedges. The short wedge is the calcaneus bone of the heel; the frontal wedge is made up of tarsals and metatarsals. The wedges work on the same principle as the architectural buttresses of a Gothic cathedral.

Fig. 52. *A:* The line of resistance.

B: Two transverse arches, formed by the tarsals and metatarsals, indicate the frontal wedge that buttresses the vertical line. Where the secondary arch meets the line of resistance a pressure point occurs, producing a slight bulge.

C: The muscular mass is represented by a triangle. In the contours, the outer arc is long and shallow, the inner arc is deeper and shorter. The tip at the end of the vertical thrust characterizes the big toe, behind which is the pressure bulge.

D: The transverse arches shape the foot. The large toe and the remaining four are separated by a definite spatial wedge.

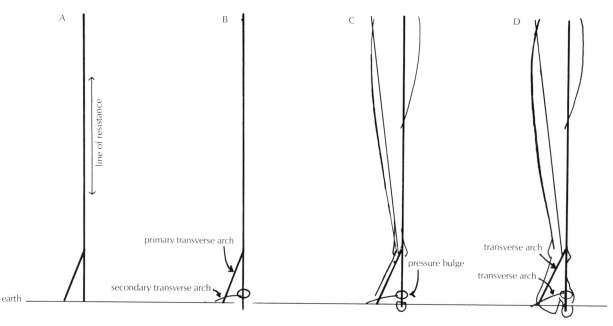

The analysis and graphic scheme of the leg viewed from the front is essentially identical to the side view, except that the longitudinal arch is replaced by two transverse arches (Fig. 52). As an exercise, sketch the side, front, and rear views of the leg as shown in Figs. 53 to 55.

To the basic linear thrust of the bone structure, we may add the converging linear thrusts of the leg muscles, which are more massive at the thigh and taper down to the ankle. We may then graphically abbreviate the limb by showing a triangle which corresponds to the basic conical shape of the converging muscles. To this we may finally add the contours of the muscular masses, expressing them as long and short arcs. This sequence of analyzing the form and then graphically abbreviating the results of that analysis is the essence of structural drawing.

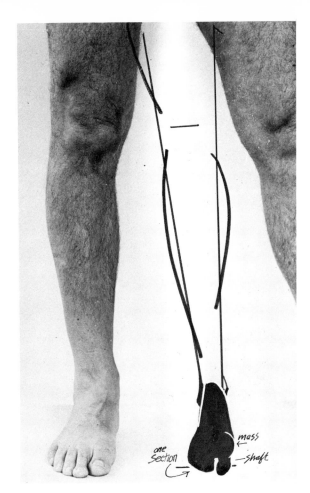

Fig. 54. Front view of leg. The outer arc is long and shallow; the inner arc is short and deep. Note the positions of the inner and outer sides of the ankle.

Fig. 53. Side view of leg. The front arc is long and shallow; the rear arc is shorter and deeper. The inner ankle is higher than the outer one.

Fig. 55. Rear view of leg. The outer arc is again long and shallow; the inner one is short. The calcaneus wedge of the heel dominates the foot from the rear.

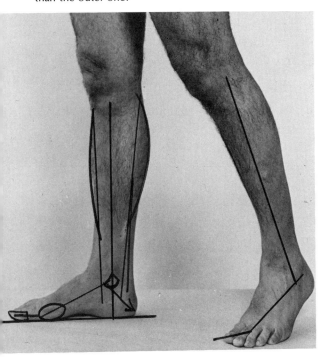

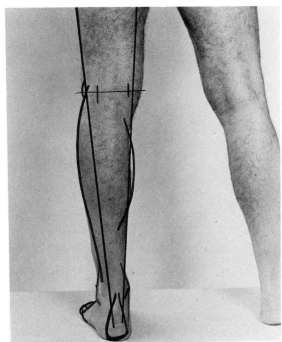

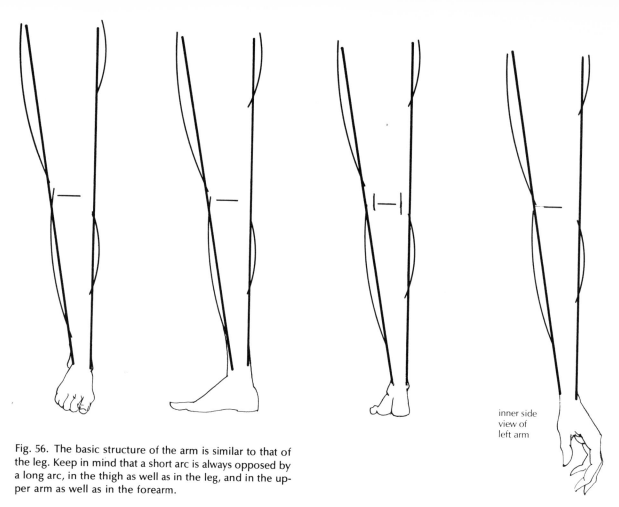

inner side
view of
left arm

Fig. 56. The basic structure of the arm is similar to that of
the leg. Keep in mind that a short arc is always opposed by
a long arc, in the thigh as well as in the leg, and in the up-
per arm as well as in the forearm.

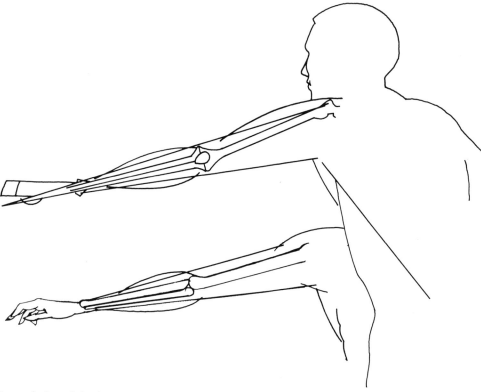

Fig. 57. The radius and ulna of the forearm are counter-
parts of the tibia and fibula of the leg; the humerus of the
upper arm is a counterpart of the femur in the thigh.

COMPARISON OF ARMS AND LEGS

A conical base and a system of opposing long and short arcs is appropriate not only for each view of the leg but for the arm as well (Fig. 56). The bone structure of the arm is markedly similar to that of the leg; the humerus, ulna, and radius are counterparts of the femur, tibia, and fibula. This is not surprising in view of the fact that both types of limbs operate on leverage principles (Fig. 58). As a muscle contracts, it draws the bone to which it is attached toward the bone from which it arises. The contraction of a flexor muscle results in a bending of the joint; the contraction of an extensor muscle results in a straightening of the joint. Usually, these muscles act in pairs to help direct the action, so that while a flexor is contracting the extensor is expanding and vice versa. The joint acts as a fulcrum and the muscle supplies the power to lift the weight of the bone to which it is inserted near the fulcrum.

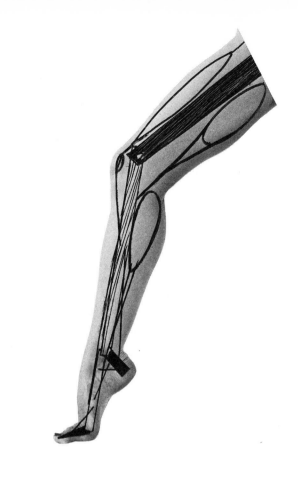

Fig. 58. The lever system of the limbs depends upon the contraction and extension of the muscles to raise and lower the bones. The main joints at the hip, knee and ankle act as fulcrums in the leg. *A:* Bone structure is represented by wood; linear thrust of the muscles by wire. *B:* Elliptical mass, the muscles. *C:* The muscle in a relaxed position. *D:* The muscle is contracted.

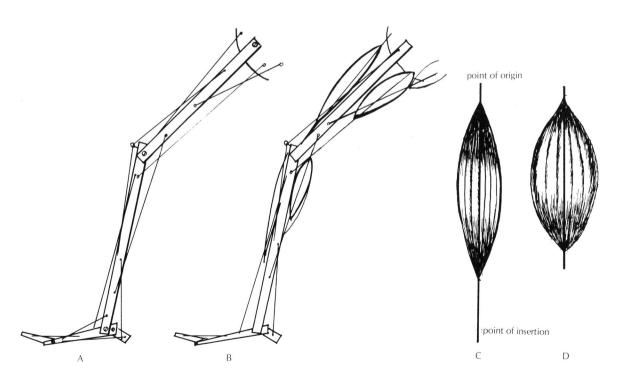

point of origin

point of insertion

A B C D

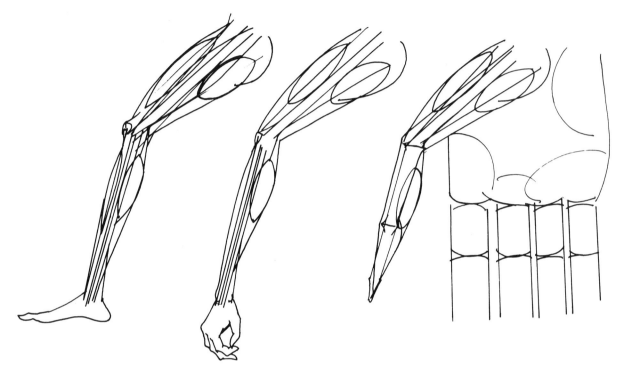

Fig. 59. The arrangement of bones, muscles, and joints in the arm and in each finger of the hand is comparable to that of the leg.

This lever system appears in the fingers as well as in the limbs (Fig. 59). Here, as in Fig. 58, for explanatory purposes, the muscles are represented by an elliptical mass and linear extensions. As an exercise, trace or draw these diagrams and photographs, beginning with the bone thrust and adding the linear and elliptical symbols for the muscles. This will acquaint you with the structural scheme of the human limbs and digits.

THE HUMAN TORSO

As an aid to understanding the apparent complexity of the human body, we can reduce the torso to the primary shape of a square or a rectangle just as we reduced the limbs to the primary shape of a triangle. In these schematic diagrams (Figs. 60 to 62), the human torso must be conceived of as being a single chamber containing the vital life systems, capped by a turret-like control tower and possessing cone-like appendages, each capable of moving in almost any direction. Notice that, regardless of the position from which it is being viewed, the human frame presents a symmetrical image.

Fig. 62. *A:* Prototype of prone figure. *B:* Side view. *C:* The same prototype can be used to express the top view with arms outstretched. *D:* Here the prototype expresses the bottom view with legs outstretched.

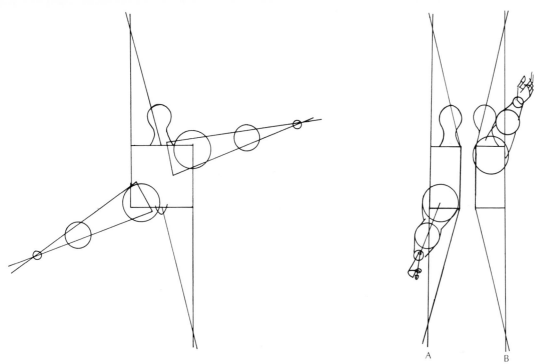

Fig. 60. Consistent with structural principles, the limbs are gradually diminishing cones, each massive at its source and considerably smaller at its terminus. The conical structures are represented by triangles, and the muscular masses of the structures are represented by circles. The square symbolizes the torso, bounded at the top by the pectoral girdle and at the bottom by the pelvic girdle, each of which supports and articulates a pair of limbs. Both front and rear views are represented in this scheme.

Fig. 61. The figures in A and B face each other. In these erect side views, the torso becomes a rectangle. In A, the right leg is extended backward; in B, the left arm is extended backward. These limbs become compressed on the picture plane (see Chapter 7 on perspective).

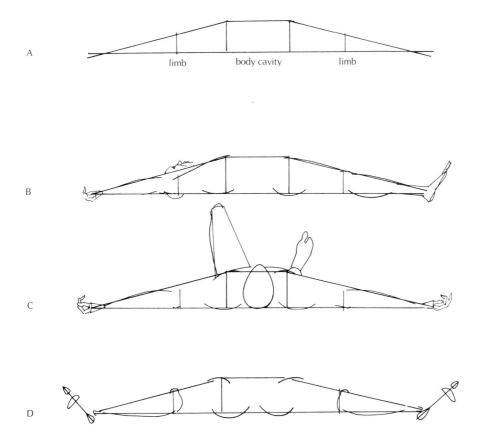

limb body cavity limb

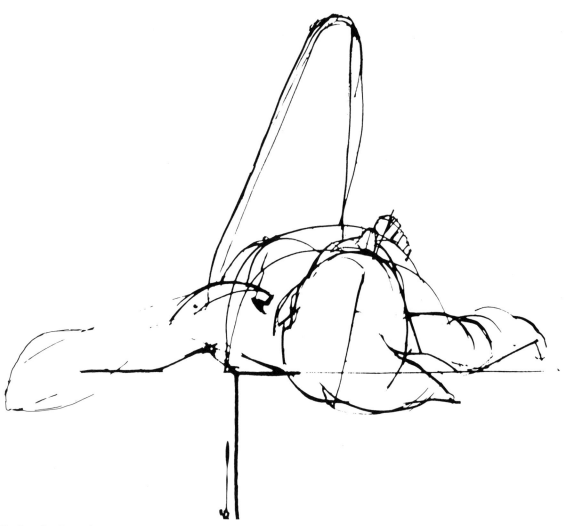

Fig. 63. Drawing by Barbara Chenecek is based on the top view (C) of prototype in Fig. 62.

Figs. 64 and 65. These student exercises are of poses shown in the corresponding photographs and are based on the prototype form of a rectangle and triangles. Compare these sketches of observed forms with the pure prototypes in Fig. 62. Using the approach shown in these sketches, draw your own version of each pose.

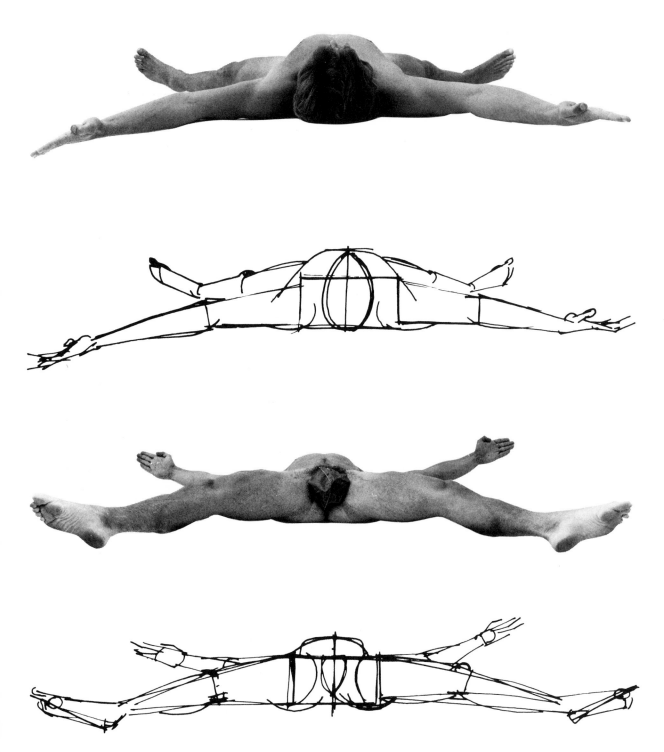

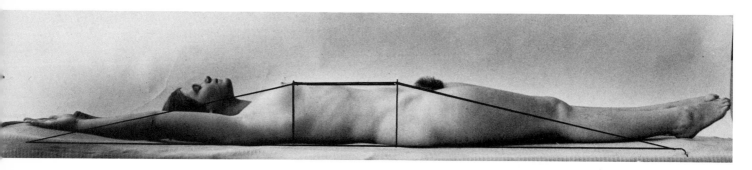

Fig. 66. Photograph shows how the limbs diverge from the prototype form according to details of muscular structure as seen from the observer's point of view.

These schematic diagrams indicate very simply the structural nature of the torso and limbs. To examine the structural theme further, we must draw on our knowledge of how the various anatomical forms contribute to the total form. We know that the pelvis, or pelvic girdle, for example, supports the upper body and acts as a foundation for the lower limbs. In the same way, the assemblage of bones (clavicles and scapulas) known as the pectoral or shoulder girdle supports and articulates the upper limbs. Each of these supporting girdles may be graphically represented by an ellipse.

Connecting these two girdles is the semi-flexible spinal column, and enclosed between these two girdles are the thoracic and abdominal cavities. The torso itself therefore may be stated as a semi-rigid, tubular form bounded at the top by the pectoral girdle and at the bottom by the pelvic girdle, with a single line of support connecting the upper and lower boundaries in the center, and with two lines indicating the two sides of the tubular form. This is the basic graphic scheme of the torso.

When the torso is erect, the spinal column is represented by a straight line. When the pelvis or the shoulders, or both, are tilted, the straight line of the spinal column becomes an arc. Similarly, the lines representing the sides of the torso vary to correspond with the position of the spine — one side becoming extended and curving in the same arc as the spine, and the alternate side becoming compressed into two angled lines.

Fig. 67. The graphic scheme of the human torso. When one side of the tube is extended, the opposite side is always compressed.

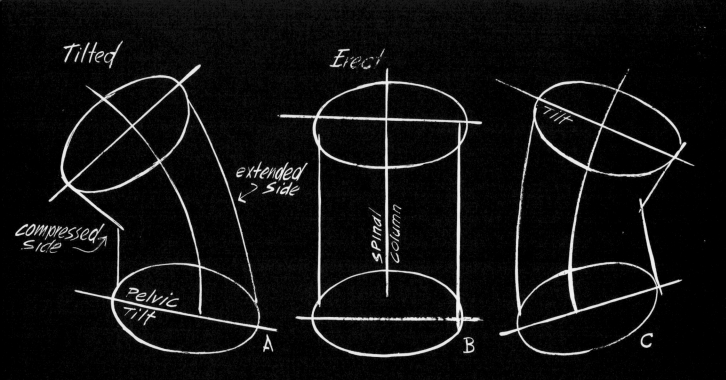

Tilted

Erect

extended side

compressed side

Pelvic Tilt

spinal column

Tilt

A

B

C

The principles and character of the human torso stated with two ellipses and a series of straight and curved lines

EXERCISES

Observe the position of the torso in part A of Fig. 67 and quickly sketch with an ellipse the position and tilt of the pelvis. Then, thrusting upward, feel the movement representing the arched spinal column. Place the upper ellipse at an angle relative to the spinal column and pelvis. If your sketch conforms to the diagram in A, you have correctly indicated the movements and the relative positions of the main elements of the torso in this specific pose. Repeat this exercise for poses B and C.

Now study the same poses as shown in the photographs (Figs. 68 to 70) and, using the same approach, repeat the torso exercise.

Fig. 68. This corresponds to pose A in the previous illustration.

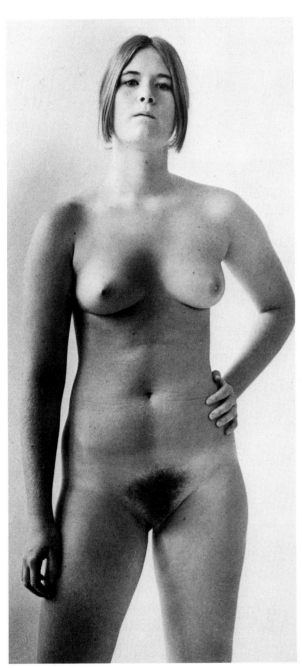

Fig. 69. This corresponds to pose *B* in the diagram.

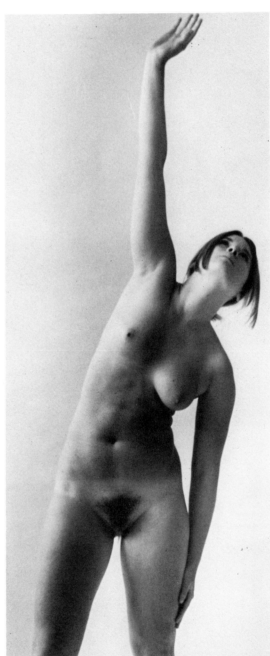

Fig. 70. This corresponds to pose *C* in the diagram.

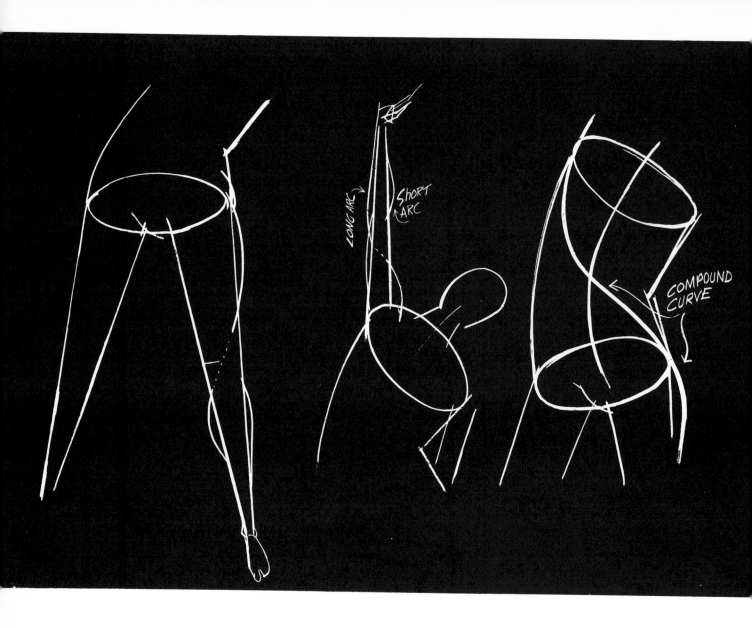

Fig. 71. The limbs are graphically stated along with the torso. Note the compound curve formed by the upper torso on one side and the hip on the opposite side. There is also a compound curve formed by the thigh and calf at the left of the diagram and by the shoulder and lower arm in the center of the diagram.

As we have noted, the upper and lower extremities of the body can also be simplified in form and, as they are fundamentally similar, they are each represented by identical symbols (Fig. 71). The conical shape of each limb is simply stated with a triangle, to which curvilinear masses are added by means of two opposing arcs, one long and one short. In Fig. 71 also notice the compressed and extended sides of the body cavity and how they combine to form the main elements of a compound curve.

Using a pencil or pen and following the principles demonstrated for the torso and limbs in Fig. 71, sketch a schematic version of the full figure in the photograph of the pose (Fig. 72). Then do the same for the pose in Fig. 73.

60

Fig. 72. Use the principles shown in the preceding illustration to sketch the entire figure in this pose.

Fig. 73. The front of the body is extended; the back is compressed. The long arcs of the limbs oppose the short arcs.

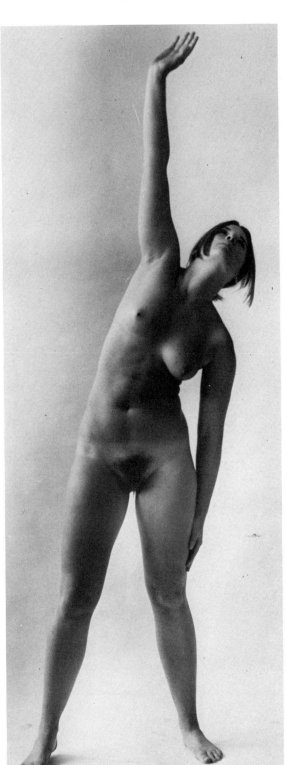 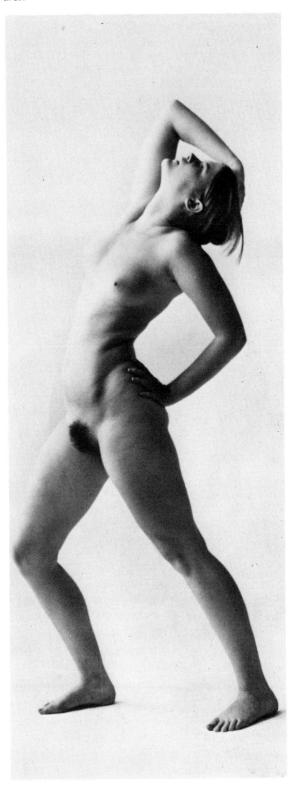

Figs. 74 to 78. The most common error the beginner makes is to concentrate on the contours of form. Especially notorious as a stumbling block is the side view of the torso. To avoid losing the essential position and character of the torso in this posture, note that the upper part of the body slopes in a dorsal direction (backwards). Contour is then added.

Spinal Column

Pelvic Projection

Side View

Fig. 74

Figs. 74 to 78 demonstrate how the body cavity slants dorsally (toward the back) as it moves from the pelvis to the shoulders. This is an extremely important characteristic of the torso which is usually ignored.

The remaining photographs and diagrams in this chapter are of several typical poses demonstrating both static and active positions. Using these photographs, or posing your own model, develop a sketch of each. Begin by studying each diagram.

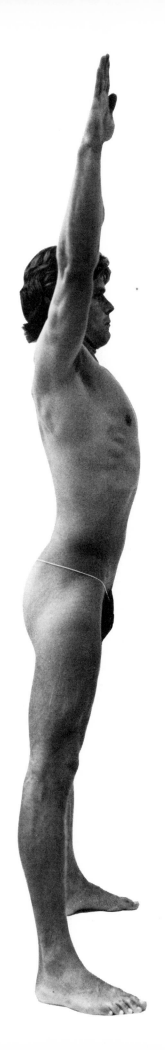

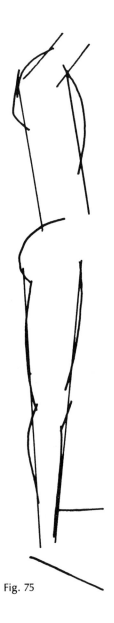

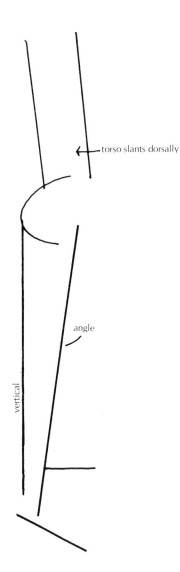

torso slants dorsally

vertical

angle

Fig. 75

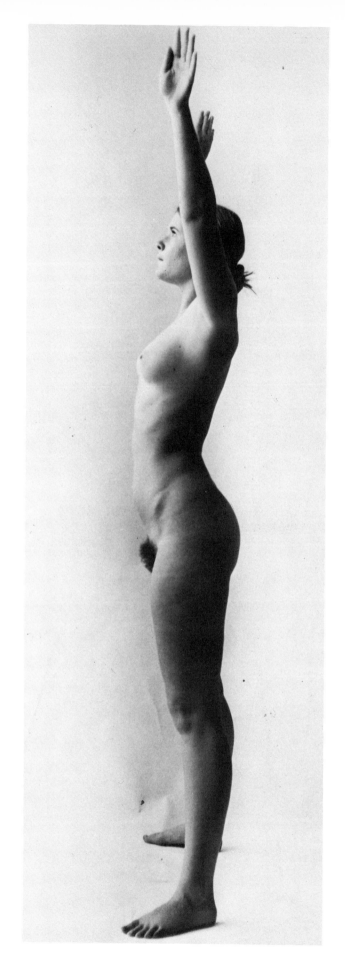

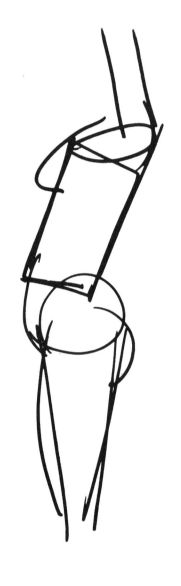

Fig. 76

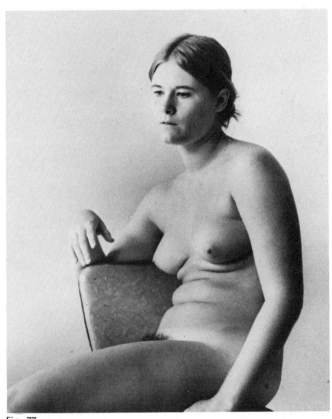

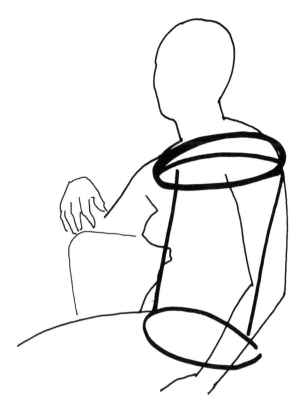

Fig. 77

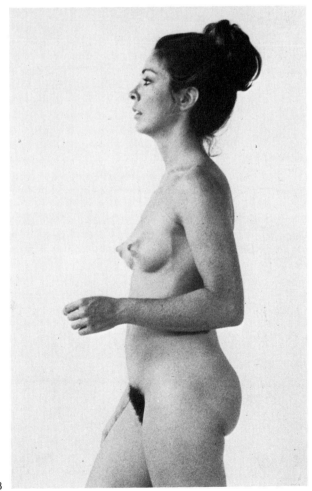

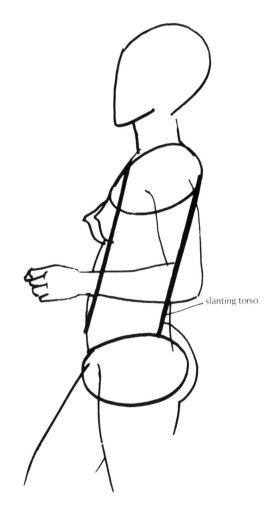

slanting torso

g. 78

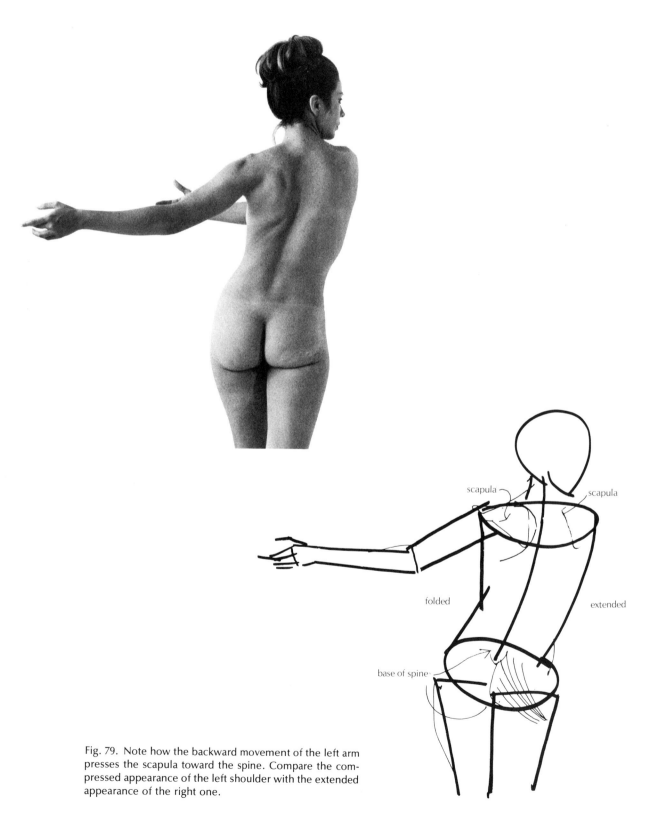

Fig. 79. Note how the backward movement of the left arm presses the scapula toward the spine. Compare the compressed appearance of the left shoulder with the extended appearance of the right one.

66

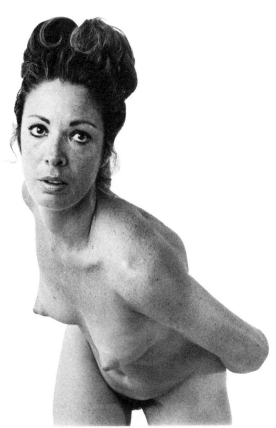

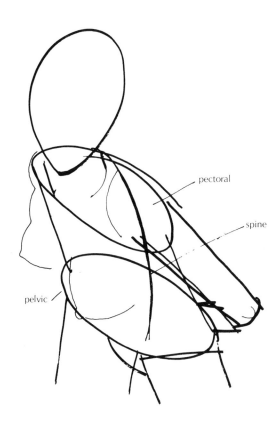

Fig. 80. A pose such as this seems complex until it is broken down to its essentials. Draw the figure in the photo, or pose your own model, and base your work on the diagram shown here. Notice that the compressed torso is shown by bringing the pelvic and pectoral girdles close together on the picture plane.

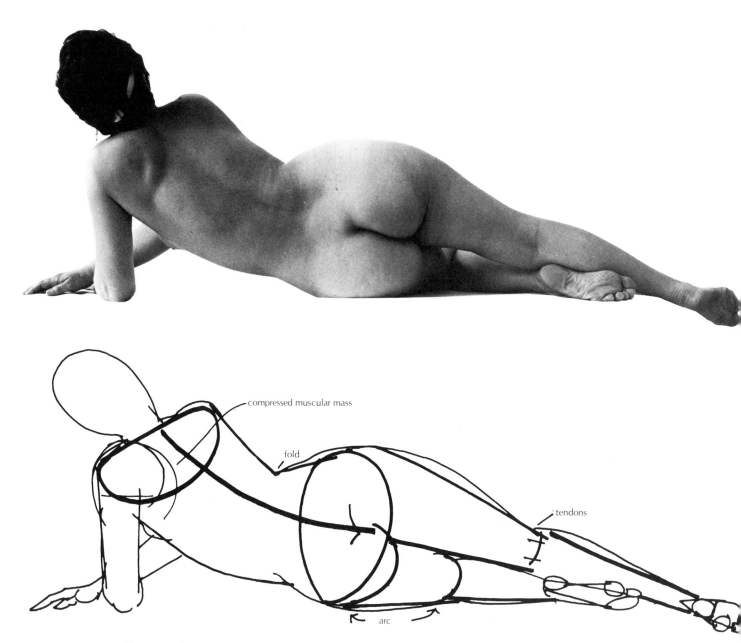

Fig. 81. In drawing the figure, it should be kept in mind that salient points may be selected to serve as a base not only to convey a realistic image but also as source of individual interpretation. Notice the pressure exerted in the region of the left shoulder; this can be described with a modified circle. Also notice the compressed right side terminating in a fold, the tendons revealed in the joint of the extended right leg, and the arc reversing the direction of the left leg.

68

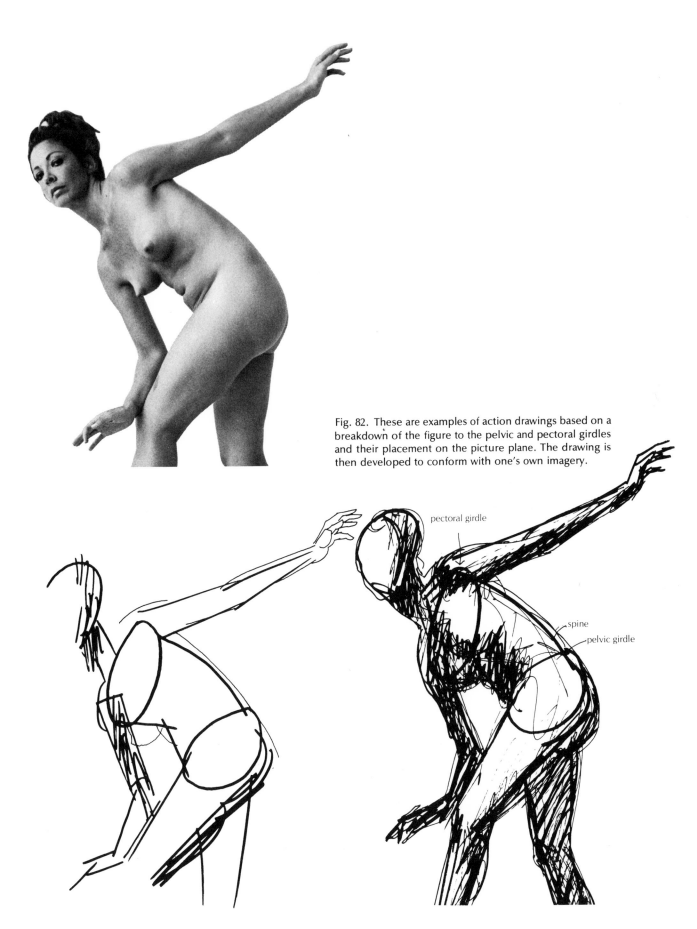

Fig. 82. These are examples of action drawings based on a breakdown of the figure to the pelvic and pectoral girdles and their placement on the picture plane. The drawing is then developed to conform with one's own imagery.

pectoral girdle

spine

pelvic girdle

Fig. 83. A study of the anatomical structure in a pose such as this requires the selection of a few reference points based on some knowledge of the subject. In this case, the tilted scapulas, the deltoid and gluteus muscles, and the curved spine are obvious starting points to which remaining muscles of interest to the student may be related.

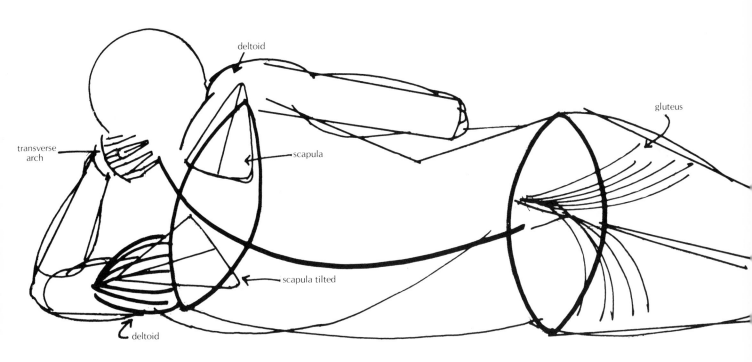

deltoid

transverse
arch

scapula

scapula tilted

deltoid

gluteus

71

5. THE PRACTICE OF STRUCTURAL DRAWING: THE HUMAN FIGURE

In this chapter, the structural essentials of the human form, graphically abbreviated as described in Chapter 4, will be studied in more detail. Each of the diagrams should be analyzed in conjunction with a good reference book on artistic anatomy. When the student is familiar with the structural themes presented in the diagrams, the accompanying photographs, or a model, may be used to pursue the theme or themes presented by each pose. It is wise to limit the amount of time devoted to sketching each pose. A first impression usually penetrates the dynamics of the action, and quick linear probes preserve the essentials of the pose while eliminating the opportunity to get mired in unnecessary details. Three minutes per sketch is a good average.

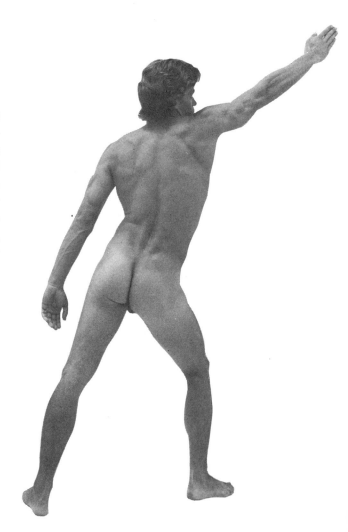

Fig. 84. *A* shows how the structural character and the action of the human body may be simply stated with straight, thrusting lines. Notice that the body cavity has been first conceived as a box. *B* shows how an individual interpretation is based upon this straight, linear concept and respects the fundamental structural realities.

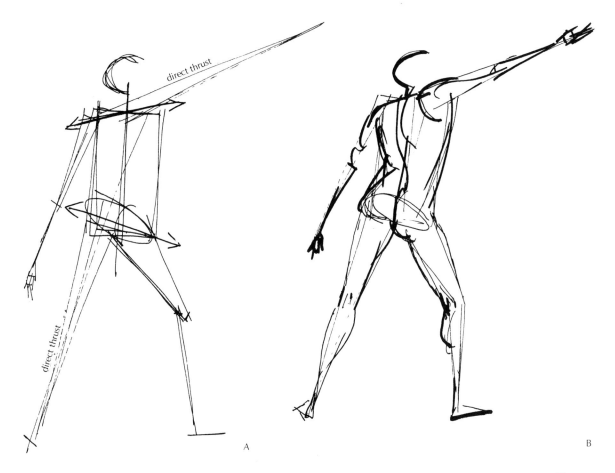

direct thrust

direct thrust

A

B

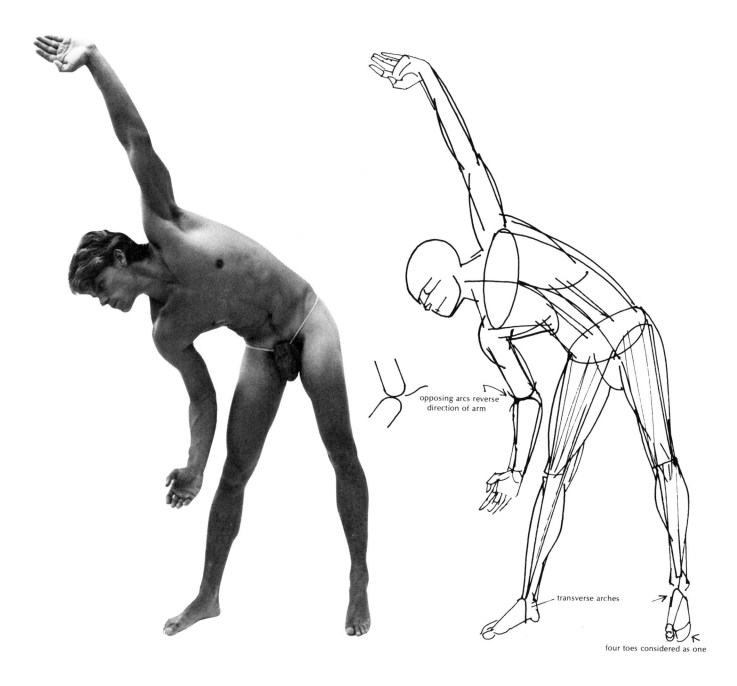

opposing arcs reverse
direction of arm

transverse arches

four toes considered as one

Fig. 85. This is a simplified version of factors to be considered in an anatomical study of the human body in action. Note the following: (1) the positions and actions of the pectoral and pelvic girdles, the spine, and the head in relation to each other; (2) the diminishing mass of the limbs; (3) the continuation of the muscular system in an extended limb from the source to the terminus; (4) the transverse arch establishing each foot; (5) the lines indicating the rectus abdominis muscles between the bottom of the rib cage and the top of the pelvis. Also note that, when the legs are straight, the knee joints are closed (that is, the knee cap is covering the juncture between the femur and the tibia) and that this is indicated by a horizontal line at the joint. The arches of the head are detailed in Chapter 6.

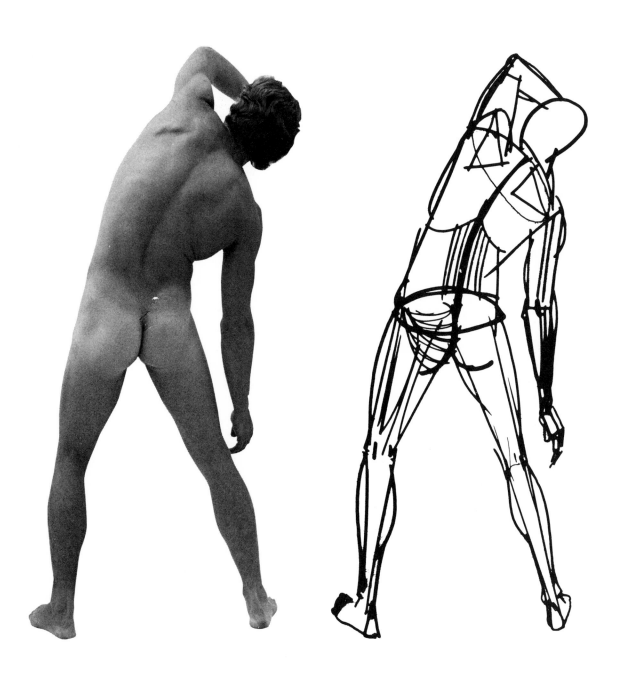

Fig. 86. The general shape and action of the basic skeletal
and muscular systems are again noted in this pose. Addi-
tional factors from the rear are the position and action of
the scapulas (tilted here) and of the gluteus maximus and
the erector spinae muscles of the hip and back. Also note
that, whether the elbow is straight or flexed, it may be
indicated by a horizontal line.

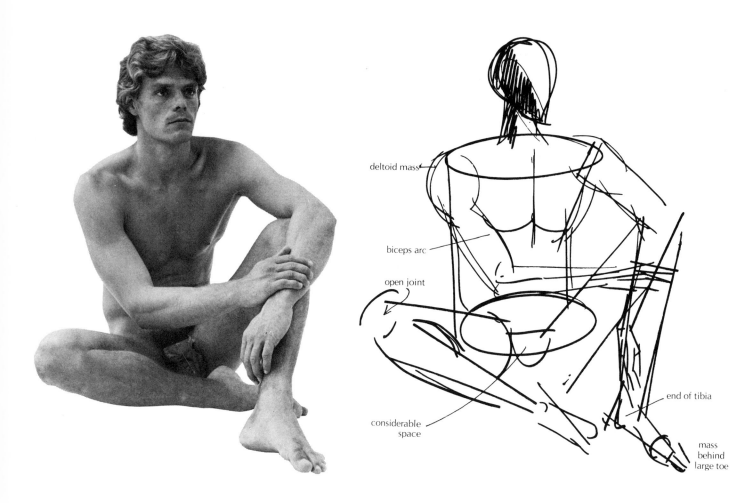

deltoid mass

biceps arc

open joint

considerable
space

end of tibia

mass
behind
large toe

Fig. 87. This quick sketch of a seated figure points out several factors: (1) the considerable space between the lower limbs at the bottom of the pelvis; (2) the open joint of the flexed right knee; (3) the mass of the deltoid muscle at the shoulder; (4) the short arc of the biceps muscle; and (5) the inner ankle formed by the end of the tibia, which is higher on the leg than is the outer ankle formed by the end of the fibula. An open joint at the knee occurs in flection because the patella slides down with the tibia to expose the end of the femur.

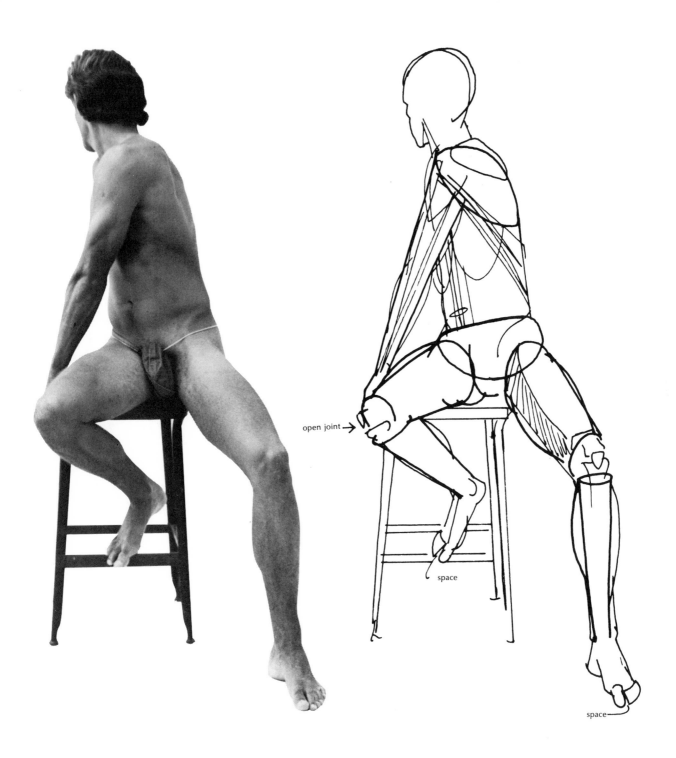

open joint →

space

space

Fig. 88. The open joints of the legs are detailed. Note the open space between the bottom of the femur and the top of the tibia, and the position of the patella between those two bones. Again the space between the legs has been considered and the movements of the latissimus dorsi and of the rectus abdominis have been indicated. The space between the large toe and the remaining toes (considered as one unit) is evident. Notice the tonal blocking of the inner thigh on the left leg, indicating its spatial position (see Chapter 9).

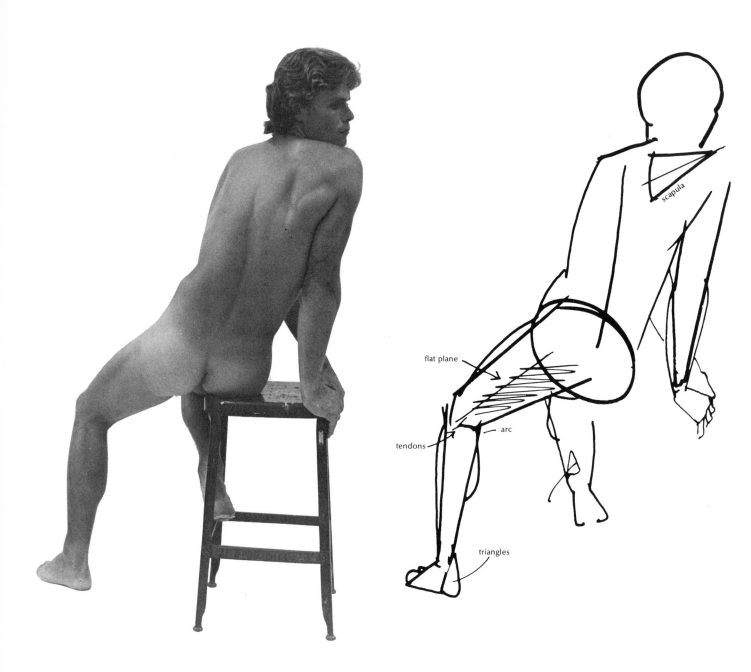

Fig. 89. The dorsal plane of the thigh has been separated from the remaining planes with tone. This immediately simplifies the complex appearance of the leg in this position. Two short dashes and an abbreviated arc separate this flat dorsal plane of the thigh from the muscular mass of the lower leg. The femoral mass at the front of the thigh has been indicated with a long arc, while the calcaneal bones are indicated with triangles. The tilted scapula shows that there is pressure applied to the right arm.

Fig. 90. This demonstrates the effect of action and pressure upon the contours of a limb. Notice the increase in the mass of the right arm, which is exerting pressure, in contrast to the left arm, which is extended. The knee has been cut away to reveal the open joint of the flexed leg. Again, notice the position of the patella.

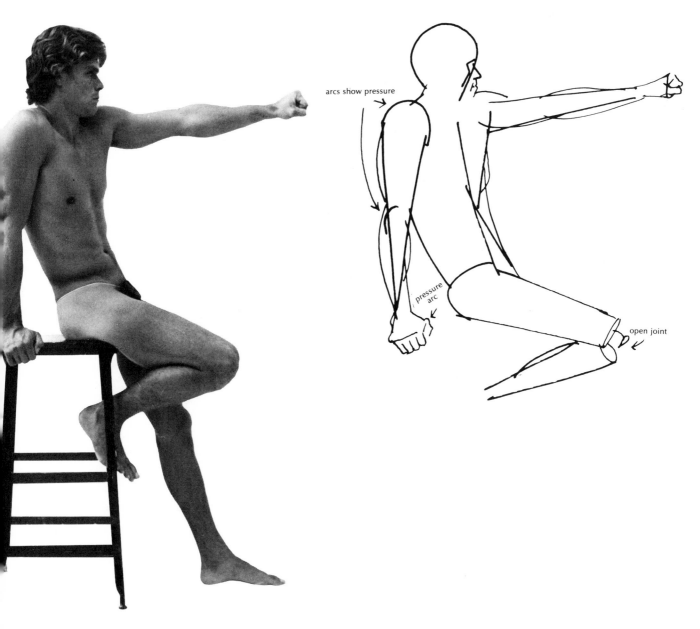

Fig. 91. One of the best ways of developing draftsmanship is to compare two corresponding parts of the body when observed in different positions and from varying viewpoints. In this pose, compare the flexed right arm with the extended left arm, the front view of the flexed right leg with the profile of the flexed left leg, and the almost vertical thrust of the left side of the torso with the angled right side. Notice how the arc at the right knee helps to foreshorten the right leg.

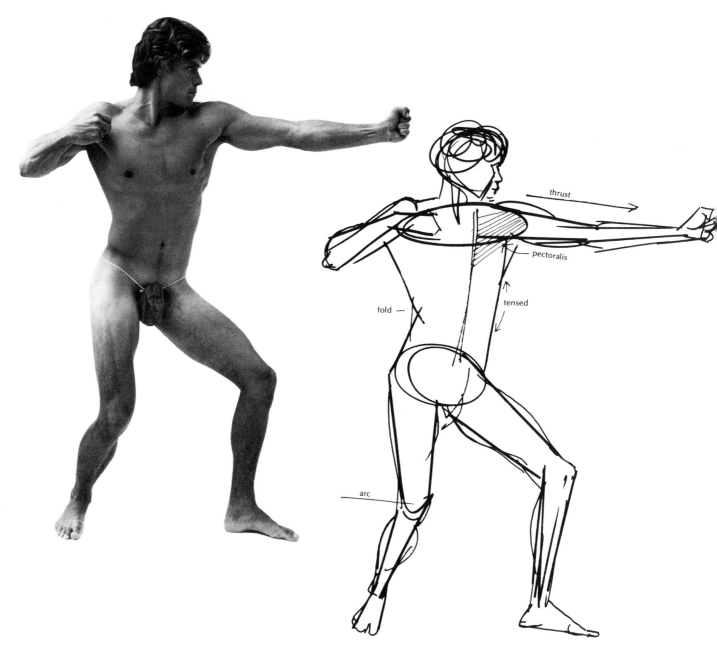

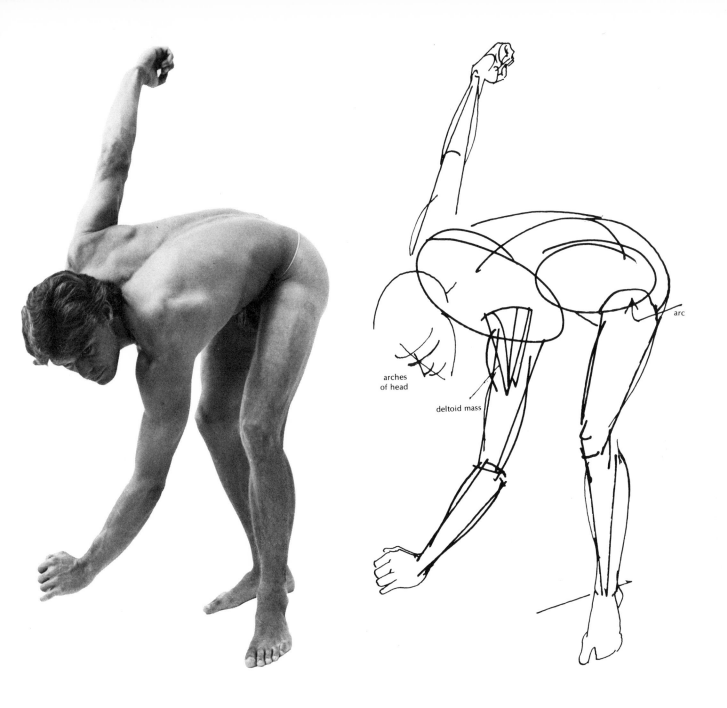

arches
of head

deltoid mass

arc

Fig. 92. An anatomical study of the human body in this position must follow the abbreviated structural concept stated here. In this case, the arching spine, the flexed limbs, and the top view of the head call for a study in which curves dominate the design. The same concept would apply whether the individual idiom of the artist resulted in a quick brush statement, such as by Matisse, or in a carefully worked tonal study, such as by Michelangelo, because the interpretation must be based upon structural factors which cannot be dismissed. Note that the deltoid mass of the left shoulder in this position becomes prominent and that the arc separating the left thigh from the pelvis helps to project the leg forward.

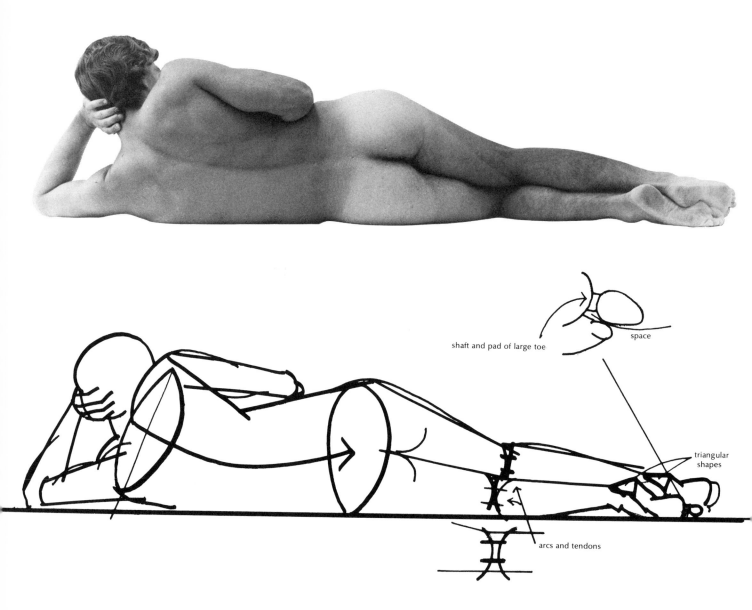

shaft and pad of large toe

space

triangular shapes

arcs and tendons

Fig. 93. In contrast to a standing pose, which is balanced against a single, vertical line of resistance, a reclining pose is governed by a horizontal base. This base supports the pectoral and pelvic girdles in relatively vertical positions, with the spine sagging like a suspension bridge in between. Notice the contrasting arcs and short dashes indicating the tendons between each thigh and the lower leg. Also note the detail of the large toe as it projects from the main body of the foot.

Fig. 94. This diagram is meant to be used as a guide in studying the lower limbs. As an exercise, sketch a facsimile of this diagram with the elements that have been indicated as reference points or points of departure, such as the long arc on the upper thigh which indicates the base for the femoral muscles. Study the difference between the closed joint of the left leg and the open joint of the right leg.

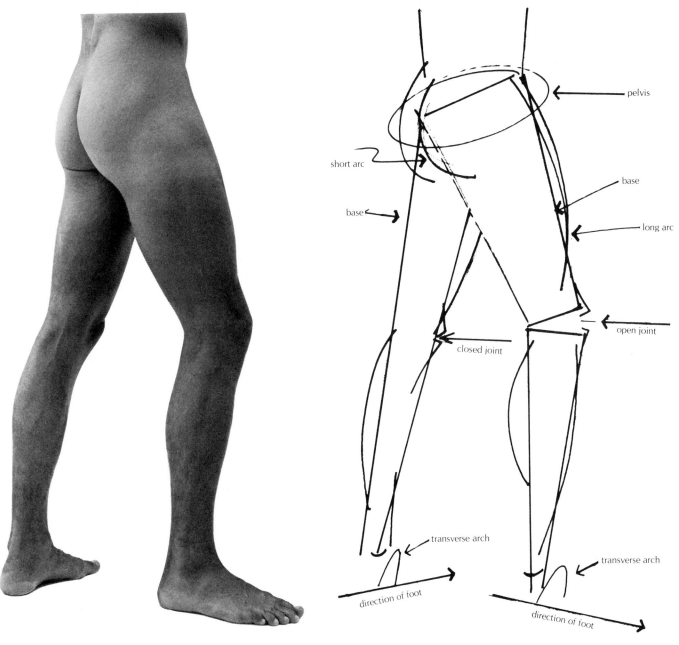

pelvis

short arc

base

base

long arc

open joint

closed joint

transverse arch

transverse arch

direction of foot

direction of foot

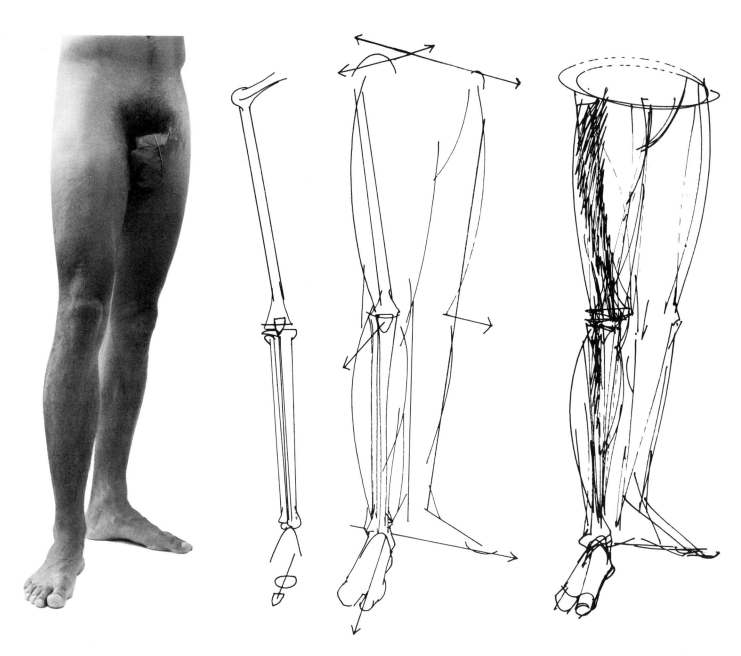

Fig. 95. In this diagram, you will notice that the legs are
rotated — the right is facing the viewer, the left is directed
away from the viewer. Arrows at the knees and feet point
out the rotation of the legs, while the arrows at the top of
the pelvis describe the general direction of the pelvic
planes. Study the structure of the right leg and constantly
compare each of its components with its counterpart in the
left leg. The foreshortened right foot, for example, can be
analyzed more easily when it is compared with the profile
of the left foot. The structural drawing at the right is based
on the diagram.

84

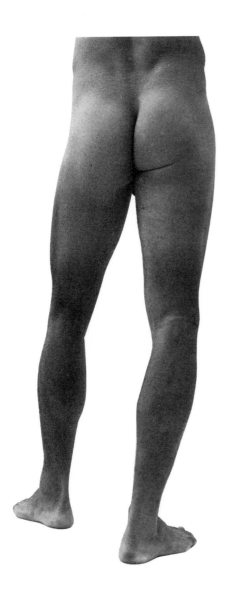
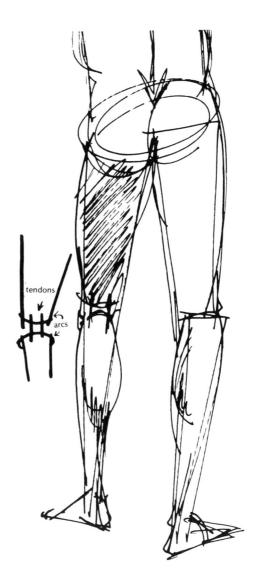

Fig. 96. In this rear view, the addition of tone thrusts the left leg away from the viewer. This is spatial toning — placing an object in space relative to its surroundings. The tone under the gastrocnemius muscle of the calf is a modeling tone; it shapes an object after the object has been placed in space. The division of the right thigh and leg with short, horizontal strokes rather than arcs emphasizes the rigidity of that leg in contrast to the flexed leg.

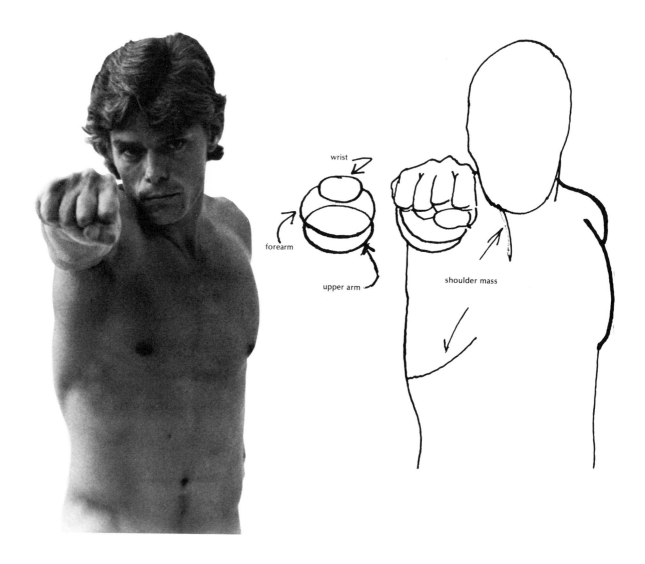

Fig. 97. An extended arm directly facing the viewer must be compressed into a small area of the picture plane. The diagram shows how the form is conceived in phases (upper arm, forearm and wrist) before it is outlined. For a further discussion of foreshortening see Chapter 7.

Fig. 98. This structural drawing of the extended right arm is simplified by continuing the basic triangular shape of the diminishing arm mass through the wrist to the index finger of the hand. Note that the hollow of the arm is formed between the latissimus dorsi and the pectoralis muscles.

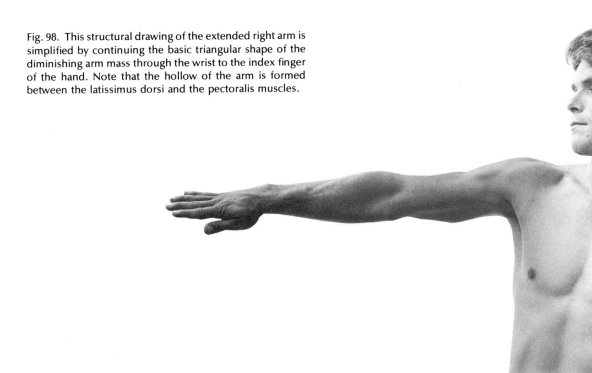

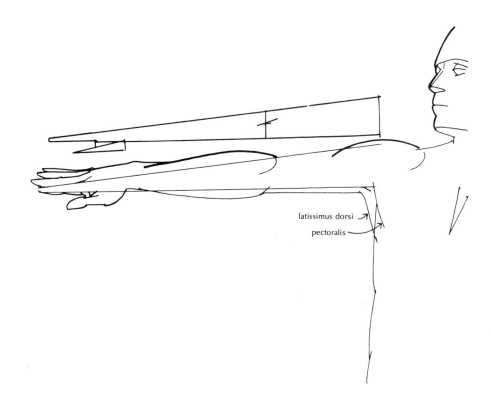

latissimus dorsi

pectoralis

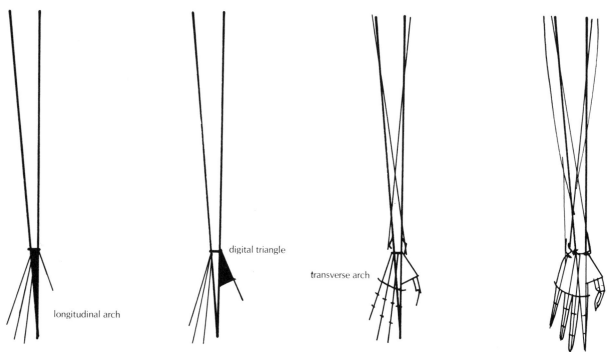

Fig. 99. These diagrams schematically illustrate how the basic triangular base of the arm can be extended through the index finger and how the remaining fingers can be added onto this concept. The longitudinal arch runs from the wrist to the tip of the index finger. The points of the digital triangle extend from the wrist to the first joint of the thumb and to the first joint of the index finger, and the transverse arch corresponds to the knuckles. These points of reference, neutrally positioned in this instance, are extremely important in drawing the hand in any position. By clenching your hand into a fist, you will be able to note these two key factors in a different position.

Fig. 100. A profile view of the hand can quickly be developed from the basic digital triangle and the transverse arch.

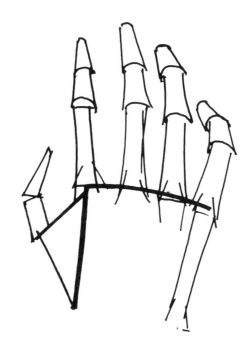

Fig. 101. Again the digital triangle and the transverse arch establish the basic shape of the hand, from which the segmented fingers are projected. Note how the arch flattens out when the fingers are stretched and how the shape of the triangle shifts according to the position of the thumb.

Fig. 102. A principal device in simplifying the complexities of the hand is to determine a primary geometric shape. Usually, no matter what the point of view, the primary shape extends from the wrist to the transverse arch. In this case, the primary shape is equivalent to that of the basic digital triangle alone.

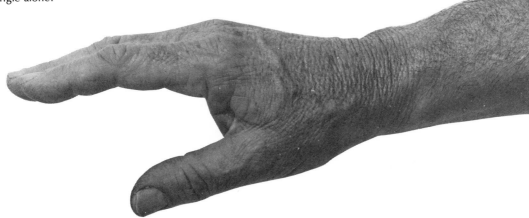

primary shape

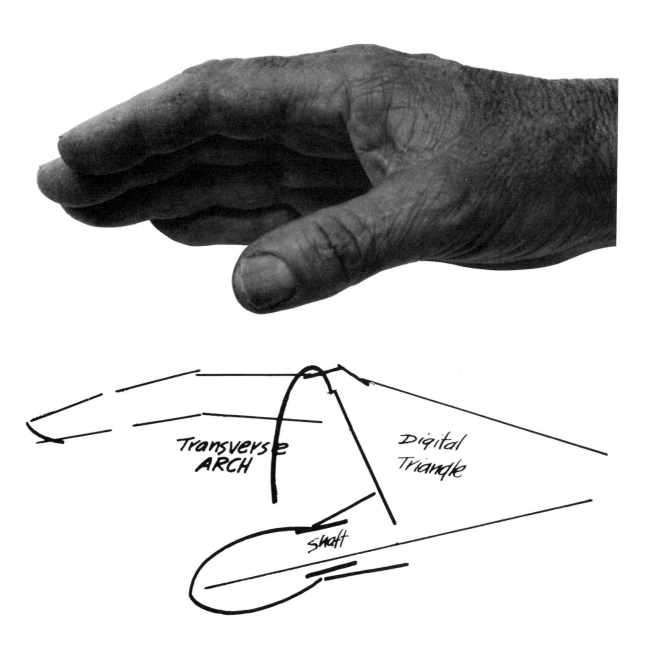

Fig. 103. The primary shape is very similar to that of the preceding example, but here the transverse arch has been added as a base for the projecting fingers. Note that the tip of the thumb is separated from the digital triangle by a shaft.

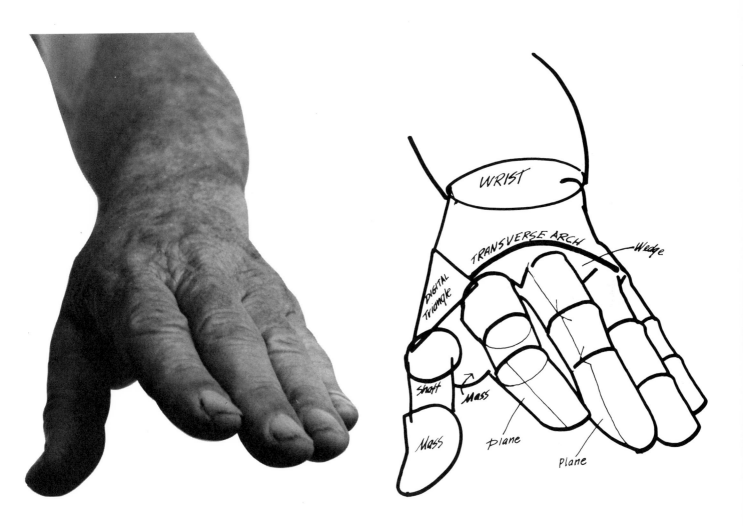

Fig. 104. Here the primary shape extends from the wrist to the transverse arch and includes the digital triangle. Note the following factors which are often ignored by poor draftsmen: (1) there are triangular planes or wedges between the fingers; (2) the fingers themselves are broken down into different planes; and (3) the shaft of the thumb separates the flattened mass of the tip from the bulkier mass at its base.

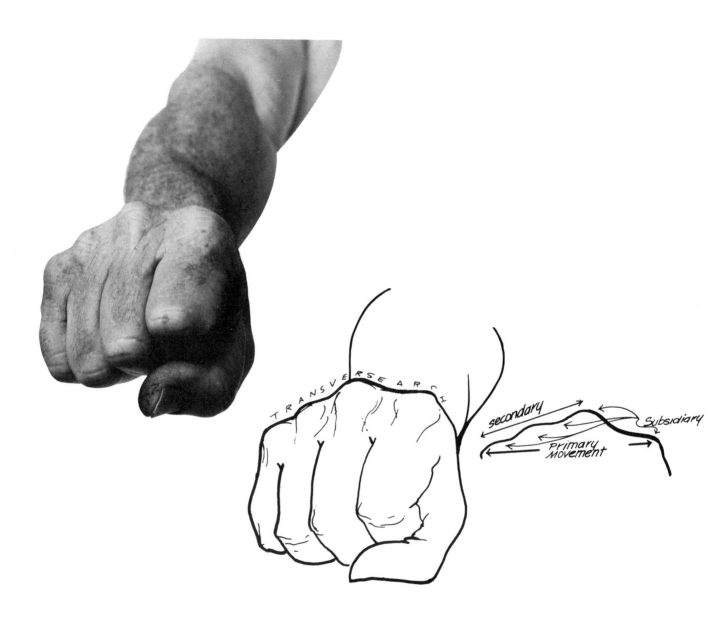

Fig. 105. This indicates how the transverse arch serves as a
base for the placement of the fingers and the general shape
of the hand. The primary movement of the mass is almost
horizontal; the straight thrust upon which the fluctuating
contour of the knuckles is based is a secondary movement,
and the contour itself is subsidiary.

92

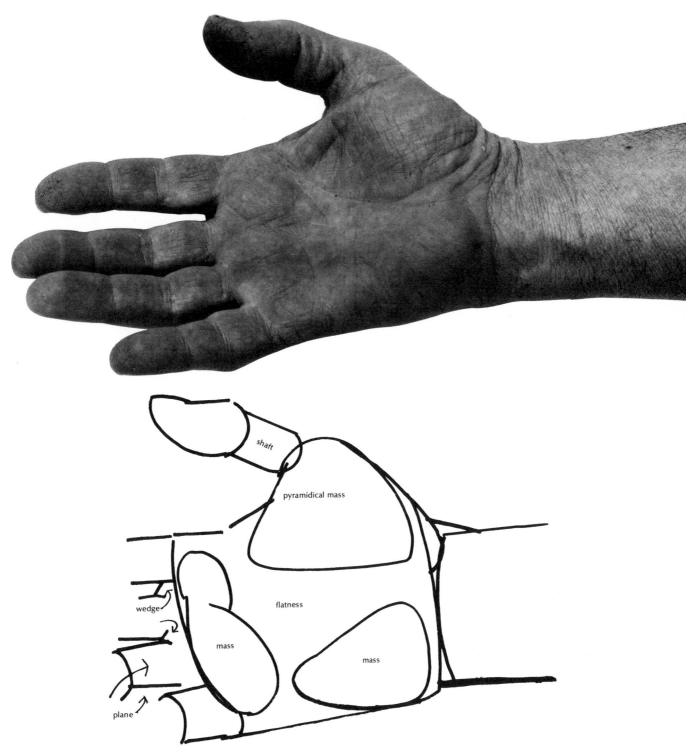

Fig. 106. To project a concept of mass in contrast to the flat areas dominating the palm of the hand, several sub-shapes are introduced.

93

6. THE HEAD

The head, like the remainder of the human body, is based on structural principles which determine both its function and its shape. It is not difficult to isolate the factors that govern the general character and appearance of a particular head if we keep in mind the structural essentials common to all human heads.

(1) The head should be conceived as the only part of the body to be protected by an exoskeletal system. As previously mentioned, the cranium is domelike and compact to enclose and support the brain and sensory apparatus. The head, therefore, contrasts with the endoskeletal system, which is designed to extend itself in space; and, as you will see, it can best be indicated by curved lines rather than with straight linear thrusts.

(2) Directly below the brain are the sensory instruments: visual, olfactory, and auditory.

(3) The eyes, being spheroid, contrast severely with the angular bones that surround them.

(4) The lower jaws, which along with the nose have retreated from a prognathic projection, are the only skeletal levers of the head.

(5) Although the nose and jaws no longer project beyond the upper region of the head, vestigial, muzzle-like characteristics remain in the area of the mouth to influence the appearance of that region.

(6) The head is balanced upon the upper portion of the spinal column in a manner closely allied to a cantilever system.

In order to fully appreciate the structural factors of the head, we should gain insight into their origins. Just as the observed form of a mountain, wave, or tree is part of a continuum, each part of the human body has developed from a series of antecedent forms. The human skull has a pedigree which has been traced to a fossil vertebrate of the Silurian period. Before that time, no form of animal life had either jaws or skull. This vertebrate, however, a fishlike animal called ostracoderm, developed a hard, bony protective plate in its anterior region to protect itself from predators. The device proved indispensable and has been maintained and developed into the only exoskeletal device of the vertebrate system.

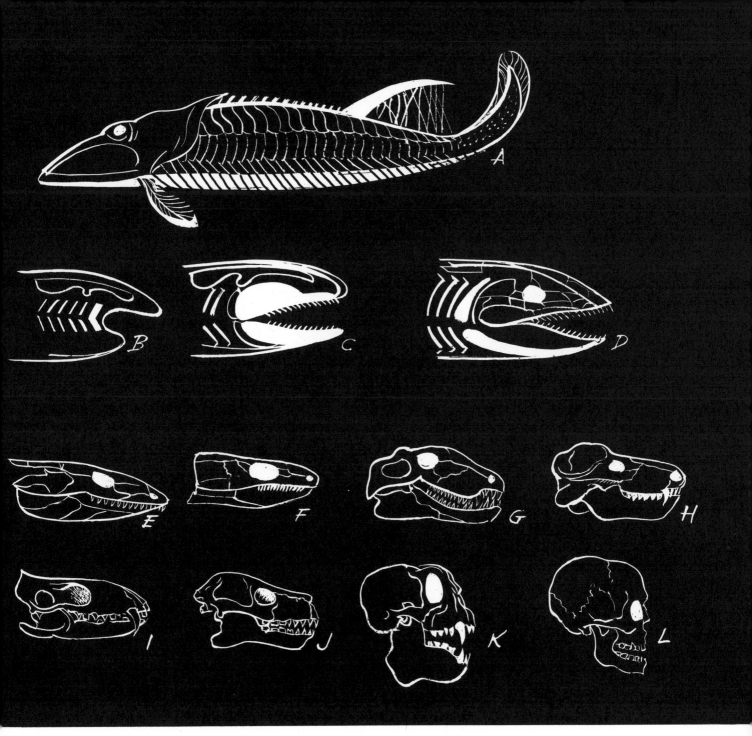

Fig. 107. *A:* The ostracoderm, an early fish form, had a solid armor plate forming and protecting its head region.

B: These primitive, jawless vertebrates possessed cartilaginous bars between the gill slits.

C: In later fish forms, like the acanthodians, the gill bars were modified and became ossified, forming jaws.

D: The original armor plate became segmented in bony fish forms.

E: Further alterations occurred in primitive amphibians adapting to terrestial life. Some retained fishlike forms and some evolved toward reptilian forms.

F: Stem reptiles *(Cotylosauria)* gave rise to a great variety of animal life.

G: Mammal-like reptiles, such as the *Dimetrodon*, showed profound changes in the bones of the skull and jaws. Note the temporal opening behind the orbit of the eye.

H: Cynognathus was an advanced mammal-like reptile; the temporal opening has widened.

I: Sinopa, an early carnivore, was a weasel-like animal.

J: Lemurlike animals evolving from early primate stock *(Northarctus)* are related to but distinct from anthropoid primates (apes, monkeys, and man).

K: Fossil ape. Note how the face has been shortened as the head is held in a more erect position.

L: Man. Note how the bones of the skull became progressively reduced after segmentation appeared in fish forms.

Jaws were developed later, from the forward gill bars of these earlier fish forms. As fish forms developed into separate types (elasmobranch, lung-fishes and bony fishes) and as lung-fishes developed into amphibians, divergent strains of which evolved into early reptiles, many additional anatomical changes took place. In adapting in different ways to non-aquatic life, early reptiles gave rise to modern reptiles, birds, and mammals, with corresponding alterations in the structural features of the jaws and skull. Fig. 107 charts the general evolution of the human head.

In examining the bony structures of the human head (Figs. 108 and 109), it becomes evident that the domelike cranium dominates the upper region of the head, culminating in the front with the superciliary ridge of the frontal bone at the brow, and in the rear with the base of the occipital bone. In addition, three key structures dominate the middle and lower regions: the bony prominences of the cheekbones (malars), the upper jaw (maxilla) and the lower jaw (mandible). These key structures are always present and therefore determine the general appearance of all heads.

The character of each of these prominent anatomical features, and the relationship of each to the cranium, can be simply stated by means of a corresponding arch, so that the basic structure of the head may be characterized by the cranial dome and four arches. The first arch curves around the face at the brow and follows the superciliary ridge of the frontal bone. This is the frontal arch. The second arch curves around the face from the hollow of one ear (concha) to the hollow of the other ear, moving along the zygomatic process

Fig. 108. Human skull, front view. The key structures of the head may each be indicated with an arch corresponding to an anatomical feature: frontal, maxillar, zygomatic, and mandibular. An imaginary medial line helps in determining the position of each arch.

of the temporal bone at either side of the face, and flowing into the malar cheekbones at the front of the face. This is the zygomatic arch. The third arch delineates the upper jaw, formed by the maxilla bone; this maxillar arch curves around the middle of the mouth. The fourth arch, the mandibular, follows the lower jawbone (mandible).

Fig. 109. Human skull, profile. Another imaginary vertical line, which meets the zygomatic arch at the side of the head, shows the position of the ear.

frontal medial line

frontal arch

zygomatic arch

maxillar arch

mandibular arch

vertical line

frontal arch

zygomatic arch

maxillar arch

mandibular arch

orifice of ear

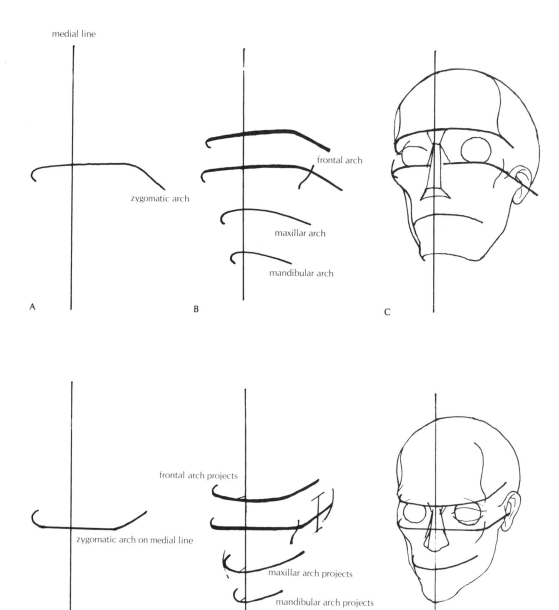

medial line

zygomatic arch

A B C

frontal arch

maxillar arch

mandibular arch

frontal arch projects

zygomatic arch on medial line

maxillar arch projects

mandibular arch projects

A B C

An aid in assessing the position of these arches is an imaginary vertical line dividing the front of the face into two symmetrical halves. This medial line runs through the center of the nose and from the top of the head to the bottom of the chin. The arches of the brow, mouth, and chin all project away from this line, while the zygomatic arch does not. By combining this medial line with the zygomatic arch, both the frontal and lateral planes of the face are very quickly established no matter what point of view is used.

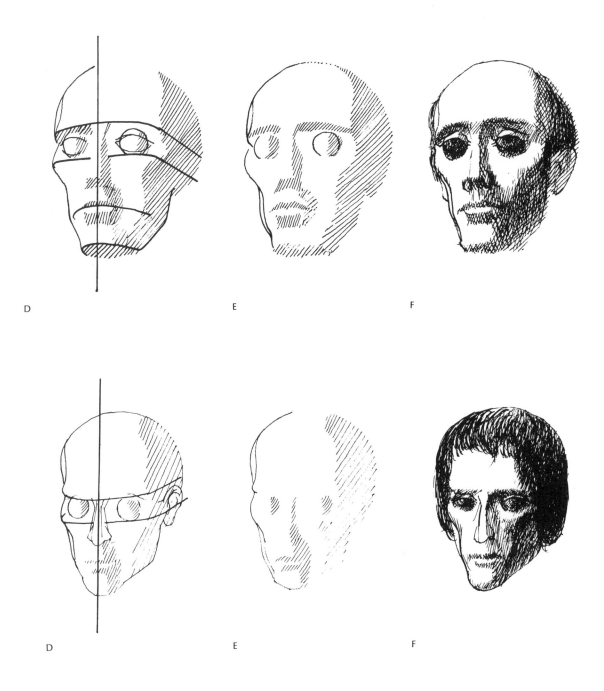

D E F

D E F

Fig. 110. All the arches, except the zygomatic, project away from the medial line. The position of the head and its frontal and lateral planes can be rapidly noted by drawing the medial line and placing the zygomatic arch across it. An upward swing to the arch places the head above eye level; a downward swing places it below eye level.

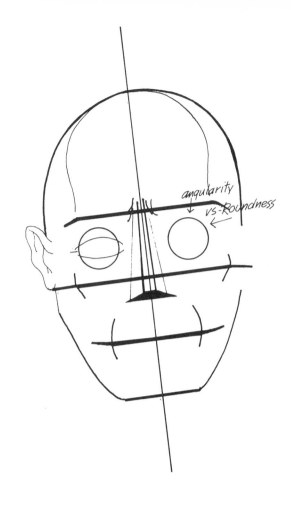

angularity
vs-Roundness

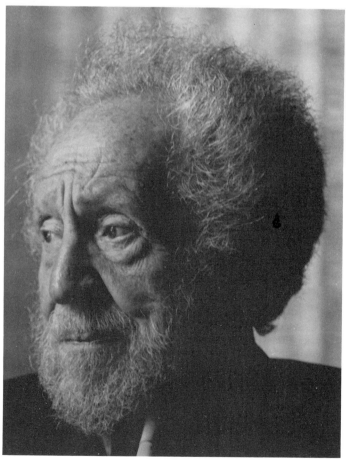

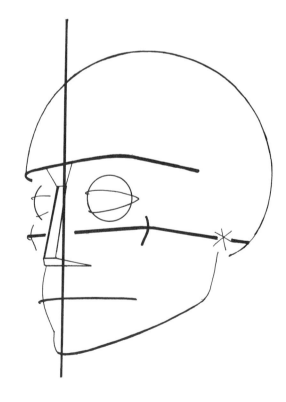

100

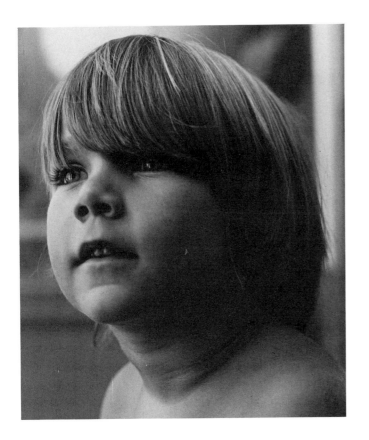

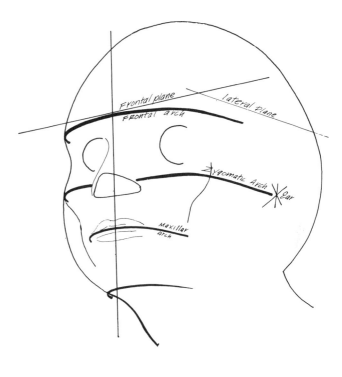

Figs. 111 to 113. The arches of the head, and the relation of each to the cranium, are the prime factors in determining both the general and specific appearance of a particular head. Compare these factors in the photographic portraits of actor Sam Jaffe with those in the portrait of a young child.

As the arches indicate the key structures of the head, they not only determine the general shape but the specific appearance as well. Individual characteristics or likenesses are based upon the spatial relationships between the arches and variations within the arches themselves. Compare the proportionate size and position of each arch in the head of a child with that of an adult, for example (Figs. 111 to 113).

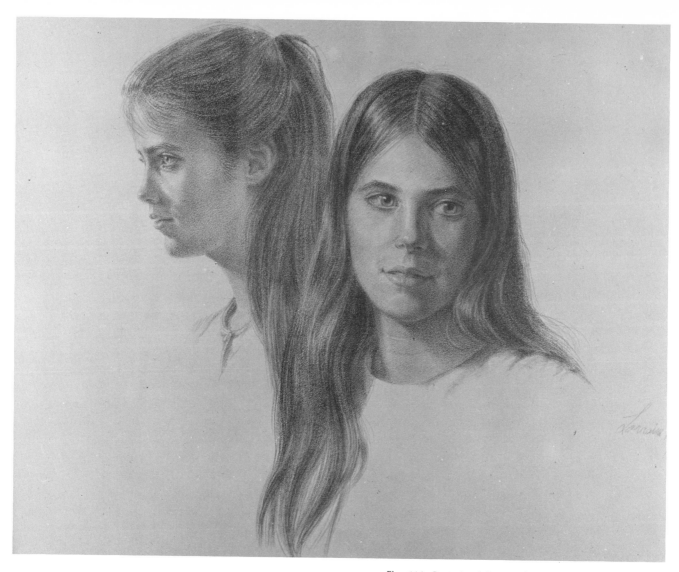

Fig. 114. *Portrait of Dena Oliver*, Lorraine Walters; charcoal pencil, 25 by 13½ inches.

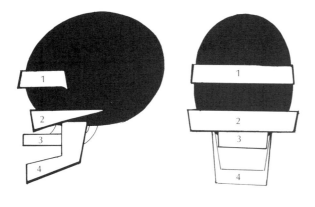

Fig. 115. Simplified diagram of the drawing in Fig. 114. The arches and the cranium are present as structural essentials although they may not be obvious in the artist's interpretation.

In drawing the head and face, the underlying structures may be more or less apparent, depending on the artist's concept, but they are always present. The subtlety of the drawing in Fig. 114 is consistent with the particular artist's method of probing form, which is to begin a drawing from light to dark in order to search the subject and become more familiar with it before committing the drawing to darks.

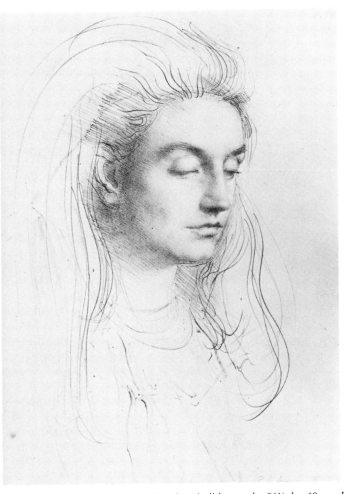

Fig. 116. *Letizia*, Pietro Annigoni; lithograph, 21½ by 19 inches.

Fig. 117. The prime tonal factor places the main planes of the face in their proper positions in space. The underlying structure is thus established. Additional, modeling tones delineate the subsidiary planes.

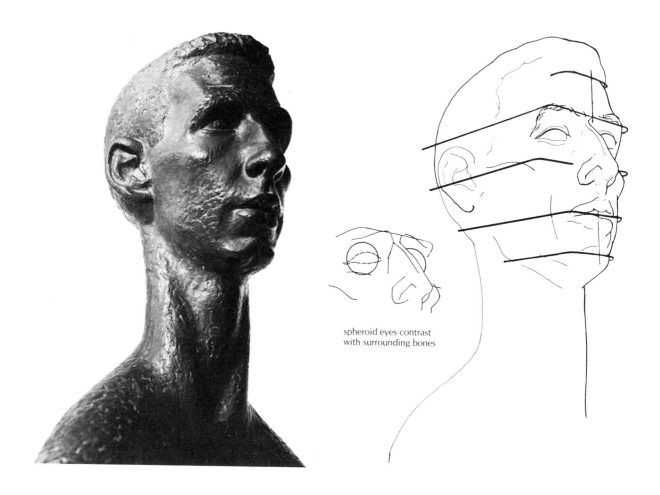

spheroid eyes contrast
with surrounding bones

The key structural factors must be respected regardless of the media in which they are expressed. The arches of the head are prominently featured in the bronze sculpture by Renzo Fenci (Figs. 118 to 120). They are conceived as structural elements but are skillfully and sensitively controlled by the artist as elements of an aesthetic statement as well. The portrait therefore conveys a universal image of the human head without abandoning the usual, rigid standards of portraiture, which require the artist to produce an authentic or acceptable likeness of the subject.

Figs. 118, 119 and 120. *Bronze Portrait,* Renzo Fenci. The demands of draftsmanship, portraiture, and the sculptural medium are not ignored but are in fact incorporated in the artist's personal statement.

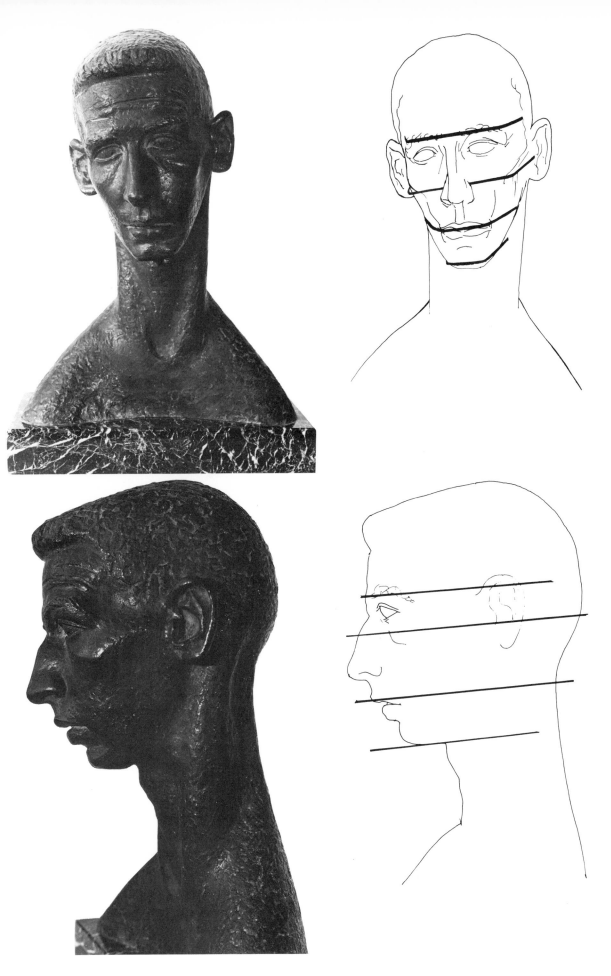

Fig. 121. Drawing and diagram based on a painting by Honoré Daumier. Note that the arches of the head have been only slightly modified in Daumier's concept. The somber half-lights of Daumier's chiaroscuro are represented here by finely shaded pen lines.

Fig. 122. Drawing and diagram of a painting by Chaim Soutine. In contrast to Daumier, Soutine's art is dependent upon distortion. Notice, however, that — although the arches have been modified — they have been relocated in proportion to the total structure.

The interpretation of the human head has always been an important subject of the visual arts. The examples shown in Figs. 121 and 122 are ink versions of two paintings, each by artists gifted with extraordinary imagination and penetrating vision. As you will notice, I have converted their highly individualistic imagery from the medium of painting to that of drawing, keeping in mind that neither of these painters were interested in reissuing in paint an optical version of nature. As artists they used the human head as a device (one might even say as a medium), for the true subject of each of these paintings is an intuitive image of a personality, and in each the key elements of the head were used as a reference, not as criteria. As skilled draftsmen, Daumier and Soutine were each able to isolate the salient features of the head and to incorporate them into his design. This demonstrates that, regardless of the artist's personal style, or idiom, the basic structure of the subject must be respected.

Fig. 123. *Head of Girl*, Ernest Robischon; conte crayon, 12 by 12 inches.

Fig. 124. *Nana*, Viona Ann Kendall; charcoal, 24 by 34 inches.

7. THE PICTURE PLANE

PHYSICAL AND PERCEPTUAL ASPECTS

Physically, the picture plane is the flat, two-dimensional surface on which the artist draws or paints. This can be a sheet of paper, a plaster wall, a canvas, and so forth. In perceptual terms, it is a transparent, vertical plane, similar to a sheet of glass, interposed perpendicularly between the artist and what he is viewing. The fact that this plane allows the artist to create an illusion of three-dimensional forms can easily be demonstrated by viewing an object or scene from a fixed position and tracing the outlines of the three-dimensional forms you see on a sheet of glass placed at a convenient distance from you and held perpendicularly between your line of vision and the subject matter.

The results, drawn on the glass with a grease pencil, would be a two-dimensional representation of space and volume, with each form being placed and proportioned according to the laws of perspective. Forms farthest from the fixed position would appear smaller and thus would seem to recede in the distance. Forms that were not parallel to the picture plane and therefore not perpendicular to the line of vision would appear to be compressed and to change shape. These and other visual phenomena are the result of the way the eye perceives form. The same perceptual factors enable the three-dimensional reality of depth and space to be created in illusion as a two-dimensional film image taken with a camera and to be re-created by projecting the image on a two-dimensional screen. The film at the rear of the camera, perpendicular to and behind the lens, and the screen, perpendicular to and in front of the projector lens, are both picture planes.

In order to demonstrate the greatest range of perceptual possibilities, the picture plane should be not only flat but neutral in shape. As a rectangular shape immediately draws attention to its dimensions, I have selected the square to represent the picture plane. In Fig. 125, various circles are used to represent form and show how the illusion of volume and space is created by: (1) overlapping opaque forms to indicate solidity; (2) gradually diminishing the size of the forms to indicate receding space; (3) inserting linear thrusts between forms to indicate distance; (4) adding detail to forms to indicate changes in direction on the form's surface; (5) combining suddenly diminished size with different linear thrusts to indicate variance in depth and direction within the picture plane.

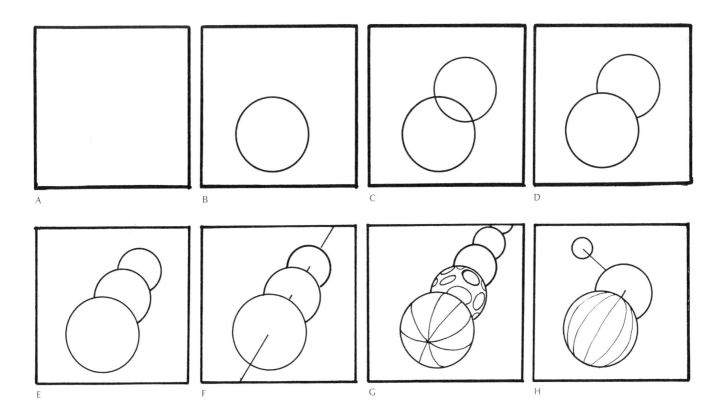

Fig. 125. *A:* This represents the picture plane as an abstract, flat, white square. It is as neutral as a sheet of paper, a plastered wall, or a blank canvas.

B: The circle does not affect the flat appearance of the square; in fact, it seems to emphasize it.

C: Even though another circle has been added, the flatness of the picture plane remains unaltered.

D: The elimination of the lower segment of the upper circle transforms both circles into opaque, disclike objects. The paper has attained a spatial dimension, for logic — springing from experience — immediately relates solidity to depth and space.

E: Three discs, gradually diminishing in size, reach deeper into the picture plane and give the illusion of receding space.

F: Added linear thrusts not only confirm the disclike shapes but indicate space between each disc and beyond.

G: Detail transforms the discs into spheres. The illusion of volume and mass has been introduced by placing radiating arcs in the foremost circle and ellipses in its neighbor. Notice that both arcs and ellipses seem to continue beyond the periphery of each circle, implying that they cover the total surface of each sphere. This, of course, suggests the

unseen half of each sphere. The untouched circles, by association with the total design, have now become white spheres, while the sectioning of the last circle suggests others beyond the picture plane.

H: By separating the third circle from the other two and decreasing its size, a new thrust in space is indicated and a new area of the picture plane has been activated. Without the relatively short thrust of the line connecting the periphery of the middle circle with the center of the upper one, the top circle would be isolated. The combination of line with the abrupt shift in the sequence of circles, however, indicates a definite thrust in space away from the viewer. By alternately covering the line and exposing it with a piece of paper or your finger, you will demonstrate to yourself the importance of line in draftsmanship, not only to depict or interpret form and structure, but also to determine the position and proportion of shapes in space. Notice also how the extremely short thrust between the two lower elements becomes a foreshortened version of the upper line. The stripes in the lower circle illustrate a simple yet valuable device which has been in use for centuries. Essentially it is based upon the optical principle that detail concentrated toward the edges of form lends an appearance of solidity and volume. This principle is strongly evident in the etchings and drawings of Rembrandt, Goya, and Daumier, etc.

Fig. 126. These panels correspond with those in the preceding illustration. Although the subject matter is representational, the same devices are used to control the picture plane, to indicate volume, mass, space and thrust. Notice in G how the geological structure of the peak in the foreground and the vegetation in the middle ground contain more detail than do the hills in the distant background.

In H, the foremost circle has become the shoulder mass, the second circle has become the upper arm, and the linear thrust terminating with the small circle has become the forearm and wrist. In B and C, the original flatness of the picture plane has been retained, while in D the overlapping cactus plants give some indication of three-dimensional form.

In Fig. 126, figurative shapes have been substituted for each circular form, yet the identical perceptual factors are present. This illustrates that whether the subject matter is abstract or representational the objective is to control the picture plane, either to preserve its two-dimensional character or to indicate volume, mass, space and thrust.

The skillfully drawn reclining figure in Fig. 127 incorporates the same perceptual factors as those shown in Figs. 125 and 126. The viewer can identify overlapping, diminished size, variance in the direction of linear thrusts, and surface details developed with modeling tone. Spatial tone supports the perception of depth (see Chapter 9).

Foreshortening and perspective may seem confusing to the novice, yet even a superficial survey of any foreshortened form reveals a simple optical rule. An object, or a part of an object, viewed in a perpendicular position and at a right angle to the observer, is extended to its full length on the picture plane, while if the same object is tilted so that it is viewed from another angle it will seem shortened, or compressed on the picture plane. For example, a telephone pole in an upright position occupies more space, vertically, on the picture plane than a pole that is leaning either toward the viewer or away from the viewer. In the diagram of Fig. 127, notice how the torso has been compressed by shortening the space between the pectoral and pelvic girdles so that the two elliptical forms overlap. Note, too, how the thighs are extended, while the lower legs are compressed, though each section is generally of the same length when the entire leg is perpendicular to the viewer.

Also notice the circular and elliptical cross sections depicting the joints of the limbs. It is important for the draftsman to realize that an ellipse represents a foreshortened circle.

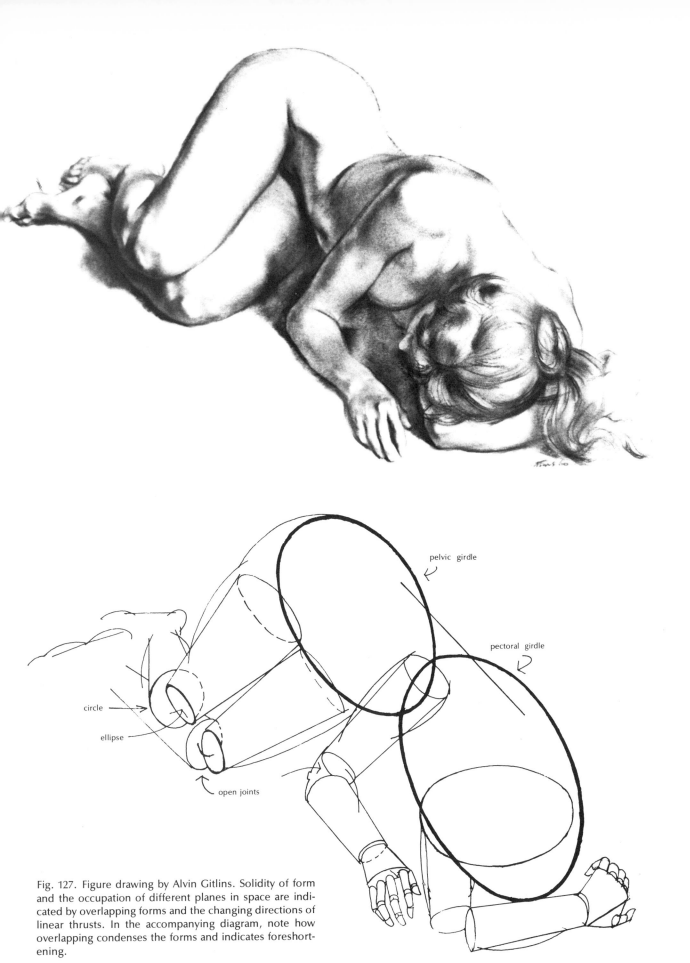

Fig. 127. Figure drawing by Alvin Gitlins. Solidity of form and the occupation of different planes in space are indicated by overlapping forms and the changing directions of linear thrusts. In the accompanying diagram, note how overlapping condenses the forms and indicates foreshortening.

pelvic girdle

pectoral girdle

circle

ellipse

open joints

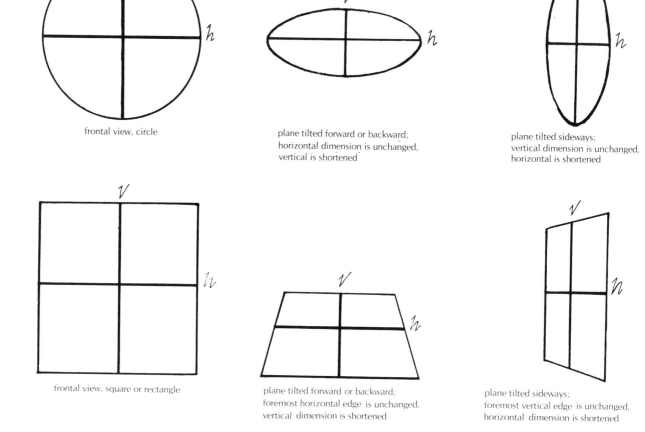

frontal view, circle

plane tilted forward or backward; horizontal dimension is unchanged, vertical is shortened

plane tilted sideways; vertical dimension is unchanged, horizontal is shortened

frontal view, square or rectangle

plane tilted forward or backward; foremost horizontal edge is unchanged, vertical dimension is shortened

plane tilted sideways; foremost vertical edge is unchanged, horizontal dimension is shortened

Fig. 128. *Top:* When a circular form is tilted vertically, the vertical dimension is condensed; when it is tilted laterally, the horizontal dimension is condensed. In either case, the plane is no longer perpendicular to the line of vision and the shape is altered.

Bottom: Unlike circular forms, rectilinear forms are not symmetrical in perspective. Although the foremost edge remains constant, the receding edge is reduced, so that the horizontal and vertical dimensions are actually both diminished. However, one horizontal edge remains unchanged when the plane is tilted vertically, and one vertical edge remains unchanged when the plane is tilted laterally.

Fig. 128 clearly illustrates the perceptual factors of foreshortening; that is, the vertical aspect of a shape becomes telescoped or shortened when the shape is no longer perpendicular to the viewer's line of vision but is tilted vertically toward or away from the viewer, and the horizontal aspect of a form is similarly shortened when the form is tilted laterally toward or away from the viewer. In other words, when the form is tilted toward the left or right edge of the picture plane, the form becomes condensed horizontally; when the form is tilted toward the top or bottom of the picture plane, the form becomes condensed vertically.

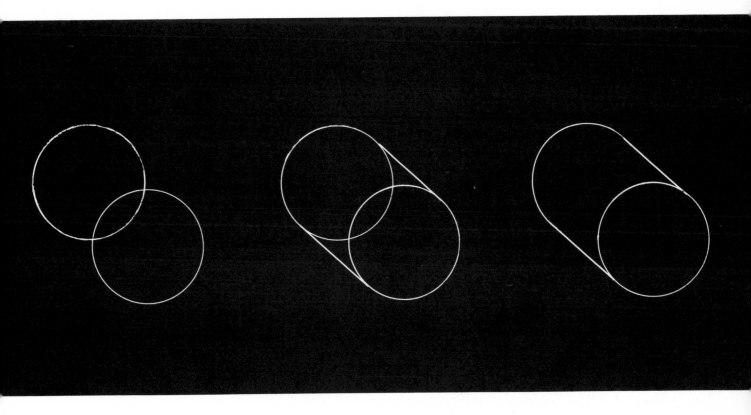

The significance of overlapping forms is shown in Fig. 129. Even without altering the shape of the circle to show perspective, the addition of connecting lines transforms two flat, interlocking circles into a three-dimensional tube. Alternately place your finger over one, then the other, of the two interlocking arcs and you will notice an apparent change in the position of the tube. It is a simple matter to apply the principle of overlapping circles to the human form viewed in perspective. First, the substitution of a smaller circle modifies the tube into a gradually diminishing cone, the basic shape of the limbs; and second, the alteration of the circular shape to an elliptical one where necessary shows the form in perspective.

Fig. 129. Connecting lines transform two overlapping circles into a three-dimensional tube. In the view at the far right, the upper of the two interlocking arcs is stressed and the lower arc is omitted. By stressing the lower one instead, the viewpoint may be altered. Because the front of the cylinder is not perpendicular to the line of vision, the circular form should be changed to an elliptical one to show perspective.

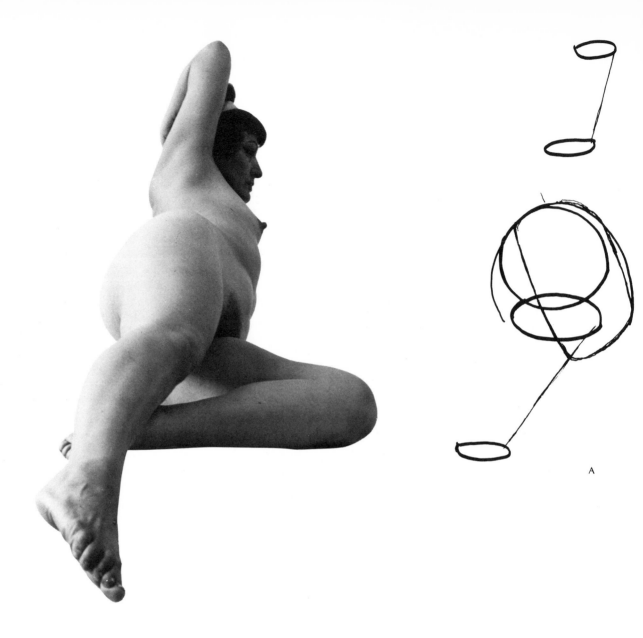

A

In Fig. 130, the extremely condensed right thigh is indicated by an ellipse overlapping a circle. Overlapping both of these forms is the larger ellipse of the pelvic girdle. The pectoral ellipse overlaps the top of the pelvic, shortening the tubular form of the torso. The lower right leg, like the thigh, is tilted away from the viewer, but it is at the front of the picture plane and looms larger. The conical shape is therefore extended, although not to its full length; consequently, the ellipses are separated rather than overlapping. The upright arm is somewhat

diminished in size by its distance into the picture plane; however, it is perpendicular to the viewer and is not foreshortened. By contrast to the right leg and thigh, the left leg and thigh are each almost perpendicular to the viewer and each is therefore extended to its full length. Note that when we say a limb is perpendicular to or tilted away from the viewer we are speaking of the longitudinal axis, whether that is positioned vertically (as the upper arm), horizontally (as the left leg) or obliquely (as the right thigh and leg) on the picture plane.

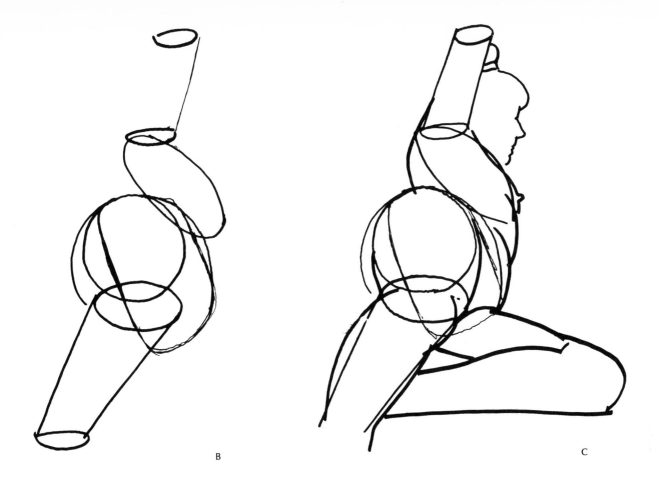

B

C

Fig. 130. The principle of overlapping circles and ellipses is essential in describing foreshortened limbs and torsos. In addition to considering questions of relative proportion, the draftsman must consider whether the longitudinal axis of the form is perpendicular to the line of vision.

Fig. 131. This is a simple yet penetrating observation by a three-and-a-half year old. One can almost see the tongue pressed against the cheek, co-ordinated with the crayon's pressure on the paper. The picture plane is only meant to receive and absorb the outlined image of a fascinating shape. This, of course, maintains the two-dimensional quality of the picture plane. (Drawing by Damon Robinson.)

Fig. 132. This design, painted by a six-year-old child (Vincent Van Suchtelen), is a joyous expression of a remembered scene drawn simply and spontaneously. As in Fig. 131, the picture plane was seen as an area upon which one could swish and sweep an interesting shape with a brush.

Fig. 133. *Cantaones*, Vincent Rascon; etching. Both tone and line are used in a flat manner. Here again, there is little indication of solidity or space.

The foregoing observations and the following drawings (Figs. 131 to 137) indicate only a few of the devices used by the draftsman as he contends with the potentials and the problems of the picture plane. Although much attention is usually given to formal rules of perspective, including the use of various vanishing points, the examples given here are meant to stress the basic idea of the picture plane, which has been used to convey the quality of two-dimensional shapes as much as to convey the illusion of three-dimensional reality.

Fig. 134. *Chele,* Alan Garrett; linoleum cut. This sophisti-
cated work also stresses the flatness of the picture plane.

"Chele"

Garrett 71

Fig. 135. Ink drawing by Masimi Teraoka. The simply stated frontal aspect is flanked by two detailed lateral aspects. Without the details, the lateral aspects would not appear to be receding planes. The principle is simple: Less detail near the middle or frontal aspect of an object and more near its edges lends solidity and depth to the object.

Fig. 136. Pen and ink drawing by Patricia Howard. By using the devices of overlapping, linear thrusts, diminished size, and altered shape, the accumulated ellipses and circles achieve the groupings and spatial characteristics of leaves and berries.

Fig. 137. Pen and ink drawing by James Blankenship. The ridges and convolutions in the mountains, and the ragged lines in the field, follow the principle of overlapping, while the diminished size of the rocks and shrubbery in the background establish the depth of the picture plane. The curtailment of the lateral aspects of the design implies space beyond the picture plane.

Fig. 138. This illustration demonstrates that we cannot depend upon the contour or outline of an observed object and must carefully consider connecting lines indicative of inner mass, proportion, and planes. One of the first experiences with the picture plane that most of us have is in sketching two overlapping squares of equal size and then connecting the corners, thus creating the illusion of a transparent cube and simulating a three-dimensional object (A). Later, we learn that, by increasing the size of the front square (in this case the one at the right), we can introduce the visual device of perspective, allowing the cube to diminish in size as it recedes in the distance (B). If we omit the connecting lines, we have a basically neutral silhouette (C). By reintroducing some of the connecting lines, we can show a closed, solid cube (D). Or, by adding portions of additional connecting lines, we can show an open, boxlike object from the same point of view (E). Finally, by slightly altering the silhouette (increasing the square at the left rather than at the one at the right), and by drawing different connecting lines, we can show the same cube from another viewpoint (F).

One of the most intriguing methods of creating a three-dimensional illusion is the manipulation of the basically neutral silhouette form to indicate both the observer's point of view and the direction of each plane on the form's surface relative to the picture plane. In this regard, the placement of connecting arcs and angled lines within the silhouette is as crucial as the initial direction or angle of the silhouette on the picture plane (Fig. 138). This was previously alluded to in the discussion of overlapping circles (page 113).

121

at eye level,
viewed from left
of subject

at eye level,
viewed from right
of subject

above eye level,
front view

below eye level,
viewed from right

above eye level,
viewed from left

at eye level,
front view

Fig. 139. The silhouette and its apparent position on the picture plane may be controlled with tangents (angles) and arcs. In the series of drawings in the top panel, solidity is implied by first introducing an arc to the left side of the horizontal bar. By shifting the position of the arc to the right side of the horizontal bar, or to the vertical bar, the apparent position of the entire subject is altered. The series of drawings in the bottom panel adds drama by slanting the horizontal element of the silhouette. Again, by reversing the position of the arc in each design, a new viewpoint is forced upon the observer.

In Fig. 139, there are two initial silhouettes, one with a horizontally placed crossbar and one with an obliquely placed crossbar. The angle of each crossbar dictates a limit in the number of directions each bar can take, but note how the placement of connecting arcs within each silhouette alters the point of view and the direction of each bar. In Figs. 140 and 141 the device is applied to the human figure. In Figs. 142 and 143, we see the importance of the initial angle of the silhouette.

122

Fig. 140. Regardless of the subject matter, spatial relationships become relevant only through basic visual principles, some of which are not always evident. All of the oblique bars are in exactly the same position on the picture plane, but each appears to be in a drastically different position. The illusion is due solely to the placement of the connecting arcs within each silhouette. In the case of the human figure, the direction of each limb is similarly influenced by the placement of details within the form.

Fig. 141. The photograph of the model is seen as a neutral silhouette which can be manipulated by the judicious placement of curved lines to present either the front or rear of the form.

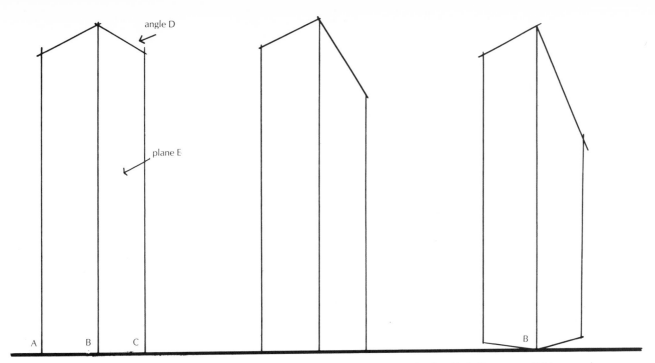

Fig. 142. The vertical lines (A, B, and C) are equally spaced in each diagram. By increasing the pitch of angle D in the second and third diagrams, the area of plane E seems to be increased. The visible form of the first two diagrams seems to be at or above eye level, which coincides with the heavy base line. However, in the third diagram, a slight upward angle drawn from medial line B to the lines A and C raises the eye level above the base line, so that part of the form appears below eye level.

Fig. 143. Relative to the average proportions of the human torso, oblique angle D in the first diagram is too horizontal for plane E. In the second diagram it is consistent. In the third diagram it is too vertical.

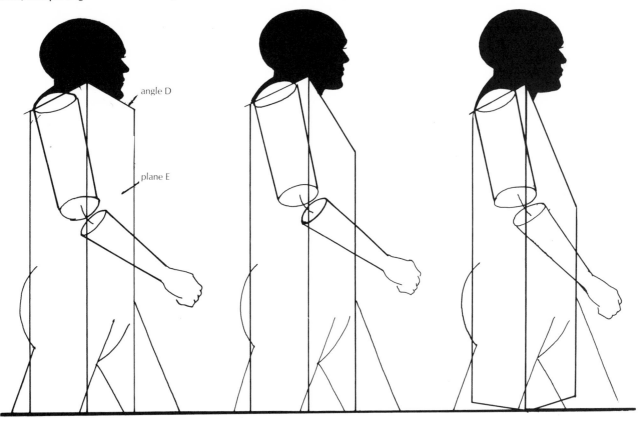

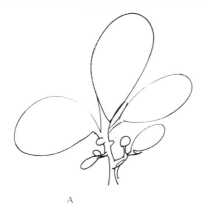

A

B

C

Fig. 144. *A:* Ink on a hard surface conveys an impression of precision. This swift, sure execution is lyrical in character.

B: Ink on an absorbent surface conveys a freer, less deliberate impression. Although the swift manner of execution is maintained, the lyrical quality is slightly blunted and the increased weight of line gains prominence.

C: Ink on a wet, absorbent surface conveys a spirited yet soft impression. The swift execution becomes a strong calligraphic statement and the impression of wetness becomes permanent.

THE CONCEPTUAL ASPECT

While the perceptual aspect of the picture plane is derived from man's visual powers — his ability to deal with concrete forms, the conceptual aspect is derived from man's ability to deal with abstract ideas. An evaluation of a drawing or painting that refers to its style, or to emotional or intellectual factors within its content, is in essence a comment upon its conceptual aspect. The conceptual aspect, like the perceptual one, can only be materialized by means of the physical aspect. Fig. 144 illustrates the interaction between the conceptual and physical aspects.

For the purposes of analysis, we can isolate each aspect in regard to a specific work of art, but all three aspects working together are essential to the import of the work. Taking Michelangelo's Sistine Chapel as an example, we can describe its physical aspect as an irregularly shaped plaster surface, highly absorbent in texture, of large dimensions and with varying contours; the colored pigments are wedded to the plaster in the fresco technique. Perceptually, the mural is composed of realistic figures which are strongly modeled with tone and highly dramatized through foreshortening. Conceptually, the work refers to the enormous struggles of mankind in a search for physical and moral perfection, the temporary setbacks and ultimate triumphs in a world tempered by divine justice. In sum, the work projects a sense of majesty and awesome power. The following illustrations are analyzed along similar lines.

Fig. 145. *Woman with Roses,* Mary Dietrich; intaglio, 4 by 9 inches. An analysis of the three aspects of the picture plane in this print would determine that its perceptual aspect is a flat, vignette design featuring a strong white pattern against a deep black background. Its conceptual aspect is to present a personal interpretation of either a witnessed or remembered image of simple beauty. Its physical aspect is the contrast of textured, ink-laden areas of paper against the pure, untouched shapes representing the garments.

Fig. 146. *Opening Night,* Joseph Mugnaini; oil painting, 60 by 85 inches. (Collection of Mr. and Mrs. Jan Cook.) *Concept:* Setting the tinsel-like honky-tonk opulence of a gambling casino in a somber mood. *Perceptual aspect:* A large rectangular shape flanked by smaller shapes submerged in chiaroscuro. *Physical aspect:* Thin glazes of color over a tonally accented and textured underpainting.

Fig. 147. Facsimile Rembrandt by Elizabeth Cox. *Conceptual aspect:* Rembrandt's art symbolizes a profound involvement with the human predicament. This is more than a self-portrait. It is man contemplating his own image, posing the eternal questions, ''Who am I; where am I going?'' For Rembrandt, existence was a brief moment of eternity; the human body a fragment of living matter in a vast, inorganic universe; his own reflection a composite of all humanity, a flicker of light within unfathomable darkness.

Perceptual aspect: A pattern of lights and darks. Light is in a minor role, presenting a spectacle of space in which a strongly illuminated shape dissolves into darkness. *Physical aspect:* Thin glazes of pigment applied in various stages over a strong pattern of textured, tonal passages.

Son of Man Adrian Van Suchtelen

Mixed media by Alvin Davis. This drawing exemplifies freedom in the use of materials and the unorthodox adaptation of the conventionally rectangular format. The use of simultaneous images on one picture plane is an innovation, no doubt influenced by cinematography.

Fig. 148. *Son of Man,* Adrian Van Suchtelen; intaglio. *Conceived* as a sensitive version of the conventional mother-and-child motif. *Perceived* as a pattern consisting of broad areas of darks modified by variations in tone. The flat shapes are contained within a curvilinear design. *Physical aspect:* There are two plates; the one containing the main figure is not quite joined to the other, which serves as a countershape. The untouched paper in between the separated plates becomes a tantalizing contradiction of the conventional picture plane.

131

8. EXPRESSIVE APPROACHES TO DRAWING

So far we have considered form primarily as a subject, using the approach of structural drawing to investigate the nature of human form in particular and to convey the results of our observations in an informative way. When we consider form as a medium for expressing abstract ideas, we have to consider drawing from the standpoint of conceiving and executing a design; that is, form must be presented in a way that conforms to the artist's intended statement. The physical, perceptual, and conceptual aspects of the picture plane must all be united. In this respect, I have found it useful to distinguish between four identifiable approaches to drawing: contained form, extended form, action drawing, and contour drawing. All of these approaches, however, are dependent for success on the proper reading of form gained through the practice of structural drawing.

CONTAINED FORM

The prime factor in conceiving contained form is the reduction of an apparently complex subject to a simple geometric shape. The result is strong, monumental imagery. Such imagery has prevailed in the design of sculpture and painting since early man first scraped symbols and pictures on pre-shaped stones (Fig. 149).

Fig. 149. The directness of contained form is demonstrated in this sketch of a Paleolithic stone carving.

132

Once the primary geometric shape has been established, the planes and edges within it are stated by freely slicing across the shape with lines that approximate the areas to be defined further. These areas are then conclusively developed as secondary and subsidiary shapes within the primary one (Fig. 150). The uniqueness of the contained shape derives from its dual image — the geometric primary shape, which conveys a monumental simplicity, and the secondary and subsidiary shapes, which conform to and complement the primary one.

Fig. 150. The primary shape is freely sliced into sections, forming subsidiary shapes. These correspond to the areas of the form that are to be defined further.

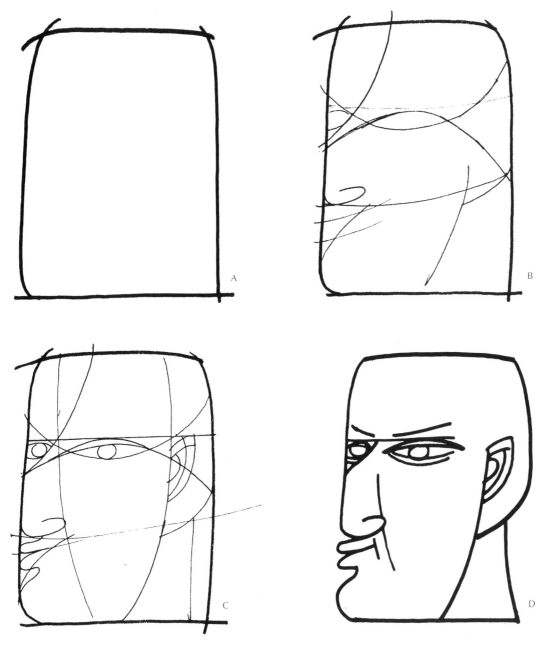

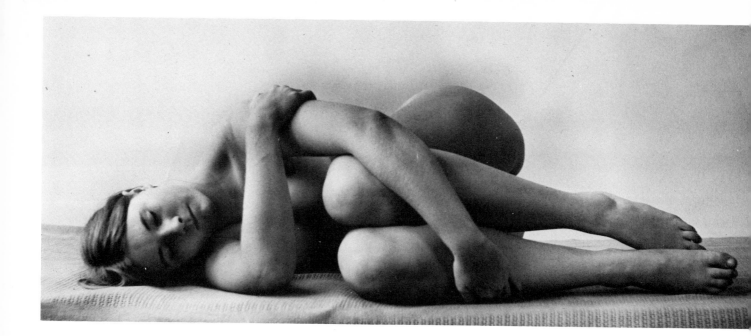

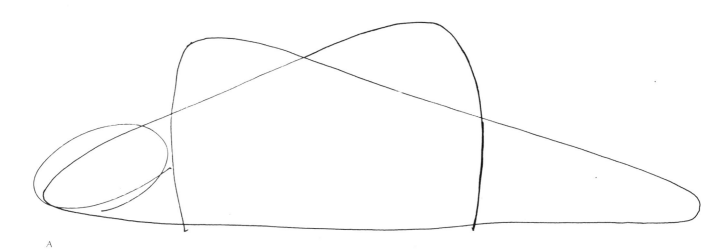

A

Fig. 151. A complex form, or a grouping of forms, may require the use of several geometric shapes functioning as one. The slicing strokes are then freely executed as before to obtain the secondary shapes.

Some subjects cannot be reduced to a single geometric shape. In that case, two or more geometric shapes may be combined to function as the primary shape, which may be analyzed and sliced into a basic linear statement (Fig. 151). This basic statement can be taken through additional phases, using line, tone, texture, or color according to one's own preference.

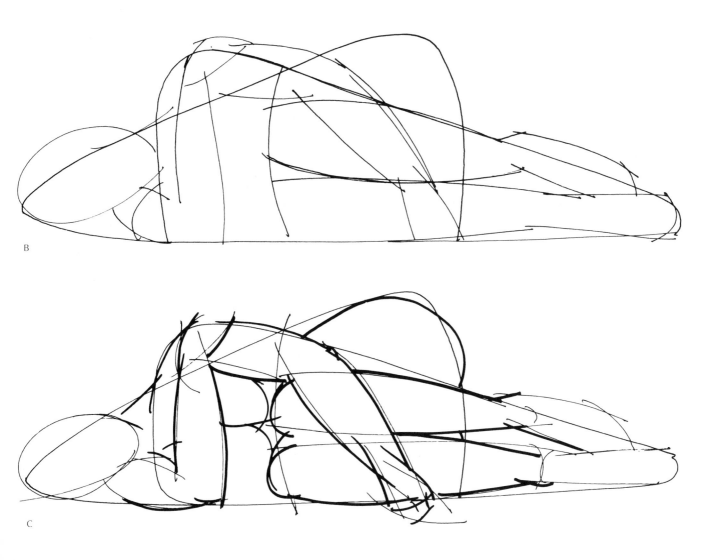

B

C

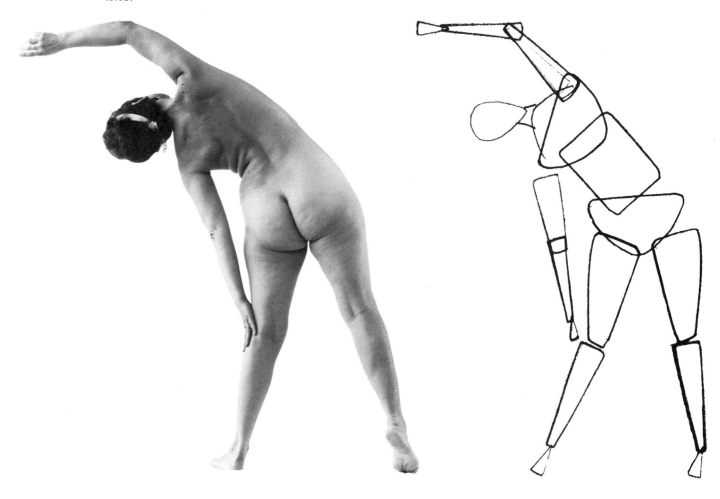

Fig. 152. The human form can be conceived of as a series of geometric shapes extending out from the nucleus of the torso.

EXTENDED FORM

Extended form is diametrically opposed to contained-form drawing. The latter approach required that the subject be conceived as a single entity, later to be qualified by detail. Extended form requires that an image or subject be developed by deliberately conceiving a section of an object as a nucleus to which each remaining section or part is added. The object is drawn by extending it section by section over the surface of the picture plane.

Taking the human form as an example, we can conceive of it as a sequence of fairly regular, geometric shapes (Fig. 152). Using the torso as the nucleus, and starting near the center of the picture plane, we can extend these shapes outward one by one until we develop the total form, to which we can add the basic contours of long and short arcs (Fig. 153).

Extended-form drawing is an unhurried and deliberately thought-out procedure. To become familiar with its premise, the student might make a template of the necessary geometric shapes (Fig. 154) and follow the edges in each opening with a soft pencil often enough to *feel* the basic character of each shape. When this has been accomplished, the template can be dispensed with and the shapes can be drawn without mechanical help.

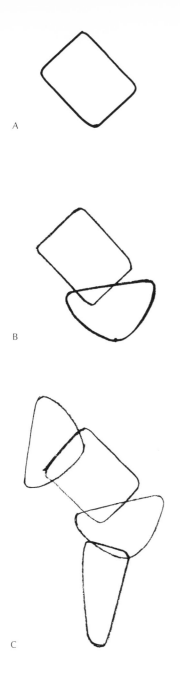

A

B

C

D

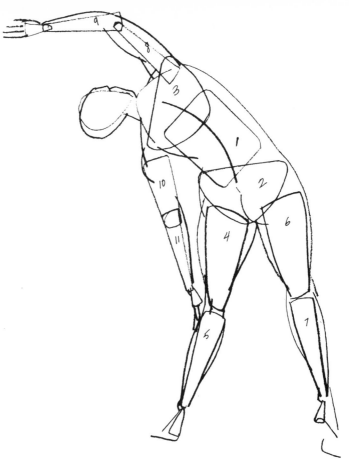

Fig. 153. The drawing progresses section by section.

Fig. 154. A template of the necessary geometric shapes can be cut from a sheet of cardboard. The openings can be cut with a mat knife or a razor blade.

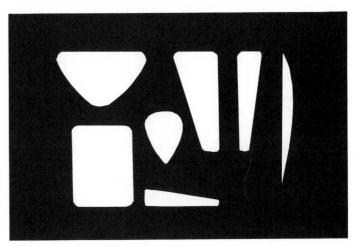

137

Although extended form drawing per se has not been exclusively used as an approach in art, it has been adopted by almost all artists at one time or another to help resolve specific problems. Many drawings by old masters, for example, show that a particular element in a study was solved by first reducing a complex area to a simplified shape, so that it related well to other sections of the design, before the details of the form were added.

Figs. 155 and 156. The template shapes are appropriately modified to show foreshortening. Although the template itself is merely a learning device, the concept of reducing complex form to geometric sections is useful in clarifying problems within a design.

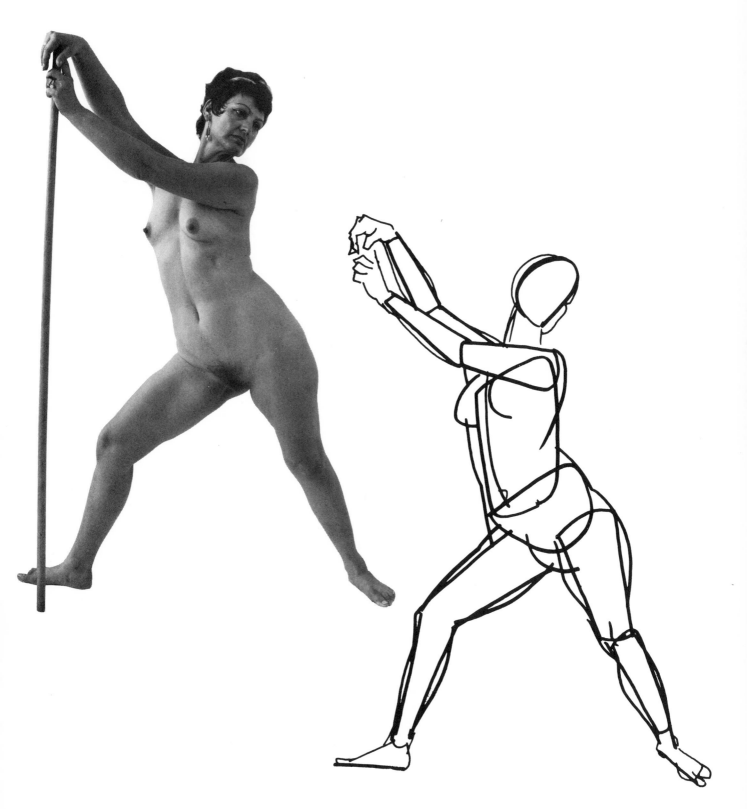

Fig. 157. Facsimile of an action drawing by Eugène Delacroix.

ACTION DRAWING

In contrast to extended form, action drawing relies on rapid, intuitive movement. The term action drawing may be misleading, however, if it is linked exclusively with the action-painting movement. Action drawing certainly is not a recent development; artists have used its free, animated approach for centuries. It is essentially calligraphic in nature, an approach in which each artist exhibits individual tendencies through subconscious, reflex-action movements. Form is neither dissected nor ex-

panded, but is energetically transmitted.

Figs. 157 and 158 are facsimile drawings of studies that were completed for more ambitious projects. One is by Eugène Delacroix, the other by Eugene Berman. In each, an equestrian subject is suggested; yet the significant content is the overall design and the visually exciting, animated calligraphy. One can almost follow the development of each drawing by analyzing the angles and the various pressures of the pen as it was used to probe and thrust for the inner image through observed or remembered structure.

Fig. 158. Facsimile of an action drawing by Eugene Berman.

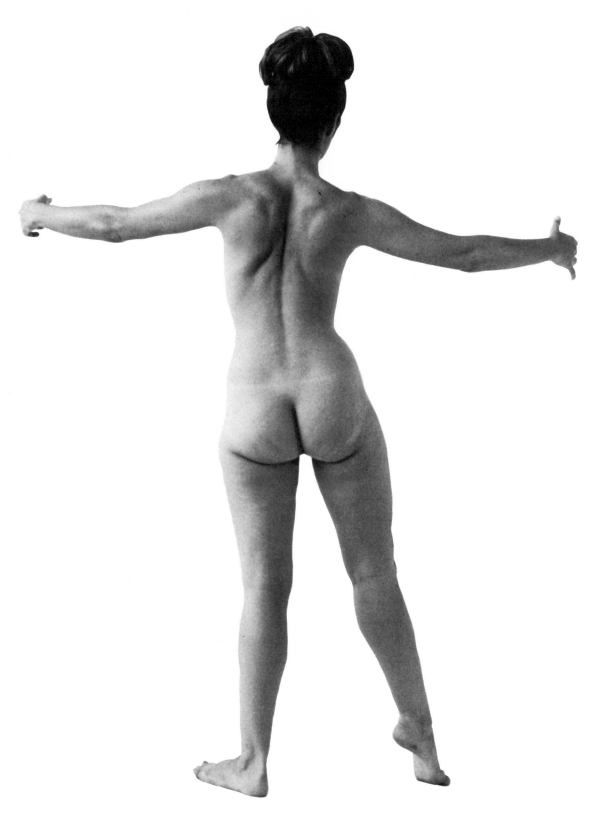

Fig. 159. The model in the photograph was used as the basis for two action drawings. The first was begun with linear thrusts establishing the structural basis, and the second was executed entirely with rapid, calligraphic strokes.

As a controlled exercise, the student may pose a model, or study a photograph of the human form (Fig. 159), and use the following method: Imagine that the pen is a sharp cutting instrument and that you are about to carve

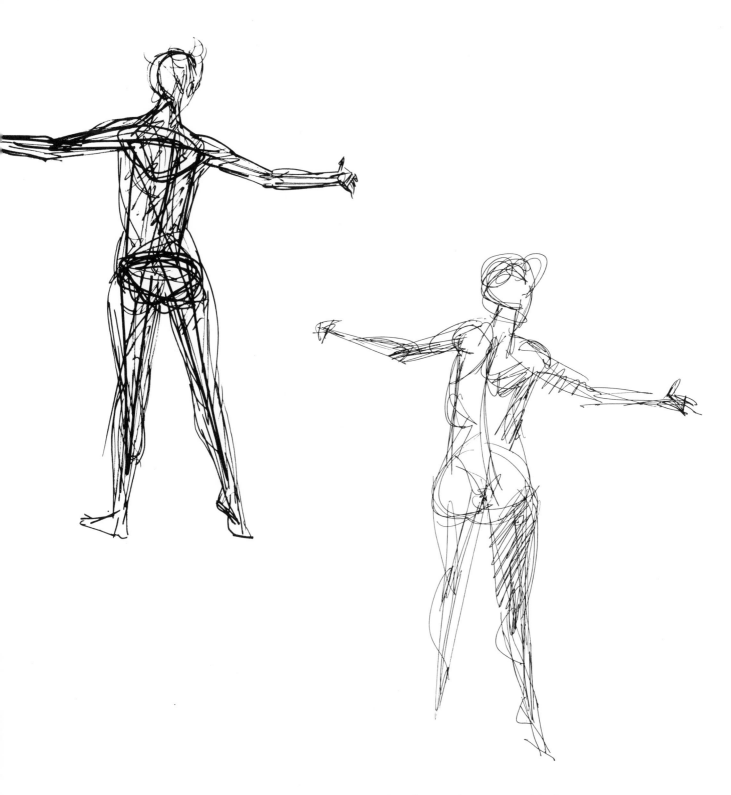

out of your subject the pelvic and pectoral girdles. Transfer this concept to the pen in terms of pressure. Quickly circumscribe the general shape of the pelvis, and, still exerting pressure, strike upward along the spine for the shoulders.

Keeping the pen in contact with the paper at all times, strike back again toward the pelvis, shaping each side of the torso. Next, quickly thrust out of the torso, probing the length of the limb systems. You will have quickly stated the human frame in this pose.

The remainder of the drawing should be completed intuitively and with a greater freedom of line — with the thought that, in this case, the act of drawing is part of its content. In the second part of Fig. 159, the preliminary structural thrusts of the controlled exercise have been bypassed and the entire drawing has been conceived and executed with freely moving strokes. Fig. 160 indicates the importance of establishing and maintaining momentum in action drawing.

Fig. 161. Anatomical study, by Al Porter; pen and ink, 10 by 14 inches. This is not a careful study but a graphic exclamation emanating from familiarity with the subject.

Fig. 160. *Old Man,* by Robert Chuey; pen and ink, 18 by 24 inches. This was derived from memory and was completed in approximately three minutes. The intense attitude of the artist is transferred to the paper through the agitated but unhesitating lines. Although the pen was lifted from the paper at times, the momentum established at the beginning was never totally broken. The act of drawing, including the use of a finger to spread wet ink emphasizing shapes in the drapery and in areas surrounding the figure, was essential to the image.

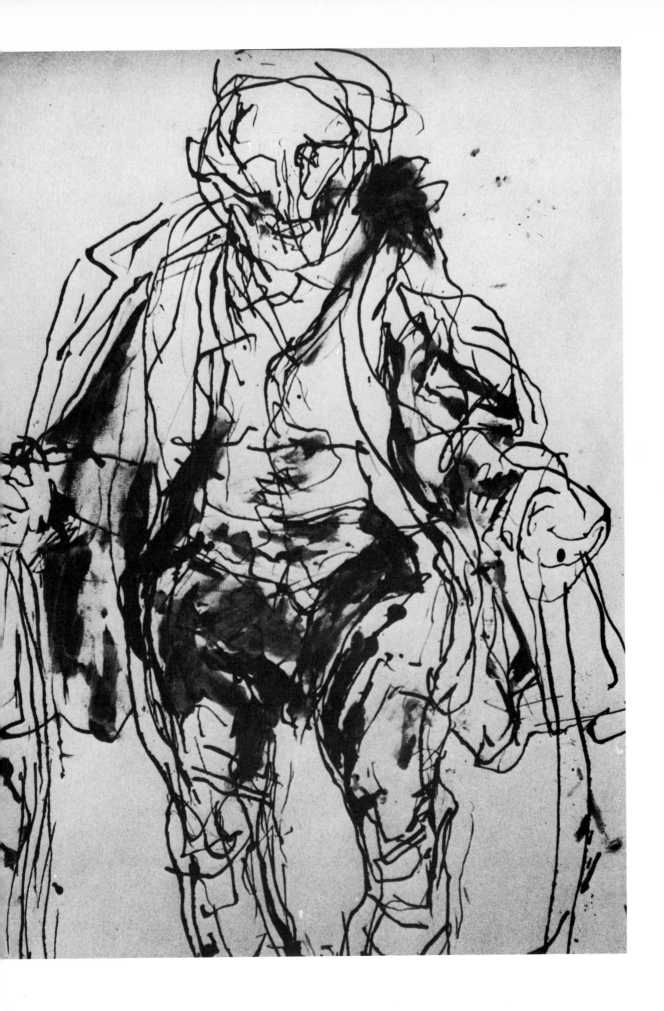

Fig. 162. *A* is a rough outline of the North American continent. *B* is the result of a common tendency for the beginning student to focus attention upon the left and right edges of an observed object with little regard to either its inner mass (or area) or its upper and lower regions. The result is a laterally compressed shape. *C* demonstrates the draftsman's method of reducing three-dimensional volume and mass to a two-dimensionally conceived area serving as a base for the irregular outline.

CONTOUR DRAWING

It is unfortunate that contour drawing is too often thought of as a tediously rendered outline graphically separating a three-dimensional object from the space which surrounds it. Contour drawing is not the result of copying the edges or contours of an object; it is an approach to conceiving and interpreting the form through the element of line.

The spirited, expressive quality of contour drawing results from an astute appraisal of the observed form as to both its general shape and the specific fluctuations formed by its projec-

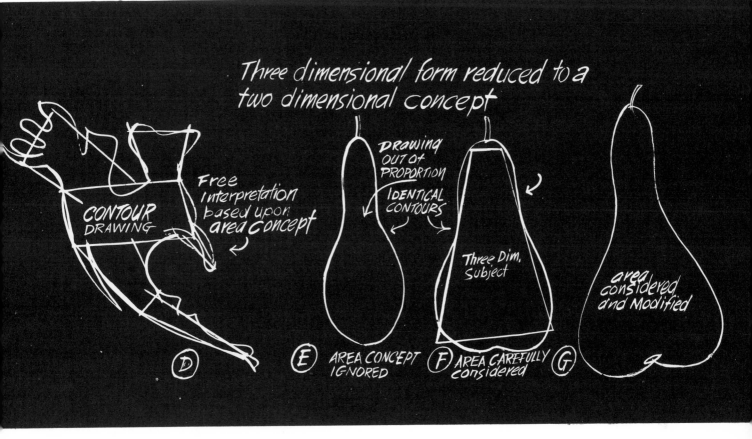

Three dimensional form reduced to a two dimensional concept

CONTOUR DRAWING

Free Interpretation based upon area concept

DRAWING OUT OF PROPORTION

IDENTICAL CONTOURS

Three Dim. Subject

area considered and Modified

D

E AREA CONCEPT IGNORED

F AREA CAREFULLY considered

G

Fig. 163. *D* is a free, linear interpretation of the total form with careful consideration of its mass. *E*, *F*, and *G* demonstrate the application of the area concept to a symmetrical, curvilinear subject.

tions and recessions, angled planes and curved surfaces. A sound evaluation becomes a difficult achievement unless we conceive of the form as having a definite area whose boundaries serve as the basis for the irregular contours. To illustrate this, let us first consider an irregularly shaped two-dimensional form (Fig. 162). It is obvious, in the drawing of a map, that properly conceived areas are as essential as accurately detailed contours. Once the area has been properly evaluated, the lines corresponding to projections and recessions may be drawn as freely as desired (Fig. 163).

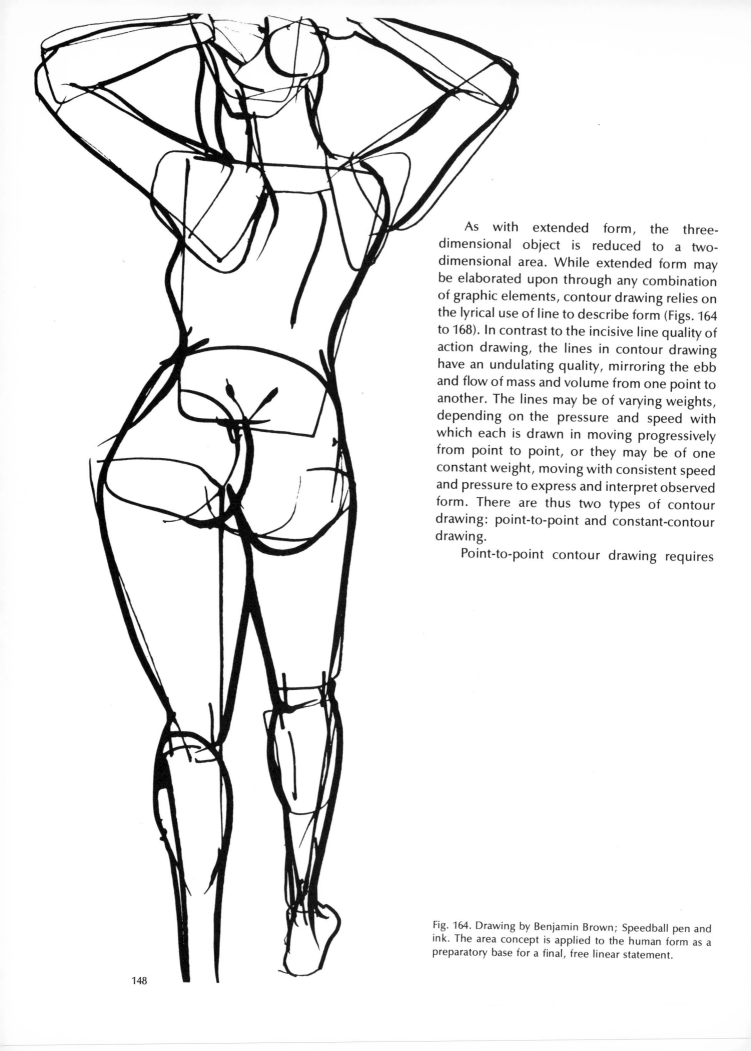

As with extended form, the three-dimensional object is reduced to a two-dimensional area. While extended form may be elaborated upon through any combination of graphic elements, contour drawing relies on the lyrical use of line to describe form (Figs. 164 to 168). In contrast to the incisive line quality of action drawing, the lines in contour drawing have an undulating quality, mirroring the ebb and flow of mass and volume from one point to another. The lines may be of varying weights, depending on the pressure and speed with which each is drawn in moving progressively from point to point, or they may be of one constant weight, moving with consistent speed and pressure to express and interpret observed form. There are thus two types of contour drawing: point-to-point and constant-contour drawing.

Point-to-point contour drawing requires

Fig. 164. Drawing by Benjamin Brown; Speedball pen and ink. The area concept is applied to the human form as a preparatory base for a final, free linear statement.

both concentration and a relaxed manner of execution. The form is alternately assessed and drawn in stages, so that a period of concentration is followed by a free, uninhibited statement. The total process may be compared to crossing a stream of water by stepping on the exposed surfaces of stones lying in its bed. First, you must appraise the expanse of the area you wish to cross and the general distribution of the exposed surfaces that might provide a route. You would then alternate your activity between mentally gauging the distance from one stepping-stone to another and physically moving from one to the other in succession until you had covered the expanse. The stepping-stones of a form are the points that provide an obvious resting place for the eye as it travels over it and therefore for the line as it reconstructs the route.

Fig. 165. *Reclining Woman,* William Zuidervaart; ink and brush. Contour drawing based on moving with varying speed and pressure from point to point.

Fig. 166. *Female Figure,* David Starrett; conte crayon, 18 by 24 inches. The varying weights of line indicate that this is also a point-to-point contour drawing.

150

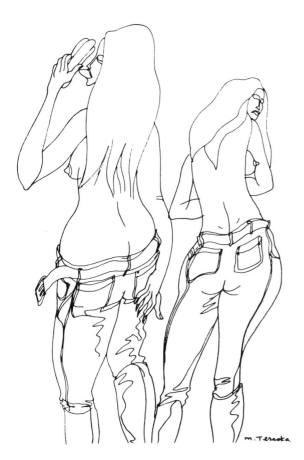

Fig. 167. Drawing by Masami Teraoka; pen and ink. Consistency in the weight of line indicates that the speed and pressure of the pen were also constant.

Fig. 168. *Figure,* Nancy Foote; brush and ink. The brush as well as the pen is responsive to varying pressure.

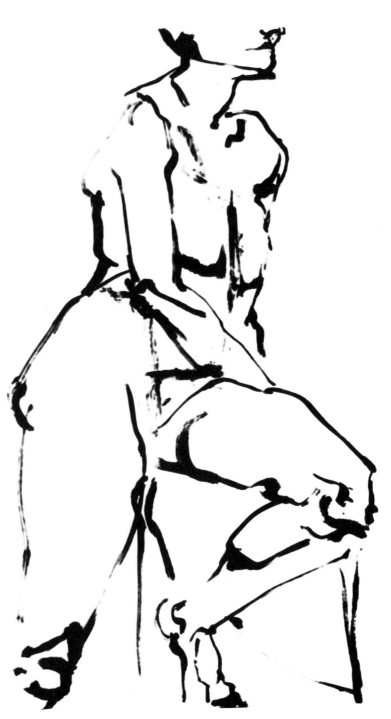

The following exercise demonstrates the nature of contour drawing: line is first programmed and then realized with a direct pulling motion. Line is not pushed. The equipment consists of a long, thin bamboo twig and a large sheet of paper. The medium is ink placed in a wide-mouthed container with a small amount of water added. The stick, like the template used for extended form, is a device, it emphasizes the importance of pulling each stroke from point to point. The end of the stick is sharpened to receive the ink. The actual drawing is done with the arm in a rigid position and each stroke is pulled with the whole body.

The subject is a leafy twig from a nearby shrub (Fig. 169). The first step is to look at it carefully, sensing its total character. The object is not to duplicate it, but to express a variation of its general aspect, in the same way that a composer plays upon an established theme. The edges of the leaves suggest both simple and compound curves, both long and short ones. The drawing is begun by pulling the twig in a simply curved path from the tip of one leaf to its base. A compound curve is then drawn opposite this, beginning from the same point and ending slightly to the left of and below the termination of the first curve. The next leaf is begun in the same way (Fig. 170).

Fig. 169. The subject for the demonstration in point-to-point contour drawing is a leafy twig.

Fig. 170. The long, sharpened stick is dipped in ink and is pulled from point to point with the arm in a rigid position.

Fig. 171. By increasing pressure on the twig, the weight of the line is increased.

Figs. 172 to 174. By alternately assessing the form and adding the appropriate line, the drawing is executed in deliberate stages but with uninhibited strokes.

In Figs. 171 to 174, the drawing emerges in stages. Although each step is complete in itself, it is also a part of a preconceived totality. The object is to vary the shapes and use them for a free expression. Pressure on the twig and the speed with which the lines are drawn are also varied to lend variety in the weight of the lines. Fig. 175 is the completed drawing.

Fig. 175. The completed contour drawing.

155

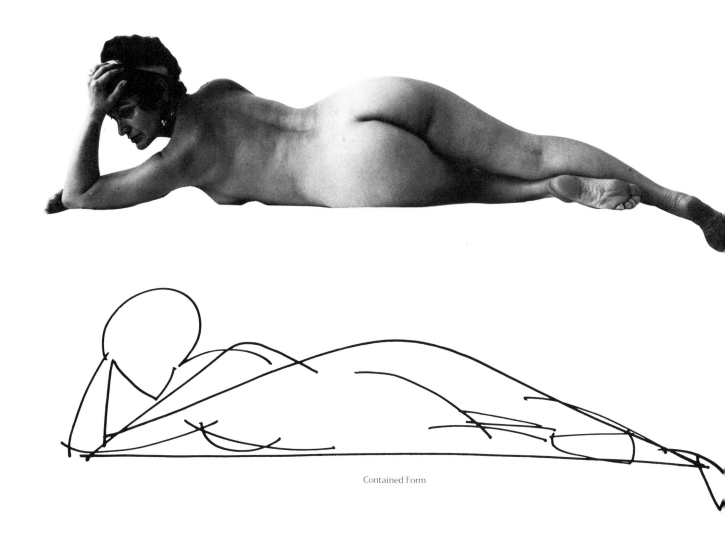

Contained Form

When the thickness or weight of the lines, and the rate of speed at which the drawing is developed, are kept constant, the effects are quite different. Constant-contour drawing usually involves more detail and the technique lends itself to extremely elaborate linear designs and patterns. Aubrey Beardsley and William Blake often developed their illustrations through constant-contour drawing.

In summarizing these four approaches to drawing, and in differentiating between them, we can say that, in using contained form or extended form, the artist is dealing with shape in diametrically opposed ways, while in using action drawing or contour drawing, he is dealing with line in diametrically opposed ways. The preference for one approach over another must be developed by the artist gradually and naturally, and in accordance with his individual needs. This calls for a great measure of experimentation, not only in dealing with form as a medium, or in dealing with the various aspects of the picture plane, but also in handling the graphic elements that are universally recognized as communicative symbols.

156

Fig. 176. These drawings, all based on the same pose, demonstrate the four approaches we have been discussing. It is obvious that the impact of each is different and that the suitability of one over another is a matter of personal choice or need for the particular artist.

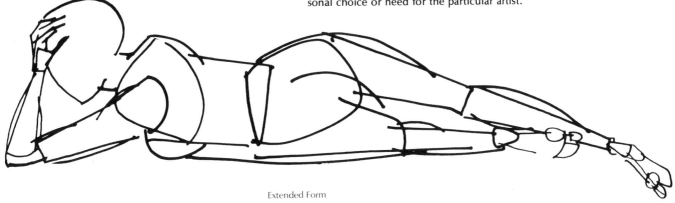

Extended Form

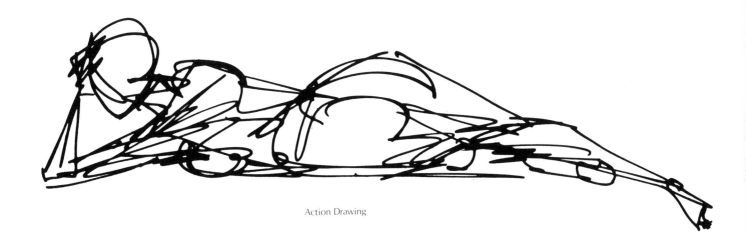

Action Drawing

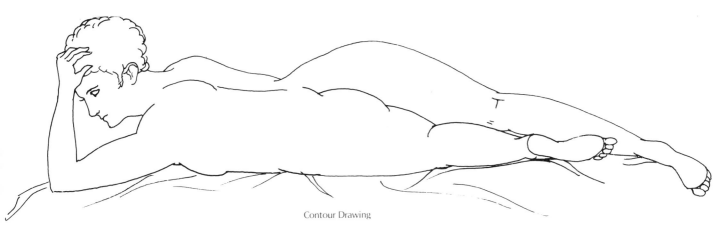

Contour Drawing

9. THE GRAPHIC ELEMENTS

Each form of art has its own system of communication based on its own set of recognizable elements or symbols, and these elements are activated by a physical medium. The elements of rhythm, motion, and time, for example, are incorporated into the art of dance and are activated through the medium of the human body. The visual arts of painting, graphics, and drawing, on the other hand, are based on the elements of line, tone, texture, and color, each of which may be activated through a great variety of physical mediums, such as pencil, ink, watercolors, oils, pastels, and so forth.

The method adopted by each artist in controlling his chosen medium may be referred to as his technique or style. His knowledge of and his manner of using the *elements* of a particular art form may be referred to as his idiom or vocabulary. The eloquence of an artist's work is dependent upon the thought behind his effort, the degree of skill in using his medium, and his aesthetic sense in the selection and control of the expressive elements.

LINE

The use of line, tone, texture, and color varies only slightly between graphics, painting and drawing. All three disciplines are closely related, especially today when various mediums are combined to stimulate versatility and a wider range of expression. For the sake of clarity and simplicity, however, let us consider drawing as an art in which color is used in a relatively limited sense. Let us also keep in mind that drawing may be considered from two aspects.

First, as we have seen, drawing is a probing, investigative device to search out and understand the structural nature of perceived shapes. In this aspect, the element of line played an indispensable role. Second, drawing is an art form ranking with music, sculpture, and literature in expressing the most sensitive, profound and significant concepts of man. Here, too, line is essential as the most prevalent, most universally used graphic element.

Although, up to this point, we have used

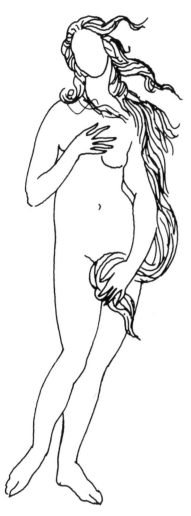

Fig. 177. Although the painting *Birth of Venus* by Botticelli is composed of subtle passages of tone and delicate nuances of color, this tracing of a detail reveals that Botticelli's art is essentially linear in character.

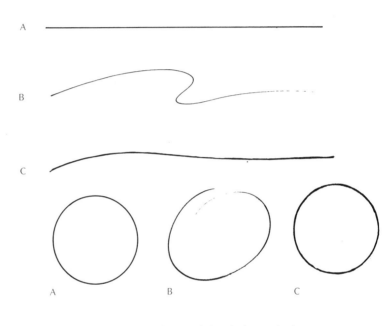

Fig. 178. In example *A*, the line and the circle are both mechanically drawn. Each can be easily duplicated. In *B*, the line and the circle are spontaneous statements; each conveys a dynamic image of swiftness. Each statement is direct and unique and cannot be easily duplicated. In *C*, the line and circle are deliberate statements. Each can be closely duplicated.

line primarily as an analytical device to indicate the dimension, position, and structural character of form, and thus translate the appearance of a physical reality into a graphic scheme, we have seen that line can also be lyrical and expressive, conveying qualitative information beyond the physical reality. The expressive character of line seems to be innately recognized. The first drawings of children, as well as contemporary primitive art and the earliest

traces of pre-historic art, are all linear in character. Paintings may also rely on line as the predominate graphic element (Fig. 177). In Fig. 178, three simple examples, using both straight and curved lines, indicate how the quality of line changes and conveys different feelings. The following fourteen drawings all show the use of one or more of these basic approaches to quality of line.

Fig. 179. When the lines are mechanically drawn, the image is rather abstract and the emphasis appears to be not on the lines themselves but on the juxtaposition of shapes formed by the lines.

Fig. 180. Action drawing by Robert Chuey. The spontaneous, agitated quality of the lines contributes to the impression of spirited animation.

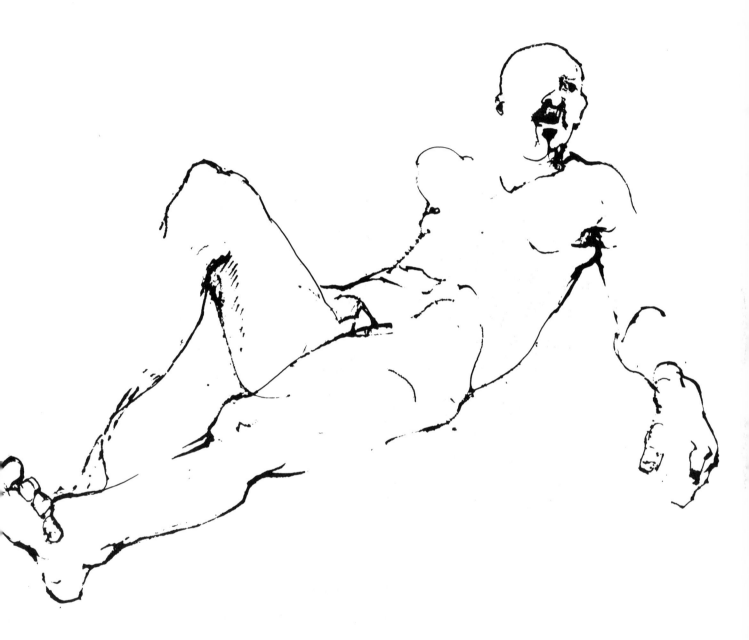

Fig. 181. Figure by Barbara Chenecek; pen and ink; point-to-point contour drawing. The deliberate but selective and varied movement of line from point to point implies a lyrical rise and fall of tempo in accordance with the form.

162

Fig. 183. Ink drawing by Masimi Teraoka. In this satirical statement commenting on contemporary social values, the contour is not only deliberate but constant as well. The concentration of detail at the left and top regions of the design, however, adds a note of activity and agitation, and lends an appearance of solidity.

Fig. 184. *Portrait of Renato Alvino*, Pietro Annigoni; ink on gesso. This drawing incorporates two approaches. The contours of the face and the details and modeling of the forehead, spectacles, and nose are deliberate, while the quick, uninhibited strokes indicating the skull and hair are energetic and free.

Fig. 182. *Seated Woman*, Susan Bravender; mixed media, including collage. While tone and texture play important roles in this well-planned composition, the linear statement is active and penetrating, and line is the prime visual element.

Fig. 185. Ink drawing by Patricia Howard; 20 by 14 inches. In this case, the short, linear thrusts are concentrated to indicate *tone*, so that the overall impression is of a design that is based on sharply contrasting areas of black and white. This is, therefore, not a line drawing in a true sense, although linear thrusts and movements were used in developing its composition.

Fig. 186. Drawing by Dorothy Merk; ink and mixed media. Here, although tone and texture are used to complement line, it is the linear elements that control the attention of the viewer. Both mechanical and deliberate lines are combined in this design.

Fig. 187. *Matador*, George DeGroat; etching with aquatint. The flowing but carefully controlled lines move in and out of the tonal areas of the composition, delineating shapes and regulating the design.

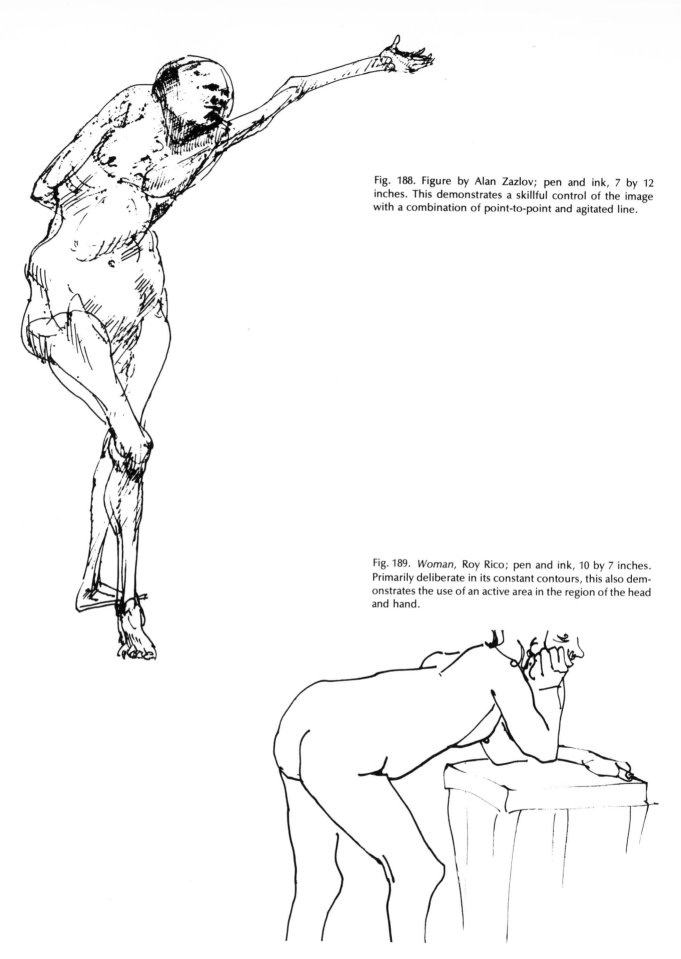

Fig. 188. Figure by Alan Zazlov; pen and ink, 7 by 12 inches. This demonstrates a skillful control of the image with a combination of point-to-point and agitated line.

Fig. 189. *Woman*, Roy Rico; pen and ink, 10 by 7 inches. Primarily deliberate in its constant contours, this also demonstrates the use of an active area in the region of the head and hand.

Fig. 190. *Laundry*, Kay Lew; pen and ink. A very deliberate, constant contour drawing in which detail is essentially considered as relatively stable, gray patterns held together with line.

F. Gilot

Fig. 191. *Head,* Françoise Gilot; brush and ink, collection of Mr. and Mrs. Sam Jaffe. Controlled lines in both constant and varying weights are used to achieve an interesting calligraphic pattern.

Fig. 192. *The Group,* Nancy Hughes; rapidograph pen. This contains both deliberate and agitated lines. Notice how the main, relatively stable and open shapes are counterbalanced by closely knitted areas of detail.

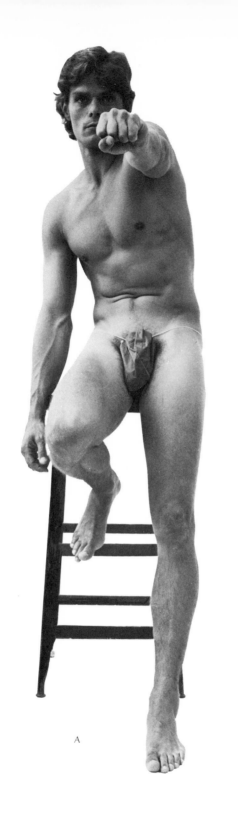

A

B

Fig. 193. In *A*, the model is represented by a photographic rendition of line and tone. In *B*, an outline of the photograph projects a flat image of the general shape. In *C*, the prime tonal factor, or spatial toning, places the thighs, legs, and arms, and the long planes of the torso, in their respective positions. In *D*, the second tone shapes or models the various forms.

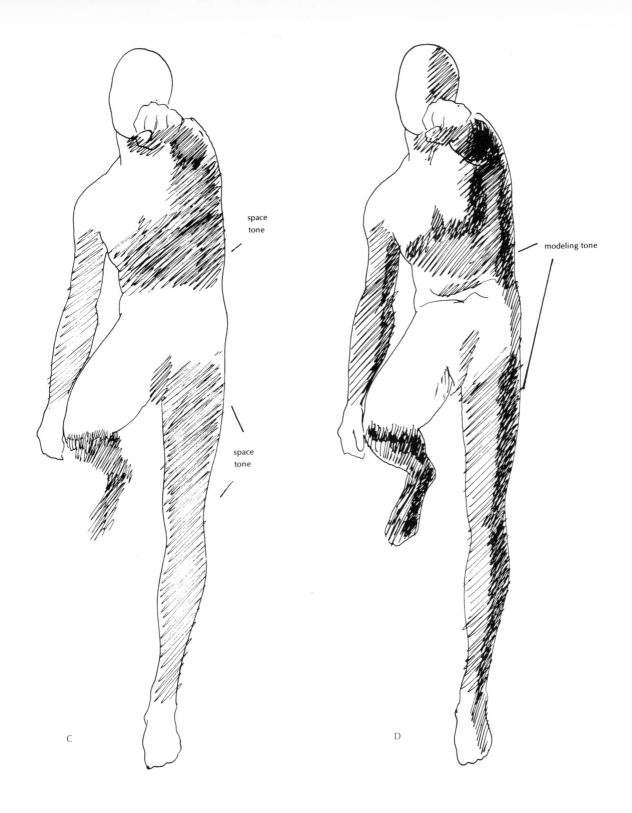

space
tone

space
tone

modeling tone

C

D

TONE

As we saw in Chapter 1, information about the physical world can be conveyed through tone (light and shade) as well as by line. While line is eminently suited to probing the underlying structural qualities of form, tone is inherently more suited to suggesting the plastic qualities of and spatial relationships between various forms. Thus, as an investigative device, tone has two aspects: spatial tone and modeling tone. Spatial tone establishes the position of a plane or an object in space and also the distance between the forms, and modeling tone establishes the changes in direction on the surface of the form (Figs. 193 and 194).

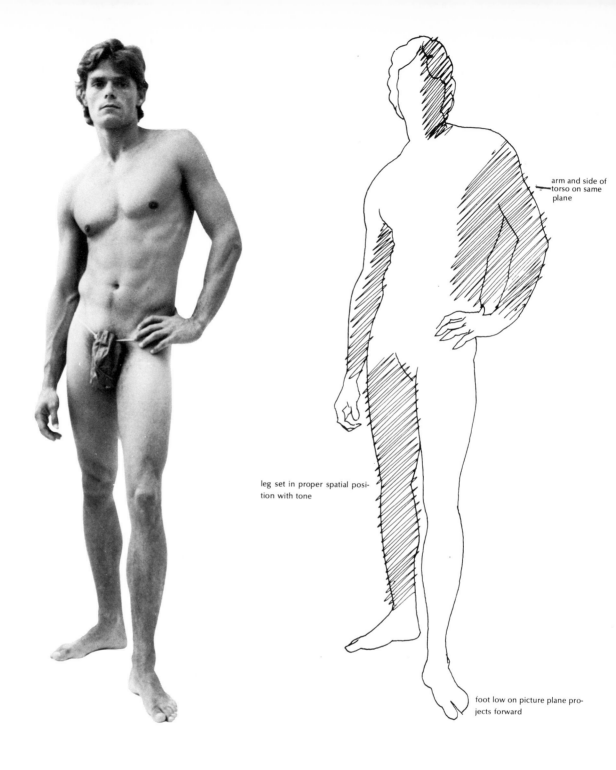

arm and side of
torso on same
plane

leg set in proper spatial posi-
tion with tone

foot low on picture plane pro-
jects forward

Fig. 194. As long as the spatial toning has been properly
related to the observed shapes and establishes the position
of each form, the secondary and subsidiary modeling tones
will easily conform.

Like line, tone provides a visual translation
of our tactile experiences concerning form.
These experiences range from that of absolute,
uninterrupted solidity to that of absolute, unin-
terrupted space. In delineating form, angled
lines depict abrupt interruptions in solidity and
curves indicate gradual changes. Similarly,
tone may also indicate abrupt or gradual
changes.

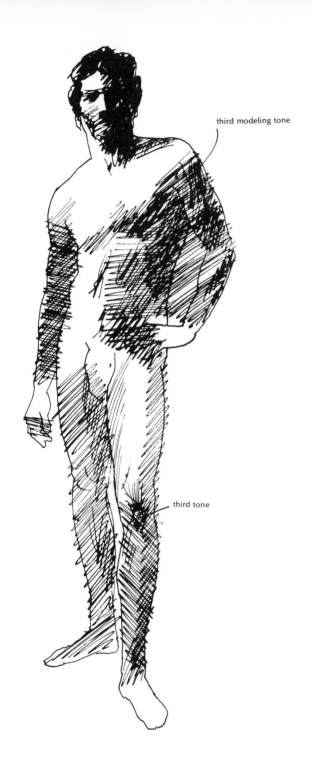

third modeling tone

third tone

Generally, sharply contrasting tones indicate that the surface being described contains abrupt changes, while softly gradated tones indicate that the surface changes are gradual. However, tone is strongly influenced by several other factors, such as the direction and quality of the light illuminating the subject and whether the surfaces absorb or reflect this illumination. Thus, while a sphere of plaster may

173

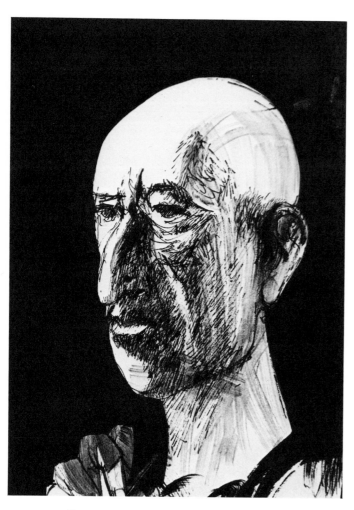

Fig. 195. *Stravinsky,* Joseph Mugnaini; pen and ink with wash, 12 by 18 inches. Sharp contrasts in the black and white areas are used to project a dramatic concept.

Fig. 196. *Cast Drawing,* Charmaine Moo; charcoal, 12 by 16 inches. A similar subject rendered in soft gradations reflects atmospheric lighting.

174

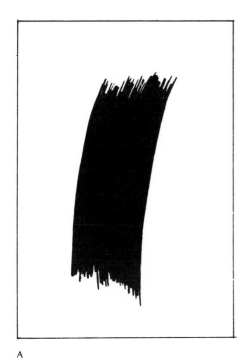

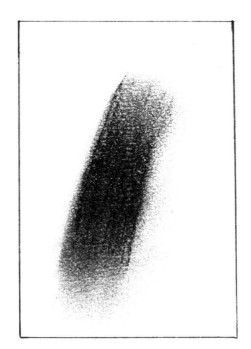

A B

Fig. 197. This diagram illustrates two different adaptations of the picture plane. In one case, the brush stroke is sharp-edged and solid, while in the other the stroke is blurred at the edges and allows the whiteness of the paper to show through. The stroke in *A* conveys a sensation of solid black against solid white; the picture plane remains flat and there is no indication of atmosphere. In contrast, the blurred stroke in *B* conveys an impression of dark against light; the variance in solidity suggests unoccupied space and adds atmosphere and depth to the picture plane.

be depicted by gradually changing tones, a sphere of shiny metal may have sharply contrasting tones; and two similar subjects may be depicted differently under different lighting conditions (Figs. 195 and 196).

In addition to being sharp-edged or gradual, tone may be solid or diffused (Fig. 197). Note that the more complete the solidity of the tone itself, the less there is an impression of depth, which is dependent upon an interaction of solid form and unoccupied space. This points out the two ways in which tone can be used to control the picture plane, either to maintain the original two-dimensional quality

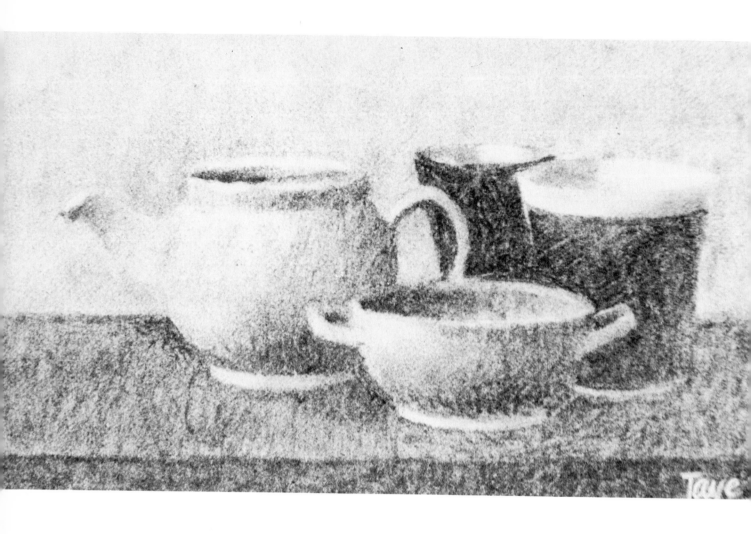

Fig. 198. *Still Life,* John Taye; charcoal, 20 by 10 inches. The use of diffused tone aids in establishing the three-dimensional illusion. This is a dark-and-light approach.

or to create an illusion of depth (Figs. 198 and 199). This also leads us to the aesthetic use of tone in the overall composition.

Whether tone is solid or diffused, it ranges in value between two extremes. Solid tone has as its extremes black and white, while diffused tone ranges from dark to light. Each set of values can be represented by a scale and each allows its extremes and intermediaries to be used in various ways for different psychological impact (Figs. 200 and 201).

Fig. 199. Drawing by Arnold Mesches; pen and ink. Solid
tone and contrast of absolutes maintain the two-
dimensional quality of the picture plane. This is a black-
and-white design.

Solid Tones
(black and white)

Diffused Tones
(dark and light)

Extreme High Range

Extreme High Range

Intermediate High

Middle Range

Middle Range

Intermediate Low

Low Range

Low Range

Fig. 200. This reference chart shows the range of values for both solid and diffused tones.

At one end of the scale, there is the use of predominantly light (or white) tones offering little contrast yet producing a pattern in a high key. At the opposite end, there is the use of predominantly black (or dark) tones offering little contrast and producing an impression of a low-key pattern. Between these two extremes, there is the full-range use of tones from light to dark (or black to white) providing the contrast of tones normally experienced and producing an impression of balance. In addition, when middle tones predominate, we approach the low-key range. When a light (or white) tone predominates but the dark or black tone is supported by a middle tone, we are midway between high key and normal contrast (Fig. 201).

Fig. 201. Another reference chart indicates how the various tones on each scale can be combined in a single design.

178

Solid Tones Diffused Tones

Extreme High Range Extreme High Range
white is dominant light is dominant

Full Range Full Range
with black in minor role with dark in minor role

Full Range Full Range
with white in minor role with light in minor role

Middle Tones Predominate Middle Tones Predominate

Extreme Low Range Extreme Low Range
black is dominant dark is dominant

Solid Tones Diffused Tones

179

Fig. 202 is based on the extremes of black and white, resulting in a two-dimensional use of the picture plane, and shows normal contrast. Fig. 203 is similar but has some diffused modeling tone added and has some depth to

Fig. 203. *Woman*, Ingrid Royer; charcoal, pencil, and shellac. Solid and diffused tones; normal contrast.

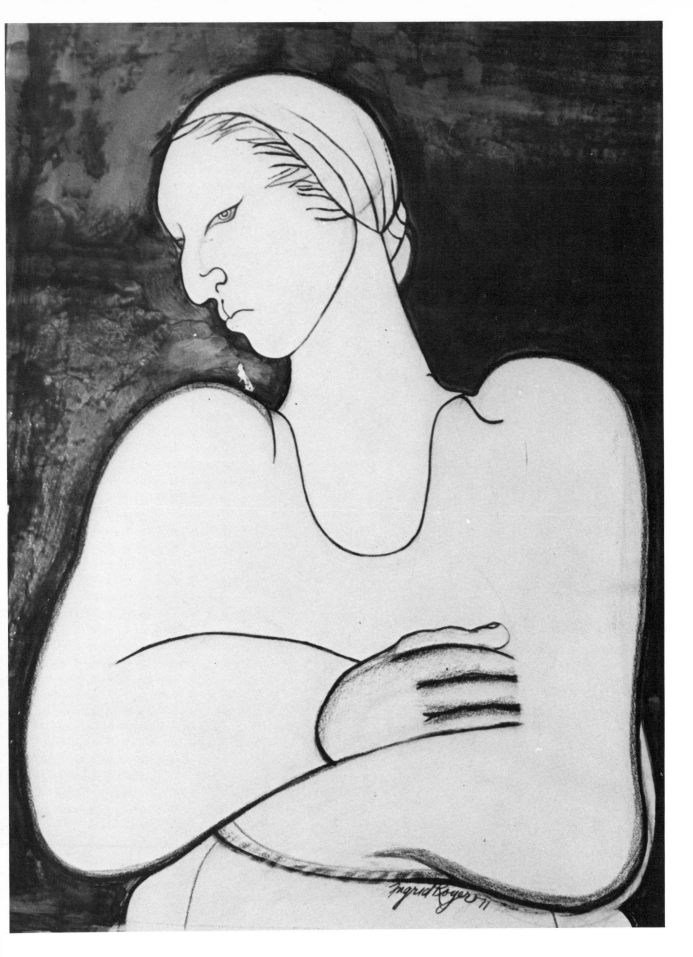

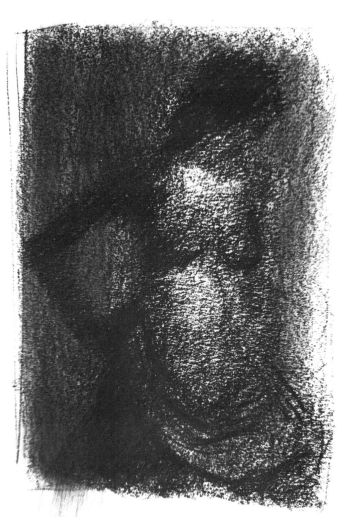

Fig. 204. *Semi-Draped Figure,* Marie Starr; charcoal, 8 by 12 inches. Diffused tones; low-key.

Fig. 205. Figure drawing by Arlene Whiting; charcoal. Diffused tone; medium-high key. This is an excellent example of combining line and tone to express solidity and shape. The tone here is primarily spatial.

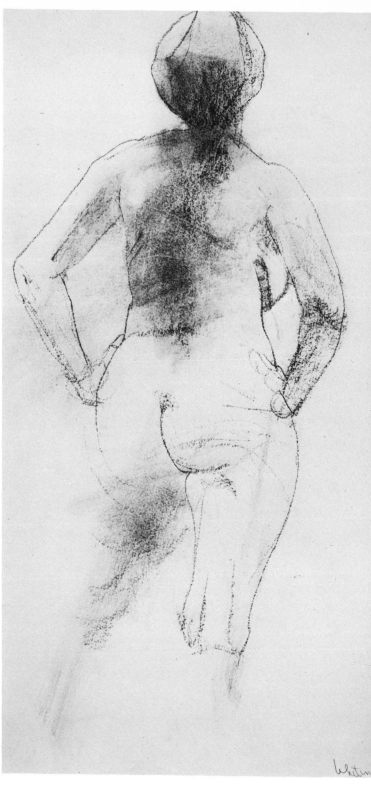

the picture plane. Figs. 204 and 205 are both of diffused tone, but the former is low key and the latter is medium-high key. Figs. 206 and 207 are both of almost normal contrast and each contains somewhat diffused spatial tones. Figs.

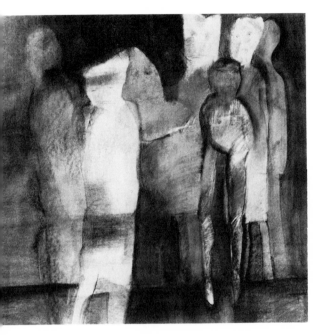

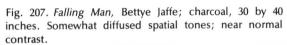

Fig. 207. *Falling Man,* Bettye Jaffe; charcoal, 30 by 40 inches. Somewhat diffused spatial tones; near normal contrast.

Fig. 206. *Figures,* Skip Storms; charcoal, 24 by 18 inches. Diffused tone; near normal contrast.

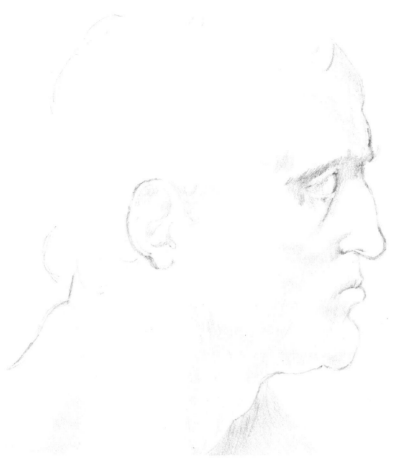

Fig. 208. Pencil study by Robert Mackie. Diffused tones;
high-key.

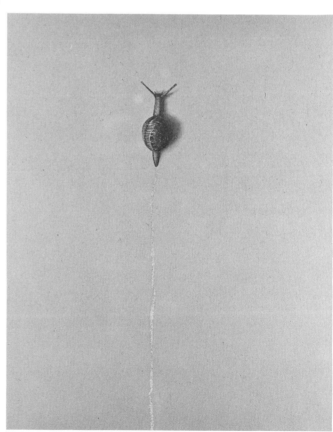

Fig. 209. *Snail*, Arnold Walter; acrylic paint, 24 by 30
inches. Solid and diffused tones; high-key.

Fig. 210. Abstract lithograph by Walter Hubert, 7 by 9 inches. The lithography crayon is a valuable medium enabling values to be built up gradually. In this case, both a black-and-white and a dark-and-light approach were employed.

208 and 209 are both high-key works. In the pencil drawing, the diffused modeling tone dominates. In the acrylic painting, the tones indicate color and textural differences as well as form and space. The background is flat and solid, while the shadow cast by the form is more diffuse.

TEXTURE

Even a cursory examination of the history of art shows that the preoccupation of the artist with both actual and implied texture has been a dominant influence upon visual art. In painting, drawing, and graphics, the medium was either exploited for its physical qualities or manipulated to simulate a visually realistic illusion of textured objects, shapes, and surfaces. For example, the works of Van Gogh and Soutine are as dependent upon the textured patterns suggested by their spirited brushwork as they are upon recognizable subject matter or the elements of good design. Artists such as Holbein and Vermeer, though they applied their medium in a relatively flat manner, were no less involved with texture as a persuasive visual element, as they incorporated renditions of wood, flesh, and velvet that are virtually painted translations of apparent reality.

Today the artist is still interested in, fascinated by, and to a great degree involved with the compelling nature of texture. The continuing and increasing adoption of "mixed media" as a complete expressive medium, one ranking with the pure forms of the visual arts, is evidence of such involvement. Concurrent with the elimination of distinct categories in the visual arts is the availability of recently developed materials. These materials not only allow for infinite combinations of color and tonality, but for extensive variations in texture.

The following exercise is a variation of an old-master technique, in which carefully shaped layers of gesso were overpainted with either tempera or oils. The exercise has been modified for mixed media using a freely designed, textured underpainting of gesso, which is allowed to dry and is then completed with selected graphic materials, such as charcoal, ink, and conte crayon.

As you proceed, keep in mind that the most compelling characteristic of a mixed-media drawing is the arrangement of contrasting elements combined with the textured pattern. Usually this is accomplished by superimposing, overlapping, and juxtaposing transparent washes, linear passages, and opaqued areas over the textured areas. The total process may be compared to a musical composition in which each element is "orchestrated" to contribute its unique character toward a projected theme.

The demonstration will combine dry and wet materials over the textured surface. In addition to the gesso base, the materials used will be: black ink, blue ink, charcoal, and red conte crayon. The background surface is a sheet of Upson Board, about 3 by 4 feet. Upson Board is a brand name for laminated cardboard and it can be purchased at almost any lumberyard. Any rigid, absorbent surface is a good substitute. The tools needed are: a brush about three inches in width, a spatula or putty knife, a Speedball pen, a single-edged razor blade, and a soft plastic container, such as a catsup or mustard dispenser, which has a long, pointed tip with a small opening.

The first step is to fill the container with gesso. Screw the top back on the container and insert a nail or matchstick in the opening when not in use to keep it from becoming obstructed. The following series of photographs describes the successive steps. You can follow the same procedure, loosely interpreting the details to suit your purposes, or you can devise methods of your own. In any case, you will find that textured drawing can be exciting and rewarding.

Fig. 211. A test pattern of gesso is applied over a roughly penciled design. The plastic container is held like a pen or brush, while the gesso is squeezed through its opening. If the pattern is not satisfactory, it may be scraped off with a spatula or scraper.

Fig. 212. A close-up of the textured surface shows where the plastic container was deliberately squeezed with greater pressure to create large globules and where it was gently squeezed to obtain a flowing line.

Fig. 213. Variations in texture are achieved by spreading some of the gesso with a brush.

Fig. 214. Spreading the lines of gesso with a spatula adds additional effects.

Fig. 215. After the gesso has dried, large areas of the pattern are generously brushed with a dark wash, using black ink.

Fig. 216. In some areas, charcoal is used.

Fig. 217. Compare the dry charcoal texture with the wet wash areas.

Fig. 218. A pen is used to apply black ink in a thin line.

Fig. 219. Scraping the ridges of the textured gesso pattern with a razor blade intensifies the whites, adding to the graphic quality of the design.

Fig. 220. The almost completed design. Red conte crayon and blue ink have been applied. In some areas, water was brushed onto the conte crayon to intensify the color aspect of the design.

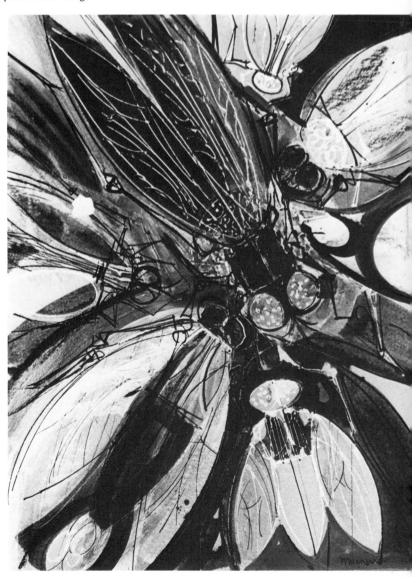

10. DESIGN AND COMPOSITION

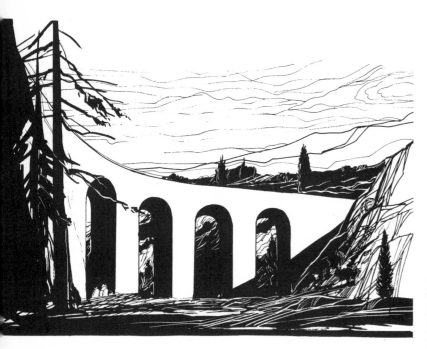

Fig. 221. Bridge viewed from ground level.

It is important to keep in mind that all design in a work of art is essentially abstract regardless of the ostensible subject or visible content. To clarify this, imagine that you have been equipped with a camera and assigned to portray, through the medium of photography, three concepts: space, monumentality, and a nonsubjective pattern. After a period of searching, you would perhaps select a subject like the bridge in Fig. 221 to serve as a medium for the three concepts.

Either instinctively or through experience, and after speculating on several views, you might eventually conclude that an impression of space could be achieved from the top of the bridge by maneuvering the camera so that the left side of the bridge becomes a horizontal line toward the top of the picture plane and the right side of the bridge becomes a curved line leading to the lower right of the picture plane (Fig. 222).

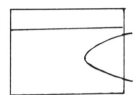

Fig. 222. Top view of bridge and diagram of compositional elements.

Fig. 223. Close-up of bridge above eye level and diagram of compositional elements.

Fig. 224. Extreme close-up of bridge above eye level and diagram of compositional elements.

To add the impression of monumentality, however, you would probably change your viewpoint, aiming your camera up at the bridge from the ground (Fig. 223). Instead of a horizontal line, you would have a sharply angled line slicing and compressing the top area of the picture plane. And instead of a fluid curve, you would have two relatively stable curves filling the remainder of the picture plane with the dramatic upward perspective of the shadowed arches.

Finally, to emphasize an abstract pattern, you might move in closer to your subject from the same view, simply dividing the picture plane into three almost vertical areas and concentrating attention on the texture and extreme tonal contrasts provided by this view (Fig. 224).

The point to note in this demonstration is that a concept may be realized through spatial organization. The drawings represent a hypothetical case. Because the aim of the project was to convey an impression of space, monumentality, and pattern — not to portray a bridge — the bridge could have been replaced by a table, a rock, or almost any object of a similar nature. The bridge was not the subject but a medium for conveying a concept.

Spatial organization not only conveys a concept, it elicits a response. Space may be so chaotically distributed as to disturb our sense of equilibrium, or it may be so evenly divided as to be displeasingly dull. Essentially most of us prefer a spatial organization that strikes a balance between diversity and unity, and this is true of other compositional elements as well.

There is no single set of rules to achieve this balance, however. The angular shape of the picture plane, for example, may be either echoed or contradicted. In the first instance, the principle of analogous composition is demonstrated; in the second case, the principle of complementary composition is followed (Figs. 225, 226 and 227).

Fig. 225. The diagram at the left illustrates analogous composition; the one at the right demonstrates complementary composition.

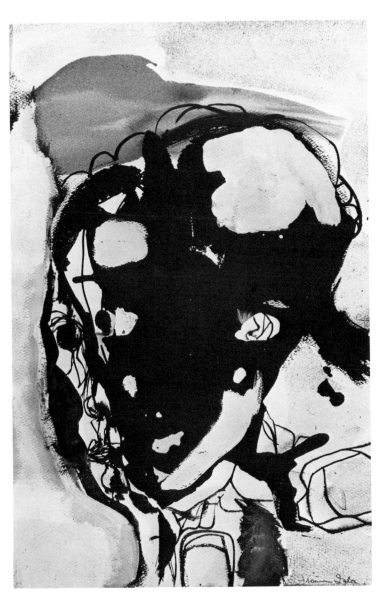

Fig. 226. *Head,* Frania Igloe; ink wash on gesso, 25 by 38 inches. The oval shape of this free interpretation of the head complements the angular shape of the picture plane.

Fig. 227. *Semi-Abstract,* Lena Gibbs. This is primarily an analogous composition, realized in the overall grouping of smaller shapes.

As another example, the entire picture plane may be incorporated into the composition, extending the subject to the edges or beyond (Figs. 228, 229 and 230); or areas of the picture plane may be used to surround and vignette the main composition, trapping the subject within the edges (Figs. 231 and 232).

Finally, the arrangement of shapes and the handling of the graphic elements allow for an infinite number of solutions to the compositional problems of concept, design, and individual expression. This will be evident in examining the drawings that make up the final chapter of this book.

Fig. 228. *Braceros,* Richard Haines; charcoal, 40 by 30 inches. In addition to exploiting the angularity of the picture plane, this drawing is based on contained form. The plane is sliced into sharp-edged areas that are qualified by detail, and the composition extends to the edges of the picture plane and beyond. A concept of rest and quiet has been achieved in this design by using angular, contained shapes.

194

Fig. 229. *Custer,* Robert Wendell; lithograph, 12 by 9 inches. The form is extended over the picture plane and spills outward beyond the edges; yet it is essentially a rotund shape contained by the angular picture plane.

Fig. 230. *Study,* Susan Vanciel-Monte; pen and ink. Again, the picture plane is sliced into sections, each one of which is developed separately but within the context of the total design. The curved shapes and edges convey a sense of motion; even though rounded shapes are used, the overall composition is analogous.

Fig. 231. *The Iliad,* Rene Lagos; brush and ink. The numer-
ous elements within the design are perceived as a single
unit, which is vignetted by the surrounding space. The
grouping of figures results in a rectangular shape, but in
this case the drawing was conceived as a chapter heading
and the picture plane is indefinite in area.

Fig. 232. *Oh Yes*, John Upston; pen and ink. This is a vignette drawing based on an angular main form which is modified by extremely varied detail.

11. SUMMING UP

In reviewing the selection of contemporary drawings in this chapter, we will see that some display what could be generally accepted as realistic interpretations, while others do not. All of them, however, in reflecting extremely varied concepts and techniques based on individual philosophies and attitudes toward life and art, exhibit a freedom of approach which is the hallmark of art today. Aside from the diversity in the apparent content of these works, we can see that each artist has come to terms in an individual way with the various graphic, compositional, and conceptual elements we have been discussing throughout this book. Thus while one artist's imagery may rely on line, another may rely on tone, with each having its own individual impact on the viewer. Such factors as skill in reading form, in handling the chosen medium, or in selecting and organizing the graphic elements, are easily recognizable and can be judged according to pre-established criteria — our own or someone else's. Other factors are more difficult to discern and evaluate. Judgments relating to the artist's intent, his initial insight, and his ability to amalgamate his physical, perceptual, and conceptual powers, can only be answered indirectly — by the influence the work has upon the viewer.

Fig. 233. *Milkweed*, Joseph Mugnaini; pen and ink, 6 by 4 inches. Point-to-point contour, a lyrical use of line in a vignette design. Various pressures of the pen and changes in the direction of its point as it moves over the paper are important in this approach.

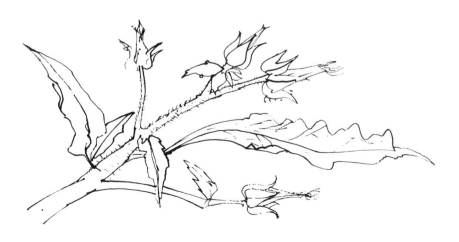

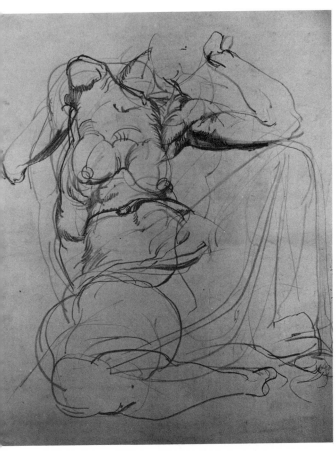

Fig. 234. *Seated Figure*, Robert Chuey; pencil on toned paper, 19 by 25 inches. A life study in which line echoes the rhythm and organization of the female form. Point-to-point contour, with strong areas of active linearity within the form.

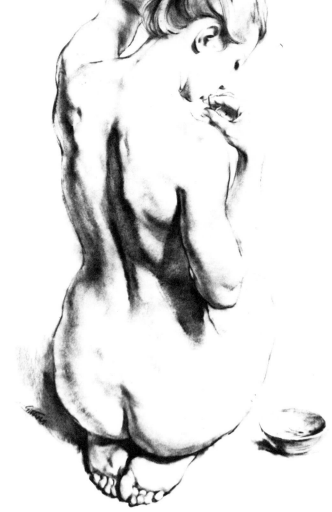

Fig. 235. *Woman*, Alvin Gitlins; charcoal, 25 by 32 inches. Very similar in subject to the preceding drawing; yet the imagery is entirely different. The point-to-point contour here is supported by the skillful handling of spatial and modeling tones, whereas the previous drawing depended on active, almost calligraphic lines.

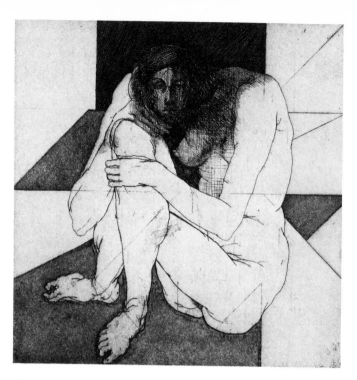

Fig. 236. *Lost in Thought,* Adrian Van Suchtelen; combined intaglio (etching, engraving, and aquatint), 5¾ by 5¾ inches. The figure is not vignetted but is centrally placed within a tantalizingly dissected square. Modeling tone is used in only a small section of the figure; and the angular, flatly toned areas of the picture plane are adroitly combined with the linear design, in which the sensitive, curvilinear forms contrast with the precise, mechanically drawn straight lines.

Fig. 237. *Figure,* Barbara Chenecek; pen and ink, 25 by 18 inches. Although the leg contours are quite deliberate, this drawing also exhibits quick, spirited lines, calligraphic in character and incisively executed. A work of this caliber issues from an intuitive appreciation of proportion and balance, not only in observing the subject, but, more important, in establishing the proper speeds, spatial movements, and pressures of the pen required to interpret the subject.

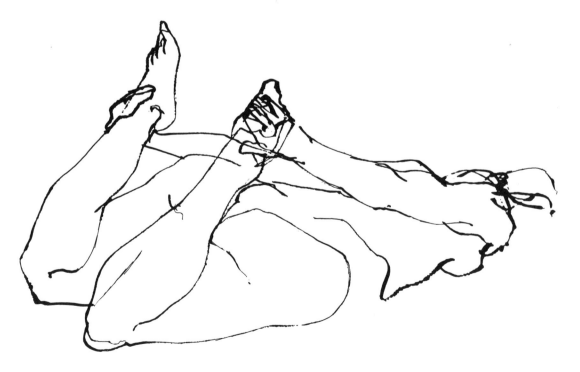

Fig. 238. *Calligraphy*, Hassan Omer; tempera on canvas, 30 by 16 inches. The swirling, dynamic movements are surrounded by the static areas of the picture plane. Flat tones in the black-white range are integrated to complement each other.

Fig. 239. Mechanical drawing by Douglas McClellen; ball-point pen, 18 by 25 inches. The mechanical element is present only in the spiraling movements of the pen; pressure exerted on the point has been deftly controlled to develop a broad range of sinuous tonal passages.

Fig. 240. *Cave Call*, Matsumi Kanemitsu; sumi brush drawing, 27½ by 39½ inches. The general design is preconceived, yet much of the execution is left to intuition. The interaction between the untouched areas and the areas of inked tones (both solid and diffused) and the impression of permanent wetness are distinguishing features of this type of drawing.

Fig. 241. *Two Figures,* Bruce Dean. The artist employs a sensitive contour to consolidate the large areas of flat tone.

Fig. 242. *Self-Portrait,* Zero Mostel; pencil, 14 by 20 inches. A vignette design with tone used essentially to separate the head from the remainder of the design.

Fig. 243. *Portrait*, Norman Greenwald. Tone is used to stress the three-dimensional nature of the subject. The total design is nevertheless quite linear and uses primarily an analogous composition conforming to the rectangular picture plane.

Fig. 244. *Self-Portrait,* Manuel De Leon; conte crayon and chalk. The entire design is contemplative and somber. There is no lyricism here, and line is practically absent. This is a good example of the mystery that low-key tonal passages occupying the total surface of the picture plane can produce. The passive head is the central element of the design, with the active background serving as a counterpoint.

Fig. 246. *Ghetto Child,* Eleanor Blangsted; brush and ink wash, 6½ inches by 4½ inches. This quick sketch contradicts the popular belief that white advances while black retreats.

Fig. 245. *Padre Pro,* Victor Casados; mixed media. Like the preceding drawing, this work is a symbolic montage employing dark tonal passages. The approach, however, is one of contained form rather than that of the extended form in the previous drawing.

Fig. 247. *Group,* Clark Walding; conte crayon. This is a good example of how the slightest application of tone reduces and modifies both the given quantity and quality of whiteness in the picture plane. Here, some white areas have been spent — reduced in intensity — by the addition of tone, while others have been amplified by surrounding and compressing them with darks.

Fig. 248. *Greed and Man,* James Westergard. This is another example of carefully spent whites, with the light areas squeezed and trapped by the dark areas. Tone here shapes strong, isolated forms, opposing the two-dimensional aspect of the picture plane.

Fig. 249. *The Call and Feeding of the Senses,* James Westergard; pen and ink. The crisp, accumulated pen strokes contain a silvery quality, distinguishing the tones in this vignette design from those in the previous one.

Fig. 250. *Abstract*, James Proctor; 24 by 18 inches. Here is an example of implied texture and carefully shaped forms against a neutral, flat whiteness.

Fig. 251. *Section of a Tree*, Geoffrey Taylor; quill pen and ink, 3¾ by 3¾ inches. In this instance, curved line both expresses the form and implies texture.

Fig. 252. Design for a bronze door, by
Stan Bitters; charcoal, 25 by 48 inches.
Line and tone are thoroughly inte-
grated in a composition based on the
contained-shape principle. This is a
working drawing for a design to be
executed in another medium; realism
is important in this case.

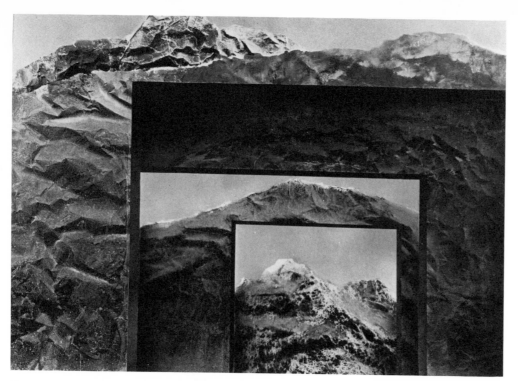

Fig. 253. *Oquirrh Series*, William Wheeler; mixed media (aluminum foil, paper, sprayed paint), 39½ by 25½ inches. While the forms seem ultra-realistic, the penetration of the picture plane actually contradicts reality. Tone and texture are intimately combined.

Fig. 254. *Verdict*, June Wayne; lithograph, 23 by 38 inches. Again, the composition is entirely tonal and textural, with a complete absence of line.

Fig. 255. *The Bridge*, Deborah Freiser; lithograph, 24 by 18 inches. The diffused tones yield a strong impression of spatial penetration in this composition of complementary forms.

Fig. 256. *Dark Image*, Barbara Chenecek; mixed media. A somber, almost threatening, image is sharply delineated against a lightly worked picture plane. The de-emphasized lower region is purposely left indefinite, in contrast to the carefully worked upper shapes.

Fig. 257. *Flight*, Kero Antoyan; ink, charcoal and mixed media. A vignette type of drawing in which the group is seen as a singular element or shape.

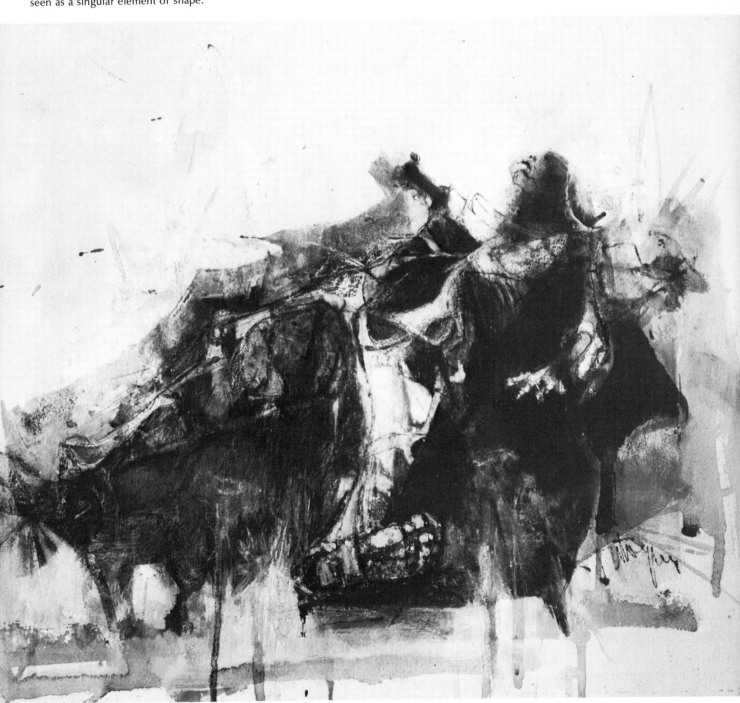